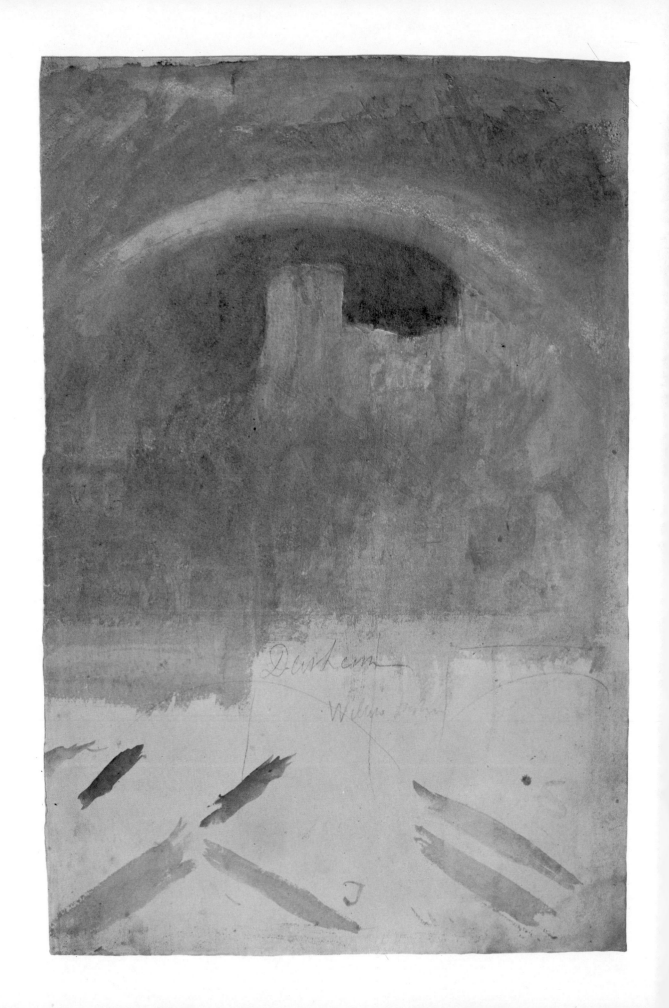

CCLXIII *125 Durham*
$14\frac{1}{2} \times 21\frac{1}{2}$ inches 369×546 mm

Gerald Wilkinson

Turner's colour sketches

1820–34

BARRIE & JENKINS
COMMUNICA-EUROPA

In series:

Turner's early sketchbooks 1789–1802

The Sketches of Turner, R.A., 1802–20

Text copyright © Gerald Wilkinson
First published 1975 by Barrie & Jenkins Ltd
24 Highbury Crescent, London N5 1RX
All rights reserved. No portion of this book
may be reproduced by any means without prior
permission of the publishers
Colour reproduction by
Colour Workshop Ltd, Hertford
Printed and bound in Great Britain by
Cox & Wyman Ltd, Fakenham, Norfolk
ISBN 0 214 20066 3

Preface

This book begins with Turner's return from his first visit to Italy, where he had gone primarily to seek inspiration from the 'antiquities'. I think he also planned a 'Turner's Picturesque Tour of Italy'; it would explain his methodical planning of the tour and his astonishing output of pencil drawings of architecture. He spent about four months in Rome, and returned home in January 1820. His great 'discovery' in Rome, it seems, was Raphael.

It may be useful here to give an outline of Joseph Mallord William Turner's career up to 1819, when he went to Italy.

He was a Cockney, born in 1775 the son of a barber in Maiden Lane, Covent Garden. He entered the Royal Academy Schools at the age of fourteen; he also had some tuition from Thomas Malton, the architectural draughtsman and engraver. During the summers the young Turner toured the Midlands (1794), Wales, the Isle of Wight, Lancashire and Westmorland, the north-east counties, and, in 1800 or 1801, the southern Highlands of Scotland, in pursuit of topographical material and subjects for his paintings. His first exhibited painting was a sea piece at the Academy in 1796 – he was 21. At the age of 24 he was elected an ARA. In 1800 he established himself in Harley Street. His mother was taken to Bedlam as incurably mad. In 1802, when he was 27, he was made an RA. He travelled to France and Switzerland.

The Shipwreck was exhibited in 1805. He began the mezzotint *Liber Studiorum: Illustrative of Landscape Composition*, his first venture into publishing, which occupied much of his time for more than ten years.

He made his own exhibition gallery in his house in Harley Street in 1804, and in 1808 also set up house in Hammersmith, perhaps with Sarah Danby and her children, and his two daughters by her. At this time his paintings and sketches, including the Thames Oil Sketches, were mostly inspired by scenery on the Thames and shipping, in the Thames estuary and at Portsmouth. He began to include country people in his pictures.

In 1810 he first visited Farnley Hall (near Leeds), the seat of Walter Fawkes, his most sympathetic patron. He went to Devon and Cornwall in 1811 and 1813, collecting material for *Picturesque Views of the Southern Coast*, engraved and published by Cooke.

Snowstorm, Hannibal crossing the Alps was exhibited in 1812, *Frosty Morning* in 1813, and the first of his 'Carthage' series, *Dido and Æneas*, in 1814. He moved to Twickenham, to the villa he had built and which he occupied with his father

until 1827. Watercolours for Fawkes built up to a climax with the Rhine series of fifty, the result of a sketching tour in 1817. *Dort packet-boat becalmed* was exhibited the following year.

He illustrated *The History of Richmondshire*, beginning work in 1816, and transcribed Hakewill's drawings for his *Italy* in 1818; also in that year he visited Edinburgh for Scott's *Provincial Antiquities*.

Turner exhibited *England: Richmond Hill, on the Prince Regent's Birthday*, in 1819 and then set off for Italy, copying down the best part of a guidebook before he went, and taking at least twenty sketchbooks.

The sketches in this book

Everyone knows that the sketches of a great artist of the past may contain the germs of his ideas in the most immediate and arresting form, free of the adaptions and modifications which the artist will usually have felt necessary to prepare his work for his contemporary public. However uncompromising the artist he cannot have escaped entirely from whatever misconceptions his age was saddled with – until it became fashionable for artists to escape. It was certainly true of Turner up to his middle fifties (about 1830). After this time he became less concerned, as this book hopes to show, to aim his work at a particular public; in the process of gradual (and partial) change he began to reveal a genius not merely romantic but universal.

Many of Turner's sketches in colour have an added claim to our attention: they have been preserved in their original freshness, first by the artist and then by respectful but only gradually more appreciative curators. Ruskin, who was charged with the business of first sorting out Turner's untidy Bequest, did not admire the Petworth watercolours or the 'Colour Beginnings' – in fact much of the main material of this book. He saw to its preservation, apart from some erotica which he burnt, but he did not recommend it for circulation and exhibition as he did large quantities of other material, and even dismembered some sketchbooks, putting the pages he didn't want into large parcels marked 'inferior leaves'. The sketches which were exhibited are now sadly faded and discoloured. Publication of the coloured drawings in this book was overdue, but we can be thankful that until our time they were kept away from the ravages of light and atmosphere.

Around 1830 Turner's voluminous pencil notebooks, while full enough of vivid material, gradually cease to contain his most inspired ideas. Instead he worked on an apparently endless supply of pieces of blue or grey paper, all torn to the same size, $7\frac{1}{2} \times 5\frac{1}{2}$ inches (190 × 140 mm). and all separate. Without the circumstantial evidence of adjacent pages they are undatable, except when they link up with other material,

which is rarely. Thus we have an amorphous, endless 'sketchbook' without covers. The pencil notebooks continue, and are here quoted in as near chronological order as is possible, to provide a stylistic, and sometimes a factual or geographical datum line against which the colour sketches may perhaps be placed. Of course the pencilwork is interesting, usually delightful, sometimes astonishing, in itself, but it is somewhat less so than that of the previous decade. More and more, Turner's pencil notes are his personal shorthand, set down with small regard for pictorial effect: he knows already what he intends to do with the material he records.

The title of this book therefore refers to Turner's sketches in watercolour – often body colour on tinted paper – which are not usually part of sketchbooks. They fall into three main groups in the period 1820–34:

1 topographical work intended for engraved series, such as the so-called 'French Rivers'
2 the Petworth watercolours
3 the 'Colour Beginnings', again so called

Only the first group had a purpose that is known. Turner did not sketch for the sake of sketching and his purposes in producing the work in the other two groups are open to speculation. Sketches were valueless except to the artist, and these works remained in his possession until by the terms of his will they became the property of the nation, with all his other unsold work, 'finished or unfinished'. He would not have approved, perhaps, of a book devoted to his sketches alone, but he did insist that his work should be seen as a whole. Containing an essential part, I believe, of that whole, this book is dedicated to that half-understood master, J. M. W. Turner, on the two-hundredth anniversary of his birth.

Acknowledgments

All the drawings and watercolours in this book are part of the Turner Bequest in the Department of Prints and Drawings at the British Museum, unless otherwise labelled. The drawings were catalogued in 1909 by A. J. Finberg, who gave each sketchbook and each group of drawings a number, set in Roman numerals, and, usually, each separate sheet a letter and each sketchbook leaf a number. These numbers appear in italic figures in this book. Only right-hand pages of the sketchbooks are numbered, the versos being identified as 2a, 3a, and so on. The names of the sketchbooks are Finberg's, unless Turner had already provided one; *his* titles, and all other quotations from Turner himself, appear in italics in the text.

All the photographs were taken by the British Museum Photographic Service, except: p. 7, Royal Academy; p. 9 top, Tate Gallery; p. 10, John Webb; p. 11, Tate Gallery; p. 13, Lady Lever Art Gallery; p. 15, Royal Academy, Tate Gallery; p. 16, Sidney W. Newberry.

John Webb photographed CCXLIV 112 and 116 (p. 59), CCLIX 7 and 38 (p. 89), CCLXXXIII 4 and 7 (pp. 78–9) and the 'Colour Beginnings' on pages 139, 142 and 151.

The colour reproduction – the hardest part of all – is by Colour Workshop Ltd, Hertford.

My personal thanks are offered to the Paul Mellon Centre for financial help while researching, and to the publishers, who have allowed a certain extravagance of expensive colour, and to the staff of the Print Room at the British Museum, who are always patient and helpful. Sarah Griffin tended the text, when it faltered, and Richard Wadleigh supervised the production.

Books

W. G. Rawlinson *The Engraved Work of J. M. W. Turner, R.A.* 1908 and 1913

A. J. Finberg *Complete Inventory of the Drawings of the Turner Bequest* HMSO 1909

— *The Life of J. M. W. Turner, R.A.* 2nd edn OUP 1961

Martin Butlin *Turner Watercolours* Barrie & Rockliff 1962

John Rothenstein & Martin Butler *Turner* Heinemann 1964

Jack Lindsay *J. M. W. Turner: his life and work* Cory, Adams & Mackay 1966

John Gage *Colour in Turner* Studio Vista 1969

Graham Reynolds *Turner* Thames & Hudson 1969

Martin Butlin, Andrew Wilton & John Gage *Turner 1775–1851* Tate Gallery (Catalogue of the Bicentenary Exhibition at Burlington House

Articles

Gerald Finley 'Kindred Spirits in Scotland' *The Connoisseur*, August 1973

Gerald Finley 'J. M. W. Turner's Proposal for a "Royal Progress"' *The Burlington Magazine*, January 1975

'Turner's England and Wales' (engravings) *The Antique Collector*, November 1974

Contents

INTRODUCTION 7

THE SKETCHES 1820–34 17

Rome, 1819–20 18
CLXXXIX *Rome C Studies*
CXCI *Rome and Florence*

Skies 20
CLVIII *Skies*

Ports and Rivers 22
CXCVIII Folkestone
CXCIX *Medway*
CC *King's visit to Scotland*
CCII Ports of England
CCIV *River*
CCV Old *London Bridge*
CCVI London Bridge and Portsmouth
CCVII Gosport
CCIX *Norfolk, Suffolk, Essex*
CCX Brighton and Arundel
CCXA Academy Auditing
CCXII *Thames*
CCXIII Mortlake and Pulborough

Holland, 1825, and Germany, 1826 32
CCXIV Holland
CCXV Holland, *Meuse* and Cologne
CCXVI Rivers Meuse and Moselle
CCXVII Huy and Dinant
CCXVIII *Trèves and Rhine*
CCXIX Moselle (or Rhine)

East Cowes Castle, 1827 36
CCXXVI *Windsor* and Cowes, Isle of Wight
CCXXVII Isle of *Wight*
CCXXVIIA East Cowes Castle

1828: vignettes 39
CCLXXX

Rome, 1828–9 40
CCXXIX *Orleans to Marseilles*
CCXXX Lyons to Marseilles
CCXXXI *Marseilles to Genoa*
CCXXXII Coast of Genoa
CCXXXIII Genoa and Florence
CCXXXIV Florence to Orvieto
CLXXVIII Rimini to Rome
CCXXXV Rome, Turin and Milan
CCXXXVI Viterbo and Ronciglione
CCXXXVII Roman and French Notebook

CCLI Caen and Isigny
CCLII Guernsey

1830 47
CCXXXVIII *Kenilworth*
CCXXXIX Worcester and Shrewsbury
CCXL Birmingham and Coventry
CCXLI Marine Dabblers

Petworth, 1828–30 51

The Petworth watercolours 51
CCXLIV
CCXLV Arundel and Shoreham

French rivers and towns: hiatus 63
CCXLVII *Morlaise to Nantes*
CCXLVIII *Nantes, Angers, Saumur*
CCXLIX *Loire, Tours, Orleans, Paris*
CCL Coutances and Mont St Michel
CCLIII *Tankerville, Lillebonne*
CCXI *Paris, Seine, Dieppe*
CCLV Rouen
CCLVII Paris and Environs

Abbotsford and Staffa, 1831 67
CCLXIV Rokeby and Appleby
CCLXV Berwick
CCLXVII Abbotsford
CCLXVIII Edinburgh
CCLXIX Stirling and Edinburgh
CCLXXII Loch Ard
CCLXXIII Staffa
CCLXXVI Fort Augustus
CCLXXVII Inverness

1832 70
CCLXXVIII Mouth of the Thames
CCLXXIX Gravesend and Margate
CCLXXIXA Life Class

1833 71

1834 72
CCLXXXI Fishing at the Weir
CCLXXXII Fire at Sea
CCLXXXV Oxford
CCLXXXVI Oxford and Bruges
CCLXXXVII Spa, Dinant and Namur
CCLXXXVIII *Givet*, etc
CCLXXXIX *Mossel and Oxford*
CCXC Trèves to Cochem, Coblenz to Mayence
CCXCI *Cockem to Coblentz. Home*
CCXCIB Colour Studies 1
CCXCIC Colour Studies 2
CCLXXXIII Burning of the Houses of Parliament 1
CCLXXXIV Burning of the Houses of Parliament 2

Sketches on blue or grey paper 80

Meuse–Moselle, 1826? 81
CCXX
CCXXI
CCXXII

'French Rivers' drawings 88
CCLIX

Meuse–Moselle–Rhine, 1834? 96
CCXCII

The 'Colour Beginnings', CCLXIII 99

CHECKLIST 160

Introduction

In the winter of 1820, on the way home from Italy, Turner's coach
was overturned in a snowdrift and the passengers had to walk.
The incident was made the subject of a watercolour for his patron,
Walter Fawkes: *The Passage of the Mt. Cenis, 15 Jany., 1820.*

Amongst his luggage which somehow survived the journey were
fifteen sketchbooks of various sizes, mostly crammed with pencil
drawings of castles, churches, streets and ruins. The sixteenth book,
we may be sure, was in his pocket – a small book which he labelled
Return from Italy.

For Fawkes he did a few conventional views of Venice and Rome.
Two or three other watercolours were exhibited in the early 1820s at
the gallery of W. B. Cooke, the engraver: amongst them, in 1822, an
Eruption of Vesuvius, which the critic of the *Examiner*, Robert Hunt,
described as a 'reddened, yellowed, and delicious horror'.*

One of the smaller sketchbooks brought back from Rome was full of
details of the Vatican Palace. These notes and others Turner used in
composing a large allegorical picture, *Rome from the Vatican. Raffaelle
accompanied by La Fornarina, preparing his pictures for the decoration
of the Loggia.* Turner's reaction to Venice and Rome was, it seemed,
that of a tourist and an earnest, ambitious student. Yet this first visit to
Italy is often regarded as the turning point in his career.

Sir Thomas Lawrence, who was in Rome in 1819 on a commission from
the Prince Regent, had written that 'Turner should come to Rome . . .
the subtle harmony of this atmosphere, that wraps every thing in its own
milky sweetness . . . can only be rendered by the beauty of his tones'.
The large *Vatican* picture was not exactly the sort of thing that
Lawrence seems to have been expecting. It was ready for the Royal
Academy annual exhibition – less than three months after the artist's
return to London – and was received with mournful derision. Nearly 150
years later at least one authority, Graham Reynolds, finds it 'hard to
quarrel too violently with the condemnation which the picture
received at the time . . . But,' he says, 'the management of the masses
is original, even for him.'

The painting measures nearly six feet by eleven. Its colouring was
described at the time as 'gaudy and obtrusive' – the colour was
'exaggerated, so that the room in which he represented Raffaelle . . . is
thought to look like a furnace'. It is sadly faded now, by that standard.
Rome from the Vatican has never been taken seriously, except by John
Gage, who devotes two most erudite pages to what he describes as 'one
of the most crucial paintings for the understanding of Turner's career,
representing as it does an autobiographical statement . . .' It is
'a thoroughly programmatic picture, fully in accordance with the new
attitudes to Raphael which were developing in Rome at the time of
his first visit. Raphael was being recast in a mould very close to
Turner's conception of his own personality'.

Turner obviously intended *Rome from the Vatican* to match his *England:
Richmond Hill* of the year before. The two pictures are the same size,
the largest he ever painted. *England* is allegorical in its way: it is Turner's

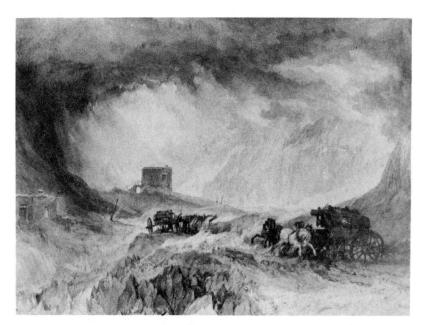

The Passage of the Mt. Cenis, 15th Jany., 1820 Watercolour, $11\frac{1}{2} \times 15\frac{3}{4}$ inches,
292×400 mm. City Museum and Art Gallery, Birmingham

* This Notice appeared on 3 February. An important eruption of Vesuvius began
on 23 February 1822. Turner could have seen a small eruption in December 1819.

Rome from the Vatican. Raffaelle accompanied by La Fornarina, preparing his pictures for the decoration of the Loggia. Detail from the engraving by A. Willmore of the picture exhibited at the Royal Academy in 1820. Tate Gallery

England, a summary in one 'breathtaking' view of the Thames valley which had cradled his happiest years and had also been the background of his struggles. Though framed in Claudian trees and peopled with Watteauesque ladies, the winding river view itself was not a personal discovery. It had an exact precedent in a watercolour* by J. R. Cozens, a spiritual father who had died, like Turner's mother, incurably mad.

The theme of 'Raphael and his mistress' also was not original: it was a 'standard'. Around the celestial pair Turner grouped all the elements of Raphael's (supposed) achievement and his own ambition, and he bathed the scene with unrestrained colour. It was as if he had planned one work to close an era, the other to open one. Thus did the genius dare to plan his career, ignoring his own warning of the *Fallacies of Hope*. Whether or not the first visit to Italy marked a turning point, Turner clearly wished it to do so.

But the real corner had been turned in about 1818, as is shown by the Rhine watercolours and the brilliant sky and sea of *The Dort*. Italy had no immediate salutary effect on his palette, or on his retina, though it spurred him to intense activity. His sketchbooks are filled with about 2000 pencil notes, mostly of architecture. His most consistent work apart from these was a series of monochrome 'chiaroscuro' studies of Rome and its ruins. With a few more or less experimental pages of watercolour he had done some justice to Lawrence's faith in his feeling for subtle harmony of atmosphere.

* In the collection of E. Croft-Murray.

But in many coloured pages he seems to have been struggling, his technique bogged down by the grey background washes: delicate colours trapped in the mud of his chiaroscuro intentions. He was in a muddle – and this will not be surprising to creative persons who have found themselves, without a breathing space, thrown among a mass of new impressions.

Throughout the 1820s, as he digested his experiences, Turner produced one oil painting of an Italian subject which showed a new freedom of colouring. The *Bay of Baiae* of 1823 seemed to Constable at the time to be 'painted with saffron and indigo' – but there is more brown in it than that suggests. In fact this is the first of Turner's oil paintings to embody the prettier aspects of his late style. It is luminous, and somewhat indistinct in its outlines. Though it is full of detail the impression is that detail is suppressed – or skilfully absorbed into the main masses. The figures of Apollo and the Sibyl are merged into the shadows. Apollo is offering her an immortality measured by the grains of dust in a handful of earth. A small flock of sheep with a shepherd, and a snake and a rabbit are no doubt part of an obscure symbolism, but are very small incidents among the accretions of vegetable and mineral which form the landscape. Turner has certainly here strayed into a different world, but it is a world with the textures of confectionary. For Ruskin, this picture marked the rejection of the whole theory and practice of Turner's past endeavours: for us, only the distant bay, hanging in misty blue, retains something of the truth of his vision.

A much more exciting, and more revolutionary, picture had been painted in the previous year. It is, unexpectedly, an interior, and is nothing to do with Italy. *George IV at a Banquet in Edinburgh* is all crimson, gold and silver; but its splendour is not merely regal. It belongs to some fairyland of Turner's invention – though he witnessed the scene in reality (apparently from behind a curtain). The light of hundreds of candles went to his head and he turned the grand occasion into something weird and fantastic – and absolutely true to himself. In the grouping of the figures, particularly the ranks of the lower tables, there is a primitive quality. The foreground group, in a pool of red shadow, is most theatrical. The chandeliers are ethereal. The king is grotesque. Perhaps Turner felt that he had failed; he never exhibited the picture, and anyway it was decades ahead of its time.

If the *George IV* had been exhibited it would have been regarded as a sketch. I have no doubt that in Turner's view it *was* a sketch for a much larger picture. It measures 26 × 36 inches, which is half the size of his smaller exhibited landscapes before this date, and as small as his biggest watercolours. For the amount of detail included and for its conception it is very small, except as a sketch. It is completely worked out – 'sketchy' only by the spurious standards of the day.

This is the first of Turner's oils to be composed in the unaffected, direct style that we associate with the sketches: composed imaginatively, that is, and not just painted from nature as were those earlier panels known as the Thames oil sketches. It is the first of a great series which includes *Interior at Petworth* and *Rain, Steam and Speed*, and relatively few other works, in which Turner treated contemporary subjects in this very idiosyncratic way. In these works the division between sketch and painting becomes irrelevant: the quality of inventiveness seems to flow from the brush.

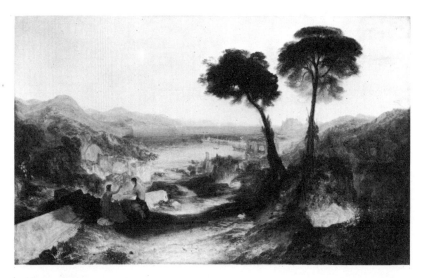

The Bay of Baiae, with Apollo and the Sybil, 1823

Sketch of Baiae from the 'Colour Beginnings', CCLXIII *350*. Watercolour, $12\frac{3}{4} \times 18\frac{1}{2}$ inches, 324×470 mm. Tate Gallery

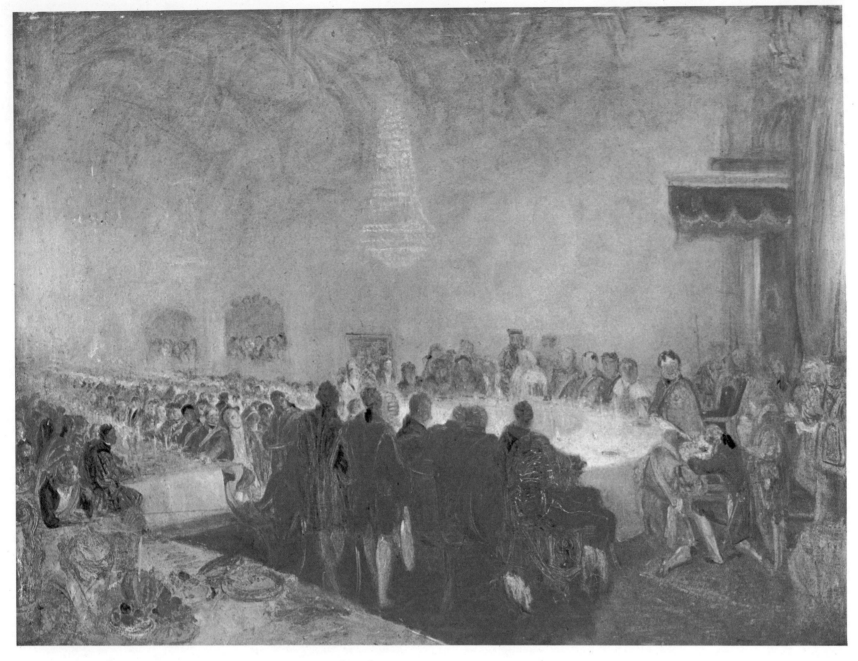

George IV at a Banquet in Edinburgh, 1822. Oil on wooden panel, $26\frac{1}{4} \times 36\frac{1}{2}$ inches, 67×93 cm. Tate Gallery

Turner's busy professional life continued through most of the 1820s undisturbed by any particular crisis. A steady flow of engravings went on to the market, backed up by exhibitions of the original watercolours – these often highly finished and crowded with detail. They were the results of almost annual tours in England, France or Germany. He rebuilt his house and gallery, pushing up the rateable value from £20 to £65, and adding a water closet at a cost of £14. He bought the leases of two adjoining houses in Harley Street in the process. A national financial crisis in 1825 ruined many wealthy people, including Walter Fawkes, who died later in the year, and Sir Walter Scott, whose publishers, Ballantyne and Constable, collapsed. But Turner's money was in patriotic Government bonds, and he lost nothing.

He had been made an Auditor of the Royal Academy in 1824, and his work for the Artists' General Benevolent Institution continued, at least to the extent of his attending the annual dinner, where he was noted for 'good humour and conviviality'. In some years he delivered his Perspective Lectures, in others he made excuses.

He was busy and successful, and had good friends and patrons, though he sadly missed Fawkes, as is proved by many records. He *was* rather lonely. His father, from all accounts at least a cheerful factotum, was all the family he had, as he more than once pointed out in letters to friends. He was now quite out of touch with Sarah and his daughters – Evelina was married and mostly abroad, and we hear nothing of Georgiana until he makes a will. Younger friends,

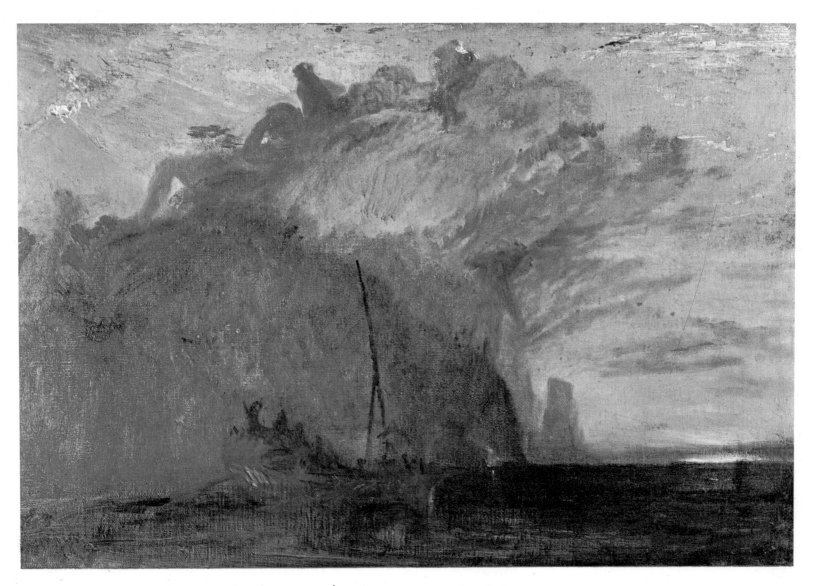

Sketch for *Ulysses deriding Polyphemus*, 1828–9. Oil on canvas, $23\frac{1}{2} \times 35$ inches, 60 × 89 cm. Tate Gallery

Holworthy and Calcott, both married, and there is a gleam of self-pity in his letters on these occasions. He did not meet Mrs Booth, the companion of his later years, until 1828, and at that time she still had her husband living. Of course, Turner was quite capable of keeping a mistress, perhaps down in Wapping, where he had some inherited property, including a pub, and where he was said to disappear more often than was strictly necessary to collect the rent.

His exhibited work rose to great heights of achievement with *Ulysses deriding Polyphemus* in 1829. We may prefer the smaller oil sketch. Lesser works, but very beautiful, were the Mortlake Terrace pictures of 1826 and 1827 and the Cowes Regatta paintings of 1827–8. He laboured on his only official commission, *The Battle of Trafalgar* (about

1823), trying – it was said with great good humour – to meet all the criticisms of sailors and eye-witnesses. He conspicuously failed to be knighted. Some illustrative compositions like *What you will!*, 1822, *Rembrandt's Daughter*, 1827, and *Boccaccio relating the tale of the birdcage*, 1828, were rather a waste of time. He surely must have known that his figure painting could never hold a candle to Rembrandt's and Watteau's. He was best known, and much loved, for his watercolours and the engravings from them.

Such was the public image of J. M. W. Turner in the 1820s: no disasters, no 'vortices'. For the time being he left the art of cataclysm to his young competitor, John Martin.

Broughham Castle, near the Junction of the Rivers Eamont and Lowther, from *Rivers of England*, 1825. Engraved in mezzotint on steel by W. Say. $8\frac{3}{8} \times 6\frac{1}{8}$ inches, 213×156 mm

Lancaster from the Aqueduct Bridge, 1827. From Picturesque Views in England and Wales. Line engraving on steel by R. Wallis. $9\frac{1}{8} \times 6\frac{1}{2}$ inches, 232×165 mm

In 1828 he went to Rome again. There he worked 'day and night', according to Eastlake, who was there; 'began eight or ten pictures and finished and exhibited three, all in about two months'. Returning in January of the next year he was again pitched into a snowdrift (and again produced a watercolour: *Messieurs les voyageurs . . .*). He intended to put some of his paintings from Rome into the Academy Exhibition, but they did not arrive in time. He managed very well with *Ulysses deriding Polyphemus*, which shocked everyone, and the safe but pleasant *Loretto Necklace* – a landscape with very incidental figures. This painting should have found a buyer; but few of Turner's oils that were not commissioned did sell.

In June 1829 there was a grand exhibition at the Egyptian Hall, Piccadilly, of the large watercolours for *England and Wales*, the last and most ambitious of his copperplate series, which he had begun in about 1826. By this year he had probably completed about fifty of the drawings. It must have been a wonderful show.

In the summer he went to France and the Channel Islands – perhaps for a holiday. Soon after he returned in September his father died, at the age of 85. He was buried at St Paul's, Covent Garden.

Lawrence, who was six years older than Turner, also died this winter, in January 1830. Turner exhibited *Funeral of Sir Thomas Lawrence, a sketch from memory* at the Academy in the following spring.

Also in the exhibition was a small oil painting, a full-face portrait of a young woman in fancy dress, called *Jessica*. Perhaps, like two other pictures he showed, this had been painted in Italy in 1828. *Jessica* was bought by Lord Egremont, and a commission followed for some landscape panels to go in the panelled Grinling Gibbons room at Petworth. A workroom was put at Turner's disposal in that great house.

A change of orientation now occurs in Turner's work. His private world of colour and fantasy begins to emerge. There is a shift of emphasis. Perhaps in the glow of Petworth patronage, the mood of spontaneous inspiration which we find so consistently in his sketches and 'colour beginnings' – his private work – now begins to be channelled directly to his canvases and watercolours.

In 1830 he travelled about the midlands of England – Kenilworth, Birmingham, Worcester, Shrewsbury, Lichfield, Chesterfield – in much his usual way. Many of these places had been the scenes of his first sketching tour at the age of 19: now he was 55. The three sketchbooks of this tour are full of vivid, muscular pencilwork. Yet they are the last to be so evocative – as they are – of the places he visited. His note-taking habit changed almost suddenly, and the small books he carried about soon contain little but the crude shorthand he needed to jog his memory. Very occasionally the bold lines are softened and flexed as a mood of landscape demands a response, but mostly it is the bare bones of fact that litter the page, disjointed.

His colour sketches, where he attempts to make immediate pictorial sense of whatever stirs his spirit – these continue. As well as his small notebooks he has a seemingly inexhaustible supply of folded blue paper. Sometimes he restricts himself to black ink relieved with chalk, but often he has a full palette of gouache watercolour. The colours are used in every degree of dilution, from subtle, semi-transparent washes to an almost dry scumble which can give the effect of pastels.

This sort of sketching is 'for real' – when he takes a piece of blue paper he means a picture to follow, soon or later. Of course many

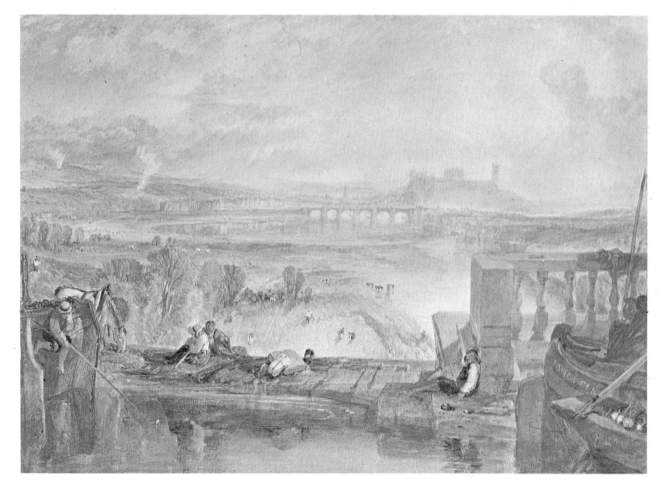

The watercolours prepared by Turner for the engravings opposite. Above, ccviii – N, $6\frac{3}{8} \times 9$ inches, 162×228 mm; below, $6\frac{3}{4} \times 9\frac{7}{8}$ inches, 171×251 mm. Lady Lever Art Gallery, Port Sunlight

sheets are left with only a few lines drawn; but the intention was there. The blue paper habit seems to have started in 1826. He had formerly used books of cheap blue paper for composition studies in the studio, and had tinted his outdoor sketching paper, usually the tough Whatman 'laid', in various shades of grey and brown. Now he had found a better quality tinted paper he took it out with him for composition studies on the spot. The blue suited him, obviously – it is greyish, and flecked, like the paper sold now as 'Ingres' – and perhaps, like most of us, he was slightly superstitious; he had worked out many successful compositions on this colour before.* Blue is the colour of distance, and it was also useful as ready-made moonlight and mist. The rather heavy East Cowes Castle series (p. 38) does give the impression of having been done by moonlight or twilight.

By the early 1830s he was producing a great variety of work on his pieces of blue paper, and it is to these, rather than to his notebooks, that we must look for his very frequent moments of inspiration, as well as for the originals of many of his engraved works in the 'Rivers of France' series. Preliminary notes in the sketchbooks are usually plainly factual, though often beautifully composed.

In the 1830s his method of oil painting changed too. In many Italianate landscapes following the precedent of the *Bay of Baiae*, and in his consistently fine sea pieces, he laid down only the broad masses – the action of the piece – and then left them. Such detail as was necessary to make them suitable for the eyes of his contemporaries he then added over the drying paint. Many that he did not so finish have come down to us, and are among his finest works.

This method he had used in watercolour as long ago as 1817, in the Rhine series for Fawkes, or so I believe. Thus these surviving 'unfinished' paintings are in fact 'colour beginnings' in oil paint. They are in no sense rough, simply direct.

It became Turner's habit to send his work in to the Academy exhibitions in this form of broad impasto, and to work up the detail on Varnishing Days – an institution of which he was a great supporter. He gave a virtuoso performance which he enjoyed as much as did his fellow artists, who had plenty of time to watch since they had usually sent in their work finished. There was often fierce competition, too, among the gladiators of the Academy, with daring employment of bright blues and reds. Turner is supposed to have completely knocked down an adjacent Constable by introducing a bright red buoy into an otherwise inoffensive sea piece. 'Turner has been here', said Constable, 'and fired a gun.' Turner was said to show his complete mastery when, on finishing his work, he gathered up his tools and left without even standing back to appraise it. Perhaps the poor man knew he had spoiled it and could not bear to look.

Apart from landscapes and seascapes with the innovations in method just described, Turner's production of epics continued with more gradual change of approach and no change at all in intention. They were still at the centre of his ambition – and it was his choice, for they were not done to satisfy a market. He must have been extremely busy, too. He was still at work on the massive *England and Wales* series, making highly finished drawings, often with complex groups of figures. Vignettes and other illustrations for Rogers' *Italy*, Rogers' *Poems*, Finden's *Illustrations*

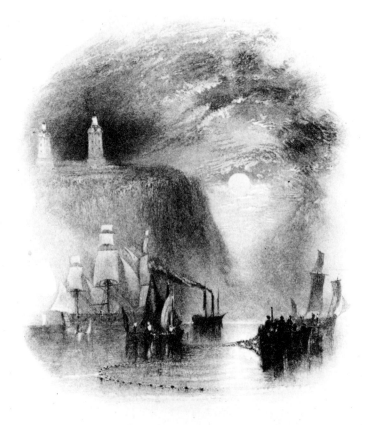

Light Towers of the Hève. Title-page vignette from *Turner's Annual Tour: Wanderings by the Seine*, by Leitch Ritchie, 1834. Engraving by J. Cousen

* A blue paper called 'Turner Paper' was available until recently.

of the Life and Works of Lord Byron, and Scott's Poetical Works were all published between 1830 and 1834, and 60 steel engravings of the series 'Rivers of France' (Turner's Annual Tour – the Seine and the Loire) were published in 1833–5; a number of popular annuals used engravings from his Italian scenes. Turner supervised all his engraved work, and proofs were sent to him for comments and 'touching' even when he was abroad.

With so many different activities dovetailing together in his life it is not surprising that changes when perceived are slow in effect. One is often led to pick out a picture or an event in Turner's career as crucial, only to find that the rest of his multifarious output flows on and round it like a mighty river: the task is to perceive how the currents interact. But it is certain that quite important changes were in progress in the early 1830s – and they were centred on Petworth.

Amidst his illustration work – and books were ever a drain on the spirit for their creators – Petworth must have been a blessed retreat. Of course, he went there to work, but he probably did quite a bit of fishing. And if the atmosphere and the content of the Petworth watercolours are at all true, he was suddenly very sociable.

The portrait of Jessica, chosen by Egremont, brings us face to face, for only the second time in Turner's work, with a person – the first being his self-portrait of 30 years before. This Jessica is rather a doll, but the picture is matched by other portraits of women, and by others which can best be described as 'close-ups' – The Letter of 1835, for instance, painted at Petworth. These, including the brilliant conversation piece, Music at Petworth (dated 1833), are the easel-painted counterparts of the Petworth watercolours – 117 miniatures in body-colour on blue paper, which together form a microcosm of the life of this great house.

The genre was a new departure, and the series is almost unique. Its genius loci is Egremont himself. It is hard to escape the feeling that the expansive personality of this extraordinary man was the inspiration of all the work Turner produced at Petworth. Also that it fired the sense of liberation that emerges from all his work of the early 1830s. Turner at 55 can hardly be thought of as young and impressionable, but there is no doubt that he could respond to a sympathetic patron. Egremont's encouragement brought out Turner's best, and the cultured but very relaxed atmosphere of his house parties clearly provided the best possible environment for Turner's diffident personality, leaving his creative ability full scope.

It is possible to theorise further that the octogenarian Lord Egremont had a strikingly different influence from that of the other octogenarian, Turner's father, with whom he had shared his life for more than twenty years until William's death in 1829. We do not know how much of Turner's thinking was shaped by his father, who 'never praised him except for saving a penny', and who dealt with all his business as well as helping with stretchers and canvases. It is not unknown for even quite mature men to be obscurely restrained by the influence of a father who is close to them – and to experience a corresponding release after the death of the parent. Much of Turner's overweening ambition and a long-protracted, unnecessary conformity may have been due to old William, who could not have held any view of art beyond the most ordinary.

Whether you regard the Petworth watercolours as the brilliant

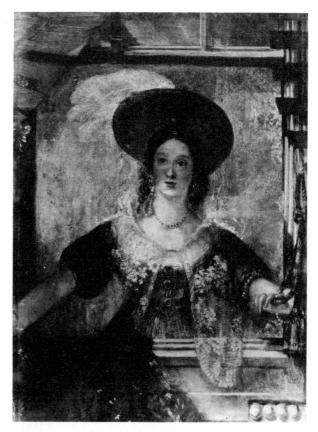

Jessica, 1830. Oil on canvas, 47 × 35 inches, 120 × 90 cm. H.M. Treasury and the National Trust, Petworth House

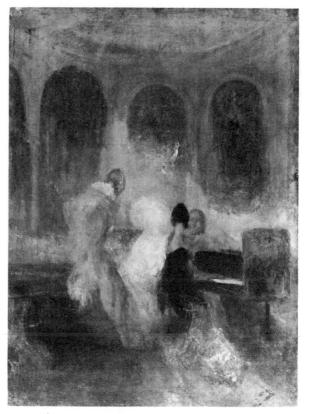

Music at Petworth, 1833. Oil on canvas, slightly larger than the picture above. Tate Gallery

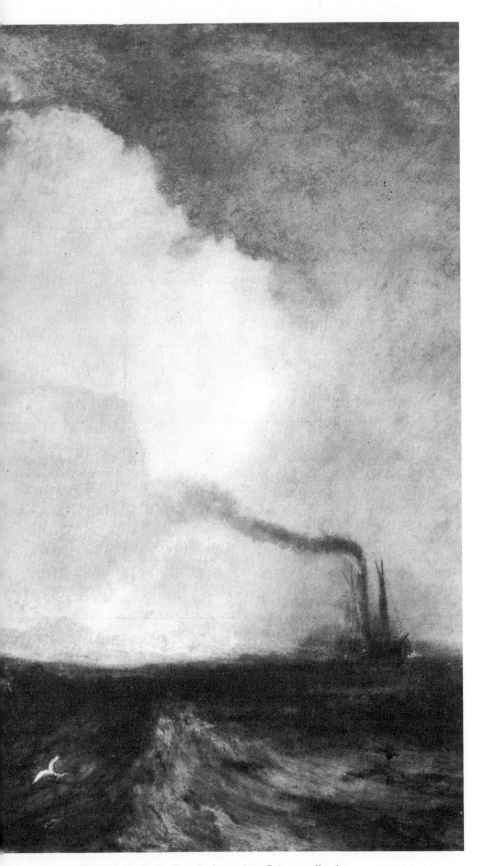

Detail from *Staffa. Fingal's Cave*, 1832. Private collection

scenario of a new freedom of expression or merely as a relaxed and engaging series of *bagatellen*, it is obvious that here and in the 'unfinished' landscapes and seascapes of the period, the strong undercurrent of Turner's hitherto concealed colour experiments has now come to the surface and is an overt part of his picture-making process. His dream world – dreams not of fantastic imagery but of lyrical colour – has collided with the somewhat uneasy reality of his life as a painter-illustrator: and there is no conflict, only a lively fusion. In at least one large area of his activity, his sketches *are* his paintings.

But no *status quo* ensued. Many an epic remained to be laboured on, many a vignette was slickly polished in the studio, many a Venetian scene was to be modelled well beyond the point of pristine perfection. But the mechanism, if you can call it that, now existed for producing the evanescent perfection of *Norham Castle, sunrise* and the ultimate achievements of *Rockets and blue lights* or the *Snowstorm at sea*, all of the early 1840s. Already, in 1832, the steamboat of *Staffa* belches a signal of Turner's victory over the elements he had chosen to master. When he could paint like this, he could tear up his sketches.

Fortunately, he didn't. He hoarded them all, and left them to us. The most important body of colour sketches is catalogued under the heading 'Colour Beginnings, 1820–1830(?)' – Turner Bequest CCLXIII. It consists of 390 watercolours, all but three on white paper, usually scraps or folded sheets. A few are identifiable as working drawings for known compositions, while a handful are studies of still-life – dead pheasants or fish. One large watercolour is the fine piece of reportage of Lawrence's funeral (reproduced on p. 47). A few carry Turner's titles or notes – not very revealing. All the rest are colour sketches in more or less abstract terms; they are not abstract designs but they contain the minimum of contextual information. Most adopt the convention of the vignette, very familiar to Turner from his work for Rogers' and Byron's poetry. Though nearly all are interpretations, or just records, of natural phenomena and scenery they defy categorisation except into the crudest groups. I regard them all as pictures and not as 'beginnings' in the sense of false starts or pieces of rejected under-painting. Some, perhaps, are a series of visual poems, illustrations to that unwritten epic of Creation, Turner's *Fallacies of Hope*. There are pictures of shadows, of places not quite recognisable, of storms, of clouds, of waves and shores, of the sun and the moon, of reflections in water; and, some have said, glimpses of eternity. They are the tangible material of Turner's thought.

As for dates, there are none. A scattering of watermarks suggests nothing useful. Finberg wisely placed these watercolours at the centre of the artist's output. It is possible to discern a vague line from the earlier 'Beginnings' (CXCVI and CXCVII, 1802–20) such as the *Mewstone* sketch of about 1815, to the brilliant series of variations on the theme of the burning of the Houses of Parliament (1834). Along this line can be placed, roughly, most of the 'Colour Beginnings' by inference of style alone. The main body of the work can be placed between 1817, the year of the Rhine watercolours for Fawkes, when Turner was 42, and 1834, when he was 59. At both the beginning and the end of this period radical changes were taking place in his work, or in parts of it. The period itself, however, is not one of 'ferment'. Though the evidence of the exhibited work is confused, the sketches show him serene on a plateau of excellence. But he seeks the distant, lonely peaks.

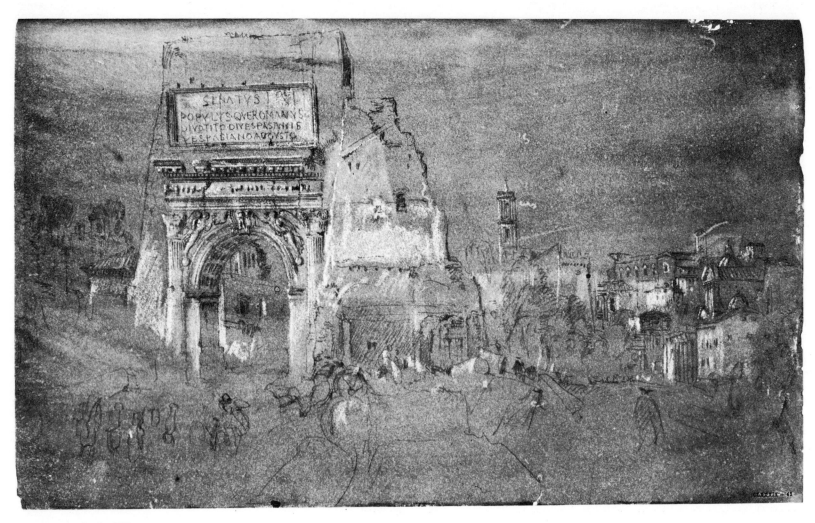

CLXXXIX *43* Arch of Titus

Rome, *1819–20*

A backward look to begin with. Turner's work in
and about Rome was almost entirely topographical,
but he found new material for his painting and he
experimented with new ways of interpreting
landscape.

Before he left London he had illustrated
Hakewill's *Picturesque Tour in Italy*, redrawing
Hakewill's own camera lucida outlines, and he had
made elaborate notes from *Select Views in Italy*
(Smith, Byrne and Emes, 1792–6). Two pages of
these notes are reproduced in *The Sketches of Turner,
R.A.*, p. 179.

The Roman sketchbooks of 1819–20 would
easily provide material for a whole book, but we
cannot pause for too long if we are to survey the
whole of Turner's work through his sketches.

He took with him, as well as ordinary small
notebooks, four larger ones with grey-washed

paper, three of which he himself labelled *C Studies* –
the 'C' standing for 'colour' or, as has often been
suggested, 'chiaroscuro'. He did numerous
'chiaroscuro drawings'; the Arch of Titus, above,
is one of the most elaborate (later turned into an oil
painting), but all of them were detailed. Some of
the pencil-on-grey drawings he worked up in
watercolour. Other watercolours on the white
reverse sides of the paper are in a variety of styles:
see Butlin, pl. 10 and *The Sketches of Turner, R.A.*,
pp. 188, 189, back endpaper and jacket. All these
are superbly skilful, confident drawings. Many of
the grey pages, too, are extremely sensitive and
well conceived, but hard to reproduce.

The coloured page (opposite) from the *Rome C
Studies* book tells a different story. For once Turner
over-reaches himself and produces a curiously
modern-looking failure. It has not escaped
the fading which was the result of Victorian
admiration, but even allowing for the yellowing of
the colour-scheme it cannot be described as elegant,

interesting though it is. The unsettled style of this
and other Roman watercolours indicates that in
Rome Turner, who so rarely faltered, was unsure
of his direction.

While his watercolours are all experimental,
his pencil notebooks, with small exceptions, keep to
topography; 2000 pages of it. Awareness of his
great interest in illustration leads me to believe
that he planned a 'Turner's Picturesque Tour of
Italy'. The exceptions take the form of earnest
study of architectural detail, sculpture and
painting. Here is a note of a Claude Lorraine from
the *Rome and Florence* sketchbook. Finally, a
scribbled page from the same book suggests an
interest more than merely topographical in *Arrezo*.

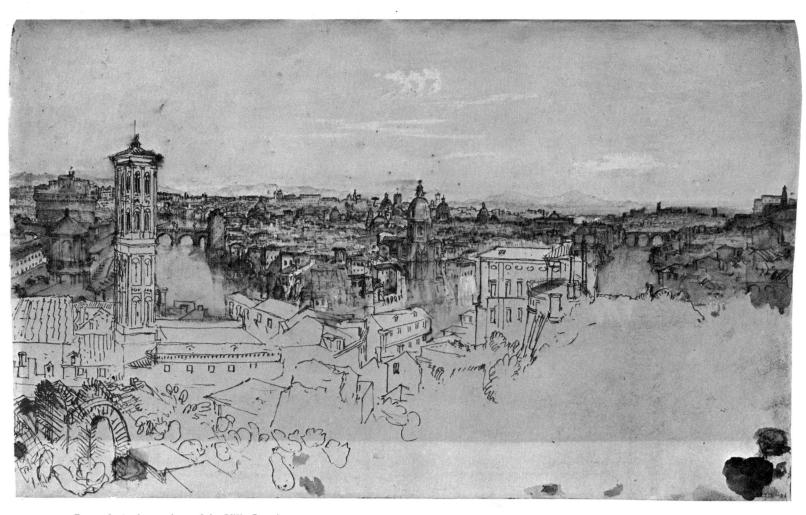

CLXXXIX *34* Rome from the gardens of the Villa Lanti

CXCI *60* Copy of a picture by Claude (in the Uffizi?). *Date 1631 or 81*
Roma he died at 82 Raf 1512 The Mast Red all painted at once with
1 colour Wonderful Grey Green etc.

CXCI *27 Arezzo*

Skies

In the catalogue this sketchbook is dated
1816–18 because of some pencil scribbles of
a garden party at Eton at one end of the book.
A footnote bears this out. 'Entry in Mrs. Fawkes's
diary for 4th June, 1818: – "Went to Eton to see the
boat race. Dined and slept at Salt Hill. Little
Turner came with us."' As they all did exactly the
same thing in 1820 and 1822 this is not good
evidence for dating the sketchbook before 1818.
Turner would hardly take a book full of his
private watercolours – there is one on nearly every
right-hand page, a total of 61 – to Eton and proceed
to make rough notes on the backs of the
watercolours. More likely, he started the book with
pencil notes, then, finding the unusual
proportions and white paper suitable for the
purpose, started at the other end with this
magnificent series of cloud studies.

The year 1820, when Turner again accompanied
the Fawkes' party to Eton, and to Greenwich
(there is a sketch of Greenwich on folios 67a–68)
is a more likely starting date. Before 1820 he
would have been unhappy working directly on to
white without the support of pencil or grey wash.
The only parallel is in the skies of the Rhine
watercolours of 1817. What seems to me very
significant is that in June 1820, on the day before
the Fawkes' outing, he sat next to Constable at an
Academy dinner. Constable's sky studies date from
about 1820. The two were not on intimate terms –
they were years apart in academic standing
although about the same age – but I think they
might just have discussed a mutual obsession after
toasting the King's health. Turner was
undoubtedly the more reticent, so it is fair to guess
that the idea came from Constable. It would be
entirely in character for Turner to play at another
artist's game, and we may visualise Constable
perched on Hampstead Hill studying clouds which
Turner, a few miles to windward at Twickenham,
had already recorded.

Turner's skies, as far as one can tell from
suggestions here and there of horizons, fall into
sequences done at different places. Some in the
early part of the book seem to be by the sea – there is
a low promontory at the left and a feeling of
breezy rising air. Elsewhere in the book a line of
stone pines below a highly coloured sunset
suggests Italy, or perhaps Twickenham.

The majority of the skies are quietly coloured
and seem to be English, not specially dramatic.
The brushwork is extremely versatile and
economical – as it must be to record such
ephemeral subjects. Sometimes, with only a blue
and a neutral grey, he exploits a wide range of
textures, from the wettest, softest blots for cumulus
to the driest of scumbles for light flecks of

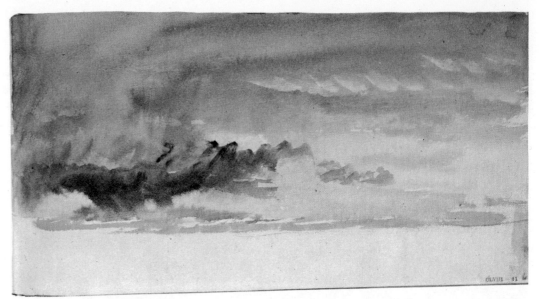

23

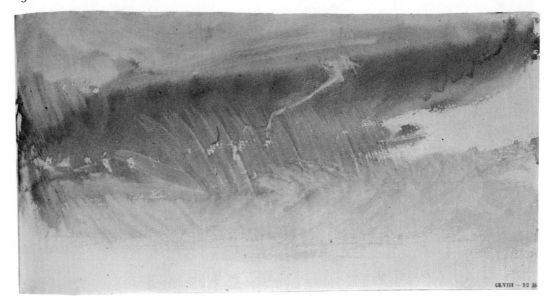

32

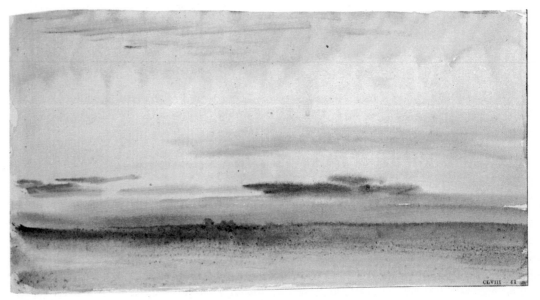

41

cirrus. He blots light out of dark with enviable ease
and accuracy. In a sunset sequence (of which folios
53 and 54 here are part) he follows the sun to
extinction and then depicts the new moon,
blotted out of dark purple, rising into a sky still
streaked from the west with darkening pink. He
must have worked by lantern light here – but this
is not as difficult as it might seem, for once the
palette is established one needs only to identify
the colours one is using, not to assess their
values.

Six pages from a series of 60 cannot be
representative, but no more could twelve.
Obviously the more highly coloured pages are
tempting. Two relatively quiet grey pages are
reproduced in black and white in Lindsay and there
is one slightly larger than life, and very clear,
in Butlin.

It may be thought that Turner felt the need for a
collection of useful skies for filling in the backgrounds
of watercolours, and that this sketchbook was just
a practical job of work. I don't believe this. Gaze
at a cloudy sky for a few minutes and you begin to
dream, if you have any propensity at all for
daydreaming. In any case, Turner and Constable,
like Girtin before them, could not work at this low
conceptual voltage. Their skies are integral parts of
their landscapes. What is different here is only that
the landscape has become a skyscape. The clouds
are properly related to the land, and the
perspective is complete. These sketches, like all
Turner's colour sketches, are pictures. They are
not backgrounds waiting to be put into other
pictures; nor are they, like Constable's beautiful
cloud studies, fragments of artistic meteorology.

There are, of course, many earlier examples of
Turner's earnest study of clouds in the form of
pencil notes, usually labelled or numbered in degrees
of tonality, especially in the sketchbooks between
1800 and 1820.

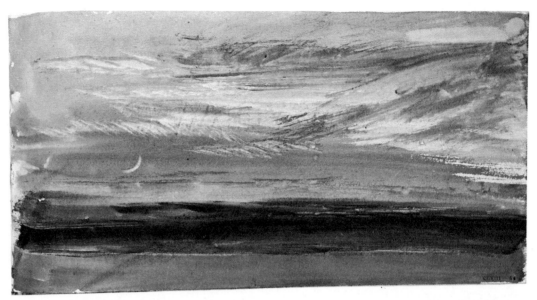

53

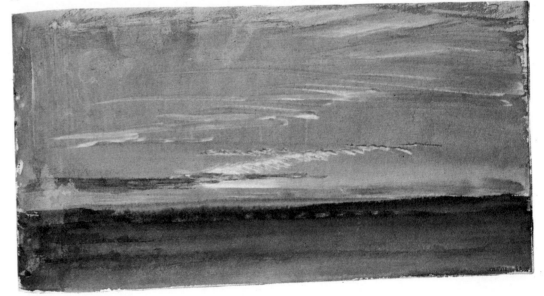

54

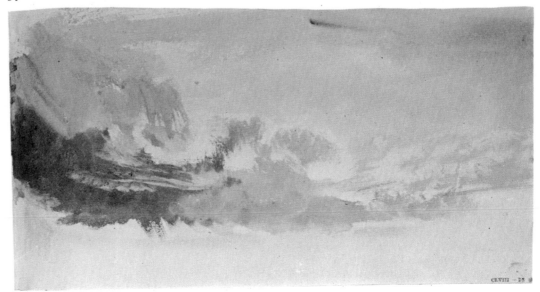

Ports and Rivers

In the year of his return from Italy, 1820, Turner
was occupied with rebuilding his gallery, now
entered from Queen Anne Street and backing
on to his house in Harley Street. The building work
went on in 1821, and prevented him from sending
any painting to the Academy in that year. He held
a couple of 'Pic-nic-Academical' gatherings for
his fellow artists at Sandycombe Lodge, his
house by the river at Twickenham. He finished a
string of five Italian watercolours for his patron,
Fawkes during the year, for which he charged 25
guineas each. Also, Finberg tells us, Fawkes owed
him £750 for previous acquisitions, and Turner
charged him interest at five per cent. But relations
remained very friendly.

A finished drawing for one of the engravings to
illustrate Scott's *Provincial Antiquities* is dated
14 September 1821. According to Finberg, Turner
then set off to Paris and down the Seine, or to Dieppe
and up the Seine to Paris, 'to explore the pictorial
possibilities of the Seine for a series of engravings'.
The only evidence for the journey is that in some
drawings of Rouen Cathedral the old spire, which
was destroyed in 1825, is visible. Drawings from
the French sketchbooks are grouped together on
pages 63–6.

Volume II of Cooke's *Southern Coast* began
publication in 1821. Relations between Cooke and
Turner were still very good, though neither can
have been making much money out of the series.
Turner may well have been looking into the
possibilities of further series. *Rivers of England*,
in mezzotint on steel, began publication in 1823,
so the drawings were probably well under way.
Perhaps Cooke envisaged a *Rivers of France* to
follow it. What actually followed was the great
series of line-on-copper engravings, *Picturesque
Views in England and Wales*, published not by
Cooke but by Charles Heath, who went bankrupt
in the process.

The sequel to *Rivers of England*, in mezzotint,
was *Ports of England*, 1826, later reissued as
Harbours of England. These were the subjects which
occupied Turner, and directed his travels, in the
middle years of the 1820s.

The small *Folkestone* and *Medway* sketchbooks are
clearly most practical studies for *Rivers* or *Ports*.
The pencil is hard and the detail remarkably
thorough, even for him.

The haphazard collection of factual detail
again characterises the two-hundredth sketchbook,
King's Visit to Scotland. Wilkie and William
Collins* had been invited to paint the King's
visit, but Turner went anyway, much to the
surprise of his colleagues. He travelled by sea

* Born 1788, made R.A. in 1820.

CXCIX *39a*

CXCVIII *55a, 56 C*[ap d'] *Antifer Cape Antonio
Strom* (?) *Lizard NW NE etc. Mavagassy Bay
Prawle and Start ENE SSE Ushant
Start Point WSW*

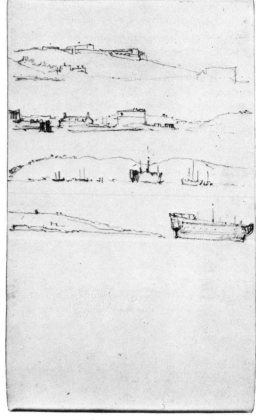

CXCIX *46a* Hulks

45, 44a

and on the way did sketches for his *Ports*, sunrises, etc. In Edinburgh he collected material for vignettes on the title pages of the two volumes of *Provincial Antiquities of Scotland*, parts of which were in course of publication.

Turner's brilliant oil sketch, *George IV at a Banquet at Edinburgh*, remained unseen by the public and became part of the Turner Bequest. He also painted a more conventional composition of the King at St Giles Cathedral. There are pencil notes of the interior of St Giles in the sketchbook, but nothing that can be construed as a sketch of the banquet scene. The notes, made on the spot at the King's reception, are mostly verbal: *Authorities in Blue and White Gowns. Red flags and Gold.*

Below is a line reproduction, in litho of course, of a photograph of a wood engraving of a copy by Ruskin from folio 3 of the sketchbook CC – *King's visit to Scotland*. It first appeared in 1860, in Volume 5 of *Modern Painters*, thus establishing an early precedent for the study of Turner through his sketches.

47

Fig. 9 7.

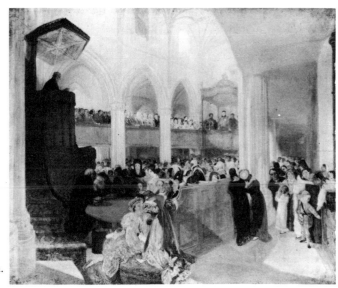

George IV at St Giles, Edinburgh, 1822.
Oil on panel, 29 × 35 inches, 74 × 89 cm.
Tate Gallery

The watercolours for *Rivers of England* are all about 6½ × 9 or 9½ inches, about the same size as the engravings. One of the finished drawings is reproduced on page 13. Probably most of them were completed on pages of this sketchbook which have been removed, those that remain being false starts or related experiments. Twenty-five drawings for *Rivers* and *Ports* are in the Turner Bequest. Turner would not sell them to Cooke, as he usually did, but charged him eight guineas for the loan of each drawing for engraving.

Though quite richly coloured, the drawings, contrary to what some critics have said, are well designed for the solid tones of the monochrome mezzotint. Small detail is avoided, and there is little reliance on the colour scheme, which in itself is little more than an extension of the scale of grey into the dual scale of ochre-blue. Such a colour scheme is an aid to drawing, no hindrance to interpretation in monochrome, and has the advantage of making the finished working drawing a potentially saleable item. The series is remarkable for the drama and intensity of its skies and, to a lesser extent, for its unadventurous but satisfying colour. We are lucky to have the drawings together, for most of Turner's engraved watercolours are widely scattered indeed.

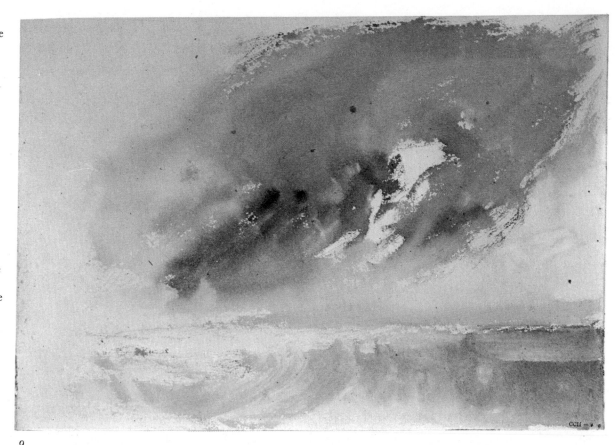

9

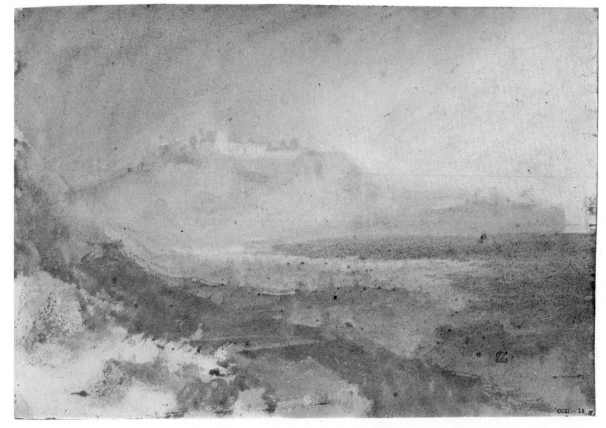

18 Scarborough

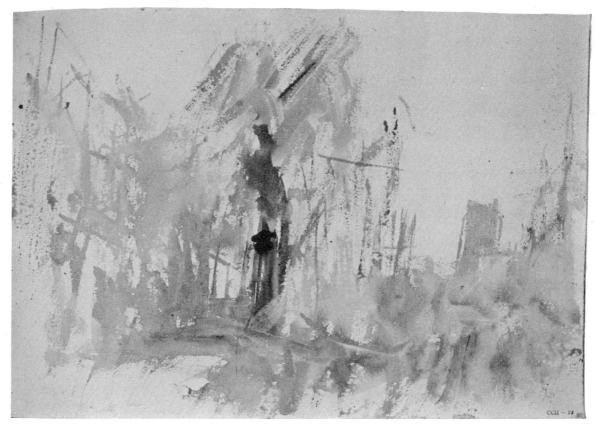

22

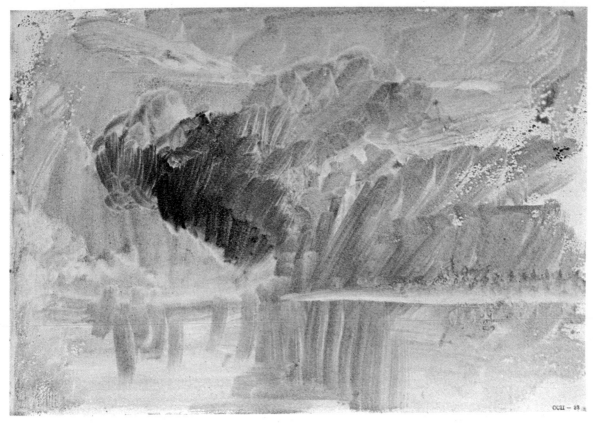

23

The three sketchbooks on these two pages all have the London river as their ostensible subject. Old London Bridge had stood uneasily against the flood for six centuries, finally enduring the indignity of having two central arches made into one. Several pages of sketchbook ccv show the bridge and the nearby church towers. Others are concerned with the engineering work for the new bridge, which was completed in 1831. Some pages in black chalk are unusual for Turner's notebooks, as are the Indian ink washes of the London Bridge book.

CCIV *40a*

40

CCV *16a, 17* Old London Bridge – *Blue Jacket*

22a, 23

8 At London Bridge

22

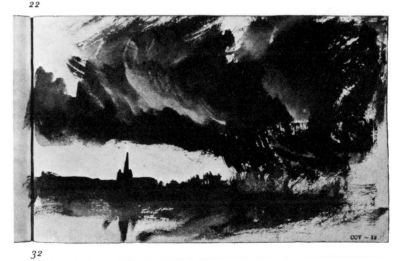

32

CCVI *17a* Ships at Portsmouth

A very small book of ships and holidaymakers is confidently labelled 'Gosport' – not on any authority from Turner. (Gosport is across the water from Portsmouth and is now a submarine base.) Besides Turner's interest in the ports of England he had a new purpose in visiting Portsmouth, for he had a royal commission to paint the Battle of Trafalgar for St James's Palace. The subject of the picture was really the Victory, which was at Portsmouth (she still is), and records of the battle were also kept there.

Turner, who had seen several younger contemporaries knighted for services to art, had been ignored by the Crown, and he was certainly delighted to have this commission. The finished painting pleased no one, even after he had made endless alterations, and is the least convincing of his sea paintings. It is large, eight and a half feet by twelve, and is now at the National Maritime Museum, Greenwich. Since Turner was so thorough, and had the advice of everyone qualified to give it, this painting can at least be claimed as an accurate historical record.

No further honours were conferred on him during his long life, in which he worked as hard for art and for artists as he did for temporal success and posthumous reputation. It has been shown that even this commission he owed to the undercover work of the kindly Lawrence. For Turner had one fault that made him totally unacceptable to the Lord Chamberlain: he did not sound his aitches.

Anyway, it seems that he had time to relax on the sea front at Gosport, and the results are very pretty.

In 1824 he was elected an Auditor of the Academy. Several pages of his sketchbooks are filled with notes of the accounts. He behaved himself and delivered his Perspective Lectures for the first time in three years. His Commission

6a

58, 57a

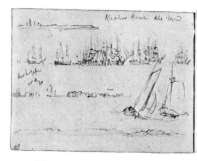
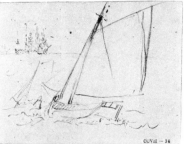

33a, 34

9

apparently occupied him too much and he sent no pictures to the Exhibition.

Cooke's third exhibition opened in April. Besides the undoubted attraction of Gainsborough's 'show box' paintings on glass, lit from behind, there were 15 assorted watercolours by Turner. They included *Brignall Church* for the *Richmondshire* series, which had finished publication the year before, the *Mewstone* from *Southern Coast*, and *Bridge and Castle of St Angelo, Rome*, done from Hakewill's sketch in 1818, before Turner had been to Rome. One drawing now unidentified was called *Morning – an Effect of Nature in the neighbourhood of London*, and another *Twilight – Smugglers off Folkestone fishing up smuggled Gin* – 'specially done for

the exhibition'. This title nicely indicates the unpretentious nature of much of Turner's art of these years; designed to please the public, and in this case revealing an intimate knowledge of the methods of contemporary smugglers.

In the summer he explored the East Anglian coast for a possible sequel to the successful *Southern Coast*. From Colchester to Dunwich and Southwold to Orford Ness, he missed no noteworthy ruin, and he observed the work of the fishing folk in details that were no doubt less mysterious to him than they appear in the pages here. Eight unpublished plates of the East Anglian coast were engraved in line by Allen (Rawlinson pp. 305–12).

He also went to Brighton and Arundel for late

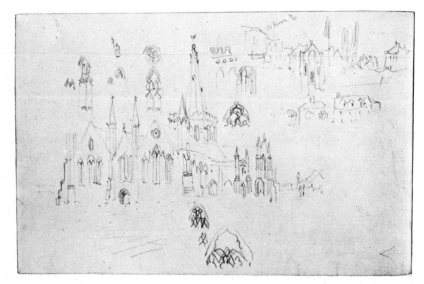

17a

CCIX *27a, 28*

CCX *30a* Brighton

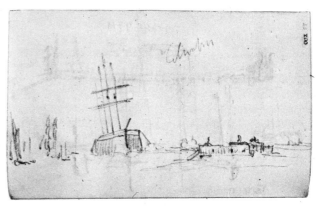

57 Columbus

additions to *Southern Coast* and for *Rivers of England*. At least, this seems to be the evidence from a notebook (with the label 'Welsh Itinerary' gold-blocked on the cover) which was taken apart by Ruskin. It was found in various packets marked 'Small Yorkshire Book', 'Rivers of England', 'Finer leaves' and 'Inferiors'. It was reassembled by Finberg and found to contain drawings of Kirkstall Abbey, Yorkshire, and Portsmouth as well as many views of Arundel and Brighton. It probably all fits in, for Turner ended up at Farnley in November, and stayed for a month.

At Farnley he used another sketchbook. This is one, perhaps the only one, which is not included in the Turner Bequest; he gave it away in 1836 to a friend, the painter Munro of Novar. Finberg says this was because it reminded him of the last time he stayed at Farnley before Walter Fawkes' death in the following year. But there is little

of interest in the book, which is mostly blank except for some light pencilwork and a wash drawing of a coach stopping at Wakefield on a stormy evening. Three of the pages were reproduced in *The Connoisseur* for October 1935.

Disguised under the title 'Academy Auditing' is a book containing some of Turner's erotica: 'One of a parcel endorsed by Mr. Ruskin . . . "They are kept as evidence of the failure of mind only".' W. M. Rossetti, who assisted Ruskin, left an account of Ruskin's burning some indecent drawings 'on the authority of the Trustees of the National Gallery', and this has led to a certain amount of speculation about the nature of the drawings. I imagine that folio 18 would have been a likely candidate for the flames. Perhaps it escaped because its tentative 'nymphs and satyrs', to use Finberg's description, form part of a sequence

of studies which Ruskin might have regarded as more 'creative' than the odd erotic drawing. One page near the end has been cut out.

CCX*a 18*

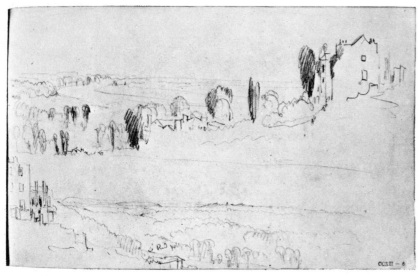

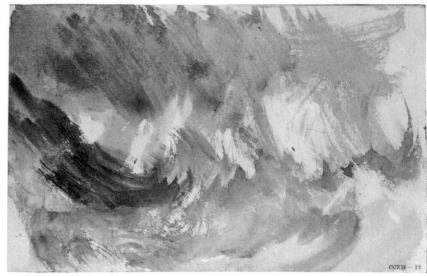

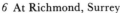

6 At Richmond, Surrey

13

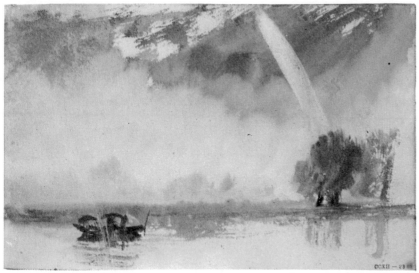

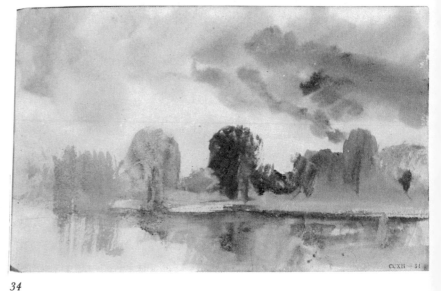

23

34

The *Thames* sketchbook of 1825(?) is the usual sort of size, but unusual for its pages in watercolour, which, in their direct, broad brushwork on white paper closely resemble some of the more prosaic of the 'Colour Beginnings'. The book contains two dates in Turner's hand: *June 25, 1823 – toute de Joie*, whatever that may mean, and, below a view from Richmond Terrace, *Star and Garter, Richmond 1825*. Except for the storm scene in monochrome, folio 13, the brush drawings are unexciting – but nice, and there is a possible link between folio 34, say, and the similarly showery no. 241 of the 'Colour Beginnings' (p.157).

In the early part of 1825 Turner dined nearly every Sunday with the Fawkes, at their town house in the Marylebone area. He had some difficulty in getting hold of his fee for the royal

Trafalgar picture. He was busy with watercolours for the mezzotint series, *Rivers of England* and *Ports of England*. In the previous year he had been content to rest his reputation on the watercolours exhibited at Cooke's Gallery, and had sent nothing to the Academy. This year he showed *Harbour of Dieppe*, a calm, 'classical' composition of fishing boats. It was criticised for its 'fairy hues' – 'a splendid piece of falsehood', said the *New Monthly Magazine*. A watercolour, *Rise of the River Stour at Stourhead*, was generally approved of.

He priced his *Dido building Carthage* (1815) right out of the market, at 750 guineas, raising this to 1000 guineas a few days later, because a firm of engravers was interested in it and he didn't really want to sell it. (The firm had been happy to pay 500 guineas for the *Temple of Jupiter restored*,

of 1816; the picture was engraved by Pye and eventually published in 1828.)

At some time in the summer he made the sketches, opposite, for a pair of paintings of *The seat of William Moffatt, Esq., at Mortlake*, finished during the next two years. They are fine examples of his imaginative treatment of such commissions. The preliminary notes show that the conception of the idea came straight from his experience of the place; but he did not trouble at the time to work up the light and shade on which the compositions depend for their effect.

He dined with Fawkes for the last time at the end of August and the next day went off to Holland. He travelled to Cologne, Aix, Ghent and Bruges, returning via Ostend to Dover.

10a, 11

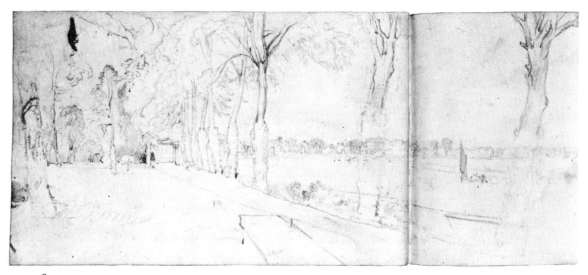

15a, 16

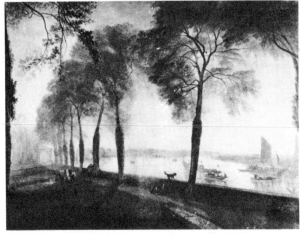

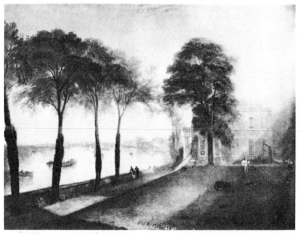

Mortlake Terrace, Summer's evening. National Gallery, Washington

Mortlake, Early (Summer's) Morning. Frick Collection, New York

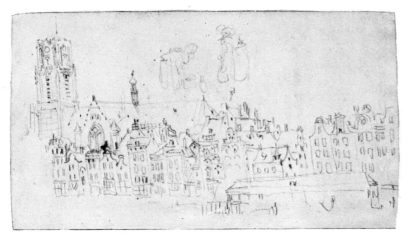

69a Rotterdam

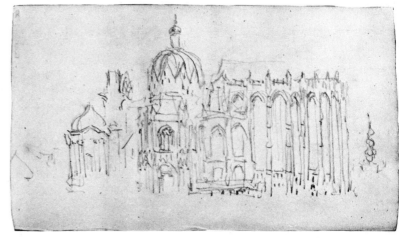

152a

81a Haarlem?

Holland, 1825, and Germany, 1826

103 Amsterdam (detail, full size)

103a (detail, full size)

The pencil sketches, 561 of them, in the small Holland sketchbook of 1825 are remarkable for their comprehensiveness. Forty pages were covered before he was even out of sight of the cliffs of Dover. He notes, it seems, every passing fishing boat. After 66 pages come *Schiedam* and *Maassluis*, then more ships for ten pages, and *Land opposite Rotterdam*. His awareness and curiosity are those of a boy, not of a seasoned R.A. of 50.

He pauses long enough to put quite a lot of detail into a sketch of Rotterdam Cathedral (folio 69a), then is back on board; 21 pages of boats follow, until a street market and some unusual forms catch his eye (folio 81a). He quickly copies a Ter Borch before embarking, and continues with another 40 pages of waterside and architecture at Delft and Leyden. Two details of pages at Amsterdam (folios 103, 103a) show that his sense of design did not sleep while his hand was so busy:

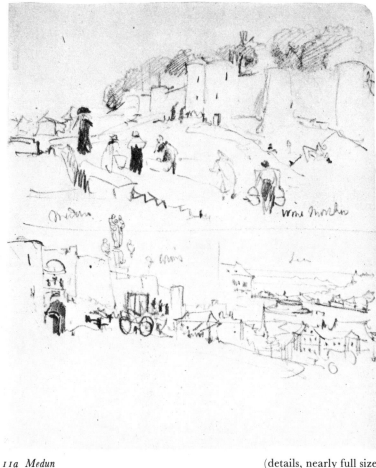

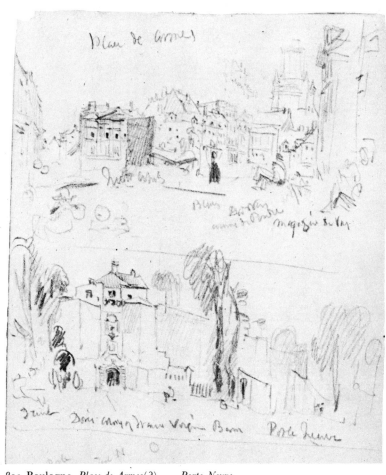

11a Medun (details, nearly full size) *80a* Boulogne. *Place de Armes*(?) . . . *Porte Neuve*

we share his pleasure in the intimacies of Dutch architecture, and a boat shaped like an old shoe.

But as a whole this crowded little book is a plain record of things seen, and such vivid impressionism as in the church at Aix (folio 152a) is rare. He is very relaxed, and even jokes – a landscape near Utrecht is captioned *Quite a Cuyp*.

The next sketchbook, labelled *Meuse* by the artist, probably belongs mostly to 1826, when he again journeyed to France and Holland or Belgium. The drawings at Boulogne (folios 11a, 80a) have a happy quality of colour and contrast. This book is of good wove paper with a pleasant 'bite' in the surface, and his pencil is softer than usual.

About this time he began to put his ideas on to pieces of tinted paper, usually blue. Sometimes he first made bare pencil outlines in his pencil notebooks but often he worked directly on the tinted paper. A relatively small proportion of these drawings were taken beyond the first pencil or chalk outlines; some had the highlights picked out in white. The chosen subjects he finished with great skill and panache in opaque watercolours, and these drawings were given to the steel engravers

to follow. A selection of them will be found on pp. 80–98. Some of the watercolours are rather less carefully finished than was necessary for engraving. The same fairly free gouache technique, on the same sort of paper, he used in the Petworth watercolours, which, whatever their real purpose, were not intended to be engraved.

The sketchbook CCXVI, called 'Rivers Meuse and Moselle', is the 'itinerary' notebook of the 1826 tour, with long lists of places to visit divided between the *Left Bank* and *Right Bank* of the Meuse. Like others of its type it is devoted to the collection of facts: I chose only the lugubrious barge of folio 159.

CCXVI *159*

23

9

With the 'Huy and Dinant' notebook, still in 1826, we find Turner hard at work on carefully detailed townscapes of the Meuse. He also has a larger sketchbook with hand-tinted pages – Trèves and Rhine, CCXVIII. He experiments perhaps with the first of those torn pieces of blue or grey paper, all of which measure about $5\frac{1}{2}\times7\frac{1}{2}$ inches, or twice that size.

Of four batches of watercolours, a total of 83, nearly all on blue paper (CCXX–CCXXIII), Finberg noted: 'They may belong to the second tour over the Meuse and Moselle made in 1834.' He attempts to arrange them in order on 'stylistic grounds' and I was at first prepared to follow his arrangement. But I found that I had a couple of watercolours under 1826 which clearly referred to pencil notes of 1834, or vice versa, and I decided to group all the Continental blue-paper drawings together and rely on the pencilwork alone for chronology.

In addition to the coloured drawings, Finberg catalogued 240 'Black and White Sketches on Blue Connected with the Meuse-Moselle Tour' (CCXXIV). One is reproduced opposite. The author of the *Inventory* states that: 'The identification of these drawings is doubtful. Some of them may belong to the rivers of France series, or even to the Italian tour of 1828.'

No one has bothered to try to sort out the muddle, for these black and white on blue drawings are not among the richest seams that Turner laid down. In fact they are very, very dull. I looked at them, and then I read what Ruskin had written on the parcels he made of them: 'Rubbish'. The rubbish remains, however, carefully protected in the Print Room.

A sketchbook of medium size is tentatively dated 1826 and tentatively entitled 'Moselle (or Rhine)' – a true scholar takes no chances. The pages are tinted in fairly even grey. In the drawings Turner himself is tentative. I expected Ruskin to

CCXIX *14* Pencil and chalk on grey-washed paper

be rude again but he says 'Fine, though slight', showing the perspicacity for which he was famous.

These understated drawings are intriguing, and, making such a consistent group, a little puzzling unless we take it that Turner was experimenting to see just how much use he could make of the background colour. He may (I only suggest) have kept this book for early morning or evening mists. He was to make such powerful use of mist and obscurity in the series which followed that some preliminary experiment is only to be expected. The drawings are so very slight that they defy repro-

duction, even for an optimist. Here is one, more visible than the rest, a true expression of silence, distance; and, you notice, in perfect proportion.

The tour of 1826 touched the Rhine at Coblenz, and followed downstream to Cologne. Turner then completed a circle back to Liège and went on to Calais, Abbeville and Dieppe. His note of the route in the 'Rivers Meuse and Moselle' sketchbook is unusually explicit, even carrying dates (and days of the week which do not agree – but they may simply be corrections to a plan that wasn't quite stuck to). The last entries read:

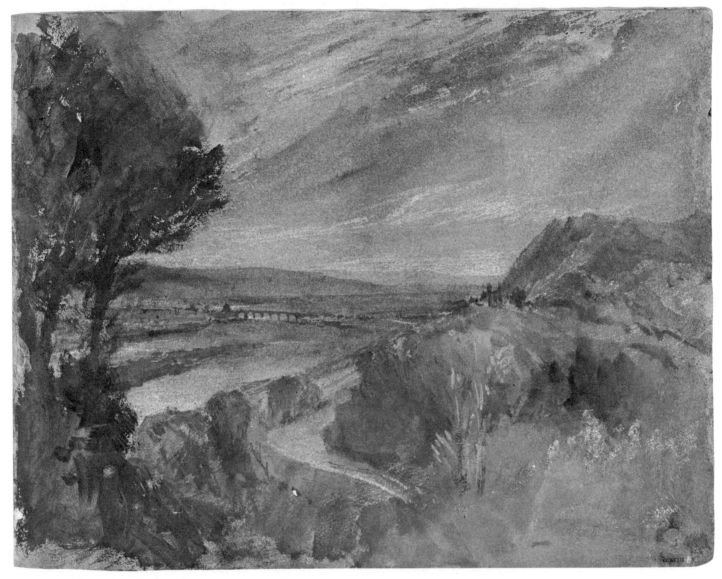

CCXVIII TREVES AND RHINE 1826 $8\frac{3}{4} \times 11\frac{1}{4}$ 221 \times 287 mm

10 Trèves. Watercolour on prepared, grey-washed paper

[Sep] *3 Coln* | *10 Abbeville*
Sundy | *11 Dieppe*
4 Liege | *12 Dieppe Samedi*
5 Bruxelles | *13 Abb*
6 Gand . . . | *14 Cal*
7 Ostend | *15 ,,*
8 Dunkirk
9 Calais

The 3rd of September was a 'Sundy' in 1826.
What 'Samedi' means on the 12th, which would
have been a Tuesday, we can only guess – but it
does look as if he returned to Calais and so to Dover,
perhaps on *Samedi*.

Finberg suggests that it is possible that he went on
by sea to Brittany and worked his way down the
coast to the Loire, returning via Orleans to Paris
and then home. He has some evidence which he is
vague about. We know that Turner was energetic,
but I find this long extension of his journey hard
to believe in: still, it could be. It still does not help
to sort out the complications of Turner's French
notebooks. We must accept the record as cumulative
rather than consecutive.

CCXXIV *57* Lead pencil and white chalk on blue paper, $5\frac{1}{2} \times 7\frac{1}{2}$ inches, 140 \times 190 mm

Later in 1826 Turner quarrelled, and finally, with Cooke. Of several joint projects only the *Southern Coast* had succeeded, and that in a very protracted way. Cooke was rather a bungler in affairs other than lines on copper, and Turner, though inspiring, was a tyrant over details: it is only surprising that the partnership lasted as long as it did. Artists were now becoming conscious of the copyright value of their work, for private owners had been lending their pictures for engraving, without charge, for the decoration of popular annuals and 'keepsakes'. The market was flooded with engravings. Turner now insisted on controlling the reproduction rights in paintings that he sold, and at the same time demanded better terms from Cooke, who accused him of ingratitude.

While Cooke advertised, in January 1827, a new series of the English coast with engravings after 'Distinguished Artists', Turner was booked for a different series, to be published by Messrs Arch: *The English Channel, or La Manche*. It was to consist of 'Views taken by him from Dunkirk to Ushant, and places adjacent; together with others on the opposite shore varying from those in the recent Publication . . .' Turner, it was stated, had toured the northern coast of France in the summer of 1826.

La Manche was never published, nor was any engraving work even started, as far as I can gather. Probably the advertisement was intended merely to test public response; such are the wiles of publishers. But some of Turner's drawing may have been done with the project in mind.

In the Academy Exhibition of 1827 he had five oil paintings, including the second of the Mortlake pictures and '*Now for the painter' (rope)*. *Passengers going aboard*, now in the Manchester City Art Gallery. *Port Ruysdael* and *Rembrandt's Daughter* are sincere tributes to those two masters, rather than mere pastiche. The latter is in the Fogg Museum at Harvard; *Mortlake Terrace* is in the National Gallery, Washington, and the fifth painting, a *Scene in Derbyshire*, is at Worcester, Mass.

Sir John Leicester (Lord de Tabley), an important collector and patron of Turner's, died in the spring of 1827. Most of his pictures were immediately put up for sale, and Turner bought back his *Sun rising through vapour* for 140 guineas, more than he had been paid for it in 1807.

78a, 79

East Cowes Castle, 1827

The chief event for Turner in 1827 was the invitation from John Nash, the architect of Brighton Pavilion and the Regent's Park terraces, to stay at his house, East Cowes Castle. Nash commissioned two pictures of the Regatta featuring the castle in the background. Normally Turner's method would have been to make notes on the spot in his sketchbooks and refer to these when painting in his studio, relying on memory for colours and atmospheric effects. But Nash was unusually hospitable, to the point of providing somewhere to work, and the subject was, it seems, unusually challenging. Besides filling the pages of three sketchbooks Turner produced a pile of 44 pieces of his blue paper with outlines in black and white chalk of rudimentary sailing boats – mere notes of abstract relationships intelligible only to him (I think) and catalogued by Ruskin, inevitably, as 'rubbish'.

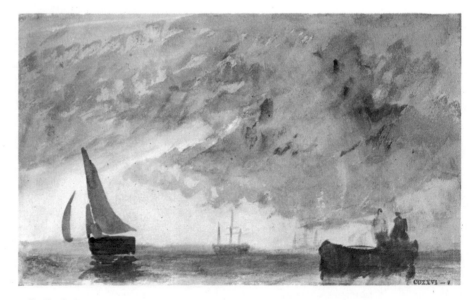

9 In the Solent

$4\frac{3}{8} \times 7\frac{3}{8}$ 111×188 mm

Turner sent to his father for extra 'light trouzers' and white waistcoats and a large canvas (Newman, the colourman, could send the clothes rolled round the canvas, he suggested) and some 'scarlet lake and dark lake' and burnt umber in powder form. (The lake colours were probably madders – vegetable dyes on a clay base – which Turner is known to have used.)

On the canvas he painted a brilliant series of oil sketches. The canvas remained, we are told, a dusty roll among the very numerous items of the Turner Bequest, until, in 1906, the subjects were cut out and cleaned, emerging as nine sketches. Three are directly connected with the commissioned paintings and others are of shipping, sea and sky, while one is a small, light-hearted figure composition known as *Between Decks*.

The sketches form the fourth series of oil sketches – Thames, Knockholt, Devon, and now Cowes – associated with periods of relaxation in Turner's busy and purposeful life.

The finished oil paintings for which all this background work was done were exhibited at the Academy show in the following year. One of them, *Regatta starting for moorings*, is in the Victoria and Albert Museum. It is tight in handling and very detailed, though the detail is well massed. It smells not so much of brine as of the studio. It follows the plan of some of his classical Carthage pictures: we look down an avenue towards the source of light, light which is diffused and spread through the picture with great skill and effect. The conception is very much 'Turner' but the composition was becoming something of a habit; the same device had been used in *Harbour of Dieppe*, two years before.

The second painting, *Regatta beating to windward* (in the Noyes Collection, Indianapolis) is intrinsically much more exciting, and not just because it shows the race itself rather than the preparing. The foreground is filled by the great luminescent trough of a wave. Above it the yachts rush towards us and outwards in the pattern of a controlled explosion, held at its centre by the bobbing boats of spectators and, a mile back, the still shape of a man-of-war. At the foot, and almost dead centre, a cunning wavepeak points to the receding axis, while in the distance, just the right amount off-centre, the castle gleams on its cliff. The treatment of the sails and masts at the left, more complicated than in the corresponding part of the sketch in the Tate, is beautifully fragmented into a pattern of movement.

This painting and the sketches associated with it are surely a breakthrough into a new lyrical realism. The glossy van de Veldes at last recede beyond the horizon, and the sunny promise of *Fishing upon the Blythe-Sand* of 1809 is fulfilled: the waves no longer have the overtone of Romantic terror.

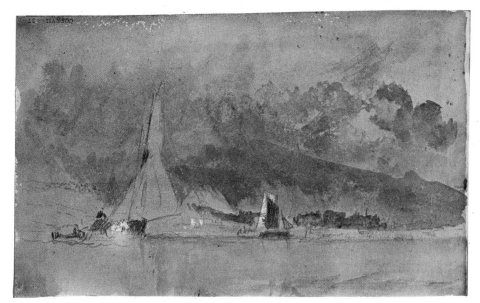

37

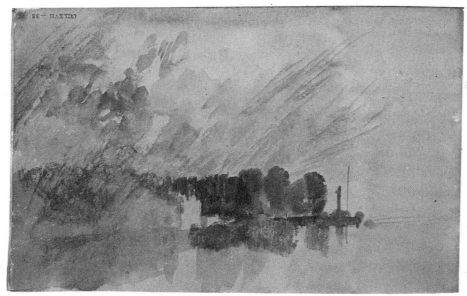

35

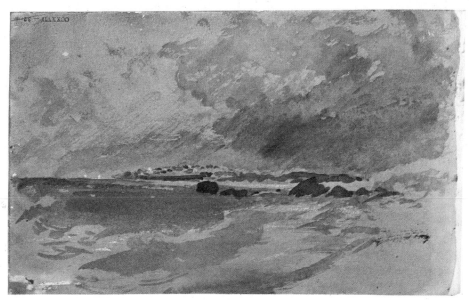

32

40a Chelsea?

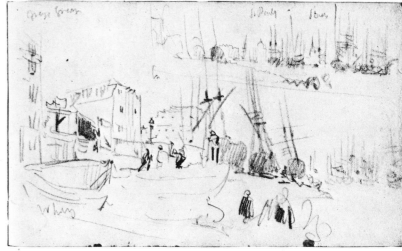

12a The Thames, near *St Paul's*

The pencilwork in the two sketchbooks associated with the Isle of Wight is less sophisticated and I am not sure that much of it belongs to this year. But watercolours scattered through the pages have great charm, though none of the force of the yachting subjects. Some pages of a bridge-building subject take us away to the calmer atmosphere of the river, perhaps at Chelsea.

The final East Cowes Castle group – not a sketchbook but a collection of blue-grey papers measuring the usual $5\frac{1}{2} \times 7\frac{1}{2}$ inches – is all force and vigour, which seems inappropriate for its subjects in the grounds of the castle. I have a theory that most of the drawings were done at night and that the master could not see what he was drawing.

Also, he may have dined too well. Ruskin says 'unworthy of him' – well, they are a bit crude. But there is poetry and music lurking in the over-emphatic undergrowth, and a pair of white figures appearing now and then adds a touch of romance to these heavy-handed nocturnes.

CCXXVIIa *26*

34

1828: vignettes *178*

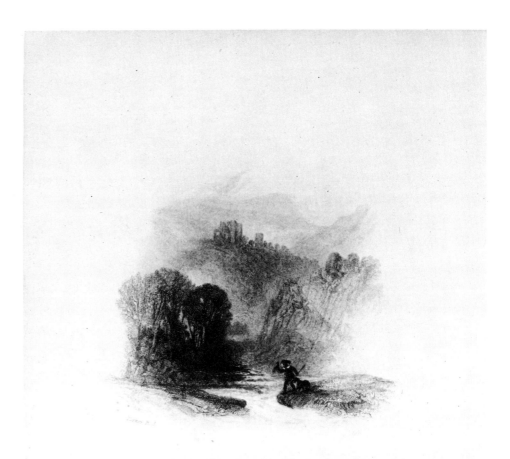

THE BOY OF EGREMOND.

" SAY, what remains when Hope is fled ? "
She answered, " Endless weeping ! "
For in the herdsman's eye she read
Who in his shroud lay sleeping.
 At Embsay rung the matin-bell,
The stag was roused on Barden-fell ;
The mingled sounds were swelling, dying,
And down the Wharfe a hern was flying ;

A page from Rogers' *Poems*. Engraving by E. Goodall

Professor Turner's lectures ran their full course this January, as Finberg tells us; but this was for the last time, though he hung on to his academic status for another ten years. He attended every meeting at the Academy that he was supposed to and he finished all his work, which included several water-colours for engraving, among them the vignettes to illustrate Samuel Rogers' de luxe edition of his verses, *Italy*.

Illustrating Rogers was not just a job: he and Rogers were friends united in a common love for the scenery and antiquities of Italy. Neither of them needed the money, and this project, which also involved Stothard, the ageing master of nymphs at play and another friend of Turner's, was an attempt to produce a fine book. It succeeded, and if, like many a fine book, its text was unworthy, we cannot blame Rogers for not realising that his poems were awful.

Vignettes, so characteristic of the French rococo, gained a new lease of life from the wood-engravings of Bewick and his pupils; wood engravings could be printed along with the type, in full harmony. The smallness of vignettes made them ideal for steel engraving, where inches are measured in months of work. A vignette is, of course, just an illustration with soft edges, but in a time when most illustrated books had large plates *after* paintings or drawings the vignette shape indicated an illustration designed for the book. So Turner was in fact engaged in book-design.

The engravings were mostly by E. Goodall, all smaller than $3\frac{1}{2} \times 3$ inches – 'the loveliest ever produced by the pure line', wrote Ruskin, who liked that sort of thing. They are pictures, for a

meaningless accretion of ornament was not Turner's idea of a vignette, and some of them are incredibly fine-detailed. In isolation they may seem to be finicking, but on the small page, with the elegant Bodoni-inspired typography of the time –

very spacious – they achieve grandeur. By engraving the illustrations in position on plates larger than the page the plate marks could be trimmed off, and Goodall's exquisitely handled graduations fade into the surrounding white

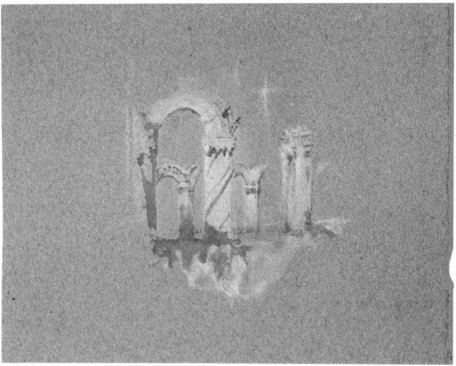

CCLXXX *111*

In August Turner set off for the real Italy.
This, his second visit, was to be a working holiday
in Rome, where the odour of past greatnesses, it
was hoped, would mingle with the megilp. His
friend Eastlake was to have a studio ready for
him, complete with canvases ready prepared and
'whatever may be necessary . . . that you think
right, and plenty of the useful, but nothing of
the ornamental; never mind gimcracks of
any kind.'

But the journey took two months, for he 'must see
the South of France, which almost knocked me up,
the heat was so intense . . .'

The pencil line of the sketchbooks on the journey
varies from desperate to flaccidly detailed, while the
subjects are what we expect from his travelling
books; buildings and yet more buildings. Looking
at the lumpy, amorphous trees of the paintings
of later years, I think he would have done well to
make a closer study of the flora. But we mustn't
quarrel. In spite of the heat he put something down.
The chiaroscuro of CCxxx 39a, *Avignon*, is rare,
but many of the rapid sketches are not without
their black shadows. At Genoa, perhaps an
overnight stop, he somewhat recovers his poise, but
there is no enthusiasm in the drawing of a street or
square, folio 33.

He was 53. Beethoven, surely his musical
counterpart, had died in the previous year, at 56.
Did Turner ever hear the Eroica? William Blake,
whom he must have known, also died in 1827.
Goya, Turner's peer, but a world apart in Spain,
breathed his last, and so did the youthful Schubert
in Vienna, as Turner, his greatest work still to be
done, marched on to Rome.

with the softness of down, contrasting with the
sharp, well-shaped type.

This effect was not achieved by accident. Turner
was not responsible for all of it, but we can be sure
that he gave at least his usual attention to the effect
of the engravings, which in this case he must have
designed in relation to the page and its letterpress.

In the minutely finished designs he uses colour
emphatically rather than naturalistically. His
intention was to guide the textures of the engraver,
who aimed at a wider range of expression than
mere tones of grey could provide. There are many
rough designs catalogued, from which I have
chosen at random a wash drawing (below)
probably copied from J. R. Cozens and a patch
of rather uncharacteristic decoration, worked out
on the blue paper. Other roughs and finished

drawings for Rogers' works are reproduced in
Reynolds (pp. 156–7).

Rogers commented to a friend: 'I never had
any difficulty with Stothard and Turner about
the drawings for my works. They always readily
assented to whatever alterations I proposed and
I even put a figure by Stothard into one of
Turner's landscapes. The two figures in the fore-
ground of the vignette on page 151 are Stothard's:
the standing figure in the vignette on page 248
is also Stothard's.

Rogers' *Italy* (1830) and *Poems* (1834) made
a European reputation for English steel engraving,
and Turner's work was best known in Europe
through this medium. Foreign admirers were
often dismayed when later confronted with the
master's brushwork in an oil painting.

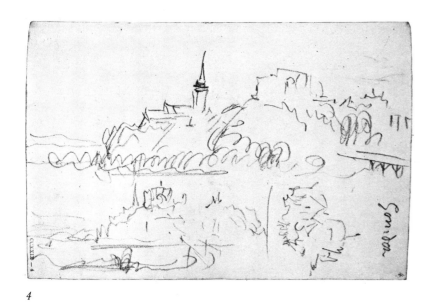

4

13a Avignon

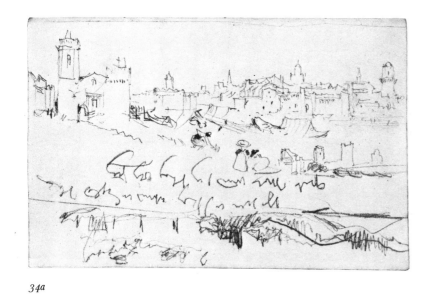

34a

17a Beaucaire

45a Marseilles

CCXXX 39a Avignon

CCXXXI *33a* Monaco

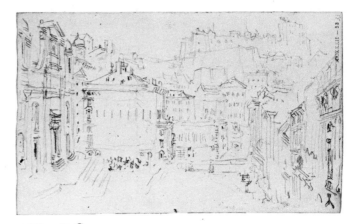

CCXXXII *33* Genoa

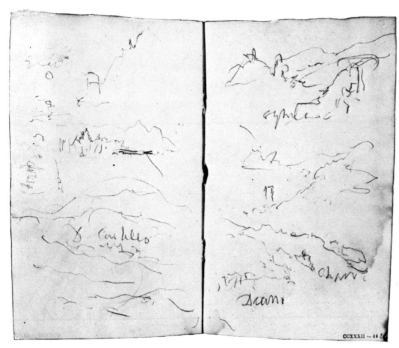

CCXXXII *43a, 44*

CCXXXIII *35*

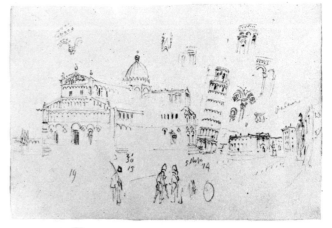

CCXXXIII *59a* Pisa

By the time he reaches Pisa he is still off balance and doubles the angle of the Leaning Tower; but Italy's spell begins to work. He has time for people and costumes, and several of the drawings on the two pages here have the colourful, analytical linework of his most relaxed sketching. Folio 19 (CCXXXIV) was obviously done in a moving carriage and is included here as an example of the worst – even so, it has a certain flair.

CCXXXIII GENOA AND FLORENCE $5\frac{3}{4} \times 3\frac{7}{8}$ 143 × 97 mm CCXXXIV FLORENCE TO ORVIETO $5\frac{7}{8} \times 4$ 148 × 102 mm [43

CLXXVIII RIMINI TO ROME $3\frac{7}{8} \times 5\frac{1}{4}$ 98 × 132 mm

CCXXXIII *55a* Pisa

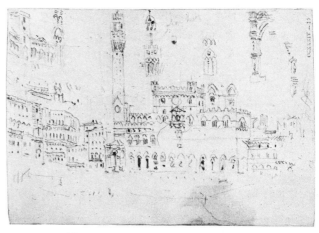

CCXXXIV *15* Sienna

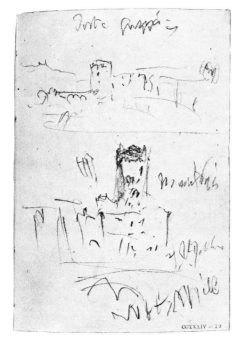

CCXXXIV *19*

CCXXXIII *55*

In Rome he contemplated the Sistine Chapel ceiling and worked on 'eight or ten pictures' according to Eastlake. He finished three: *View of Orvieto*, *Regulus* and *Medea*, and these (and perhaps others) he exhibited privately, framed in pieces of rope stained with ochre. His reputation as the 'first of living painters' drew at least a thousand visitors, some of whom were shocked, others delighted. The large *Palestrina* and the 'portrait' *Jessica* were begun in Rome.

The two pages below, left, are from a sketchbook which Finberg first included in the 1819 visit to Rome and then updated to 1828. But I think the style of this drawing would be of 1819.

CLXXVIII *5a, 6*

CCXXXIV *31a*

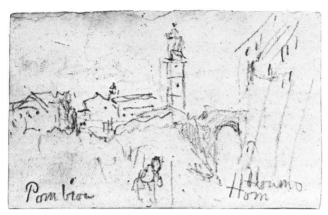

2a *Pombioa*

4

8a, 9 Turin

13 *Fabrico Rossio Urbus Prefecto*

29

He left in January 1829, via Loreto, Milan and Turin. His carriage, of course, was again overturned on the Mt Cenis Pass, but 'his good temper', according to a fellow traveller who knew nothing of him, 'carried him through all his troubles'. He was 'continually popping his head out of the Carriage window to sketch whatever took his fancy', and cursing the driver, who would not wait.

41 St Francis

25

The 'Viterbo and Ronciglione' sketchbook
may belong to the journey home or, more likely,
to an excursion from Rome. All the subjects are
within 40 miles of the city, and the sketches of
folio 25 are Roman thoughts.

CCXX-I $5\frac{3}{4}\times10\frac{3}{4}$ inches 146×273 mm

The 'Roman and French notebook' is just
that – started in Paris on the way out. Like others of
Turner's books of memoranda it has its fair share
of pictorial matter, including a sylvan view which
Finberg connects with a watercolour (left) on
white paper, catalogued in the Meuse-Moselle
series. The connection isn't very clear to me, but the
watercolour is very fine.

CCLII *59*

CCLI *27 St Aubin*

CCLI *28a* (detail) *Bayeaux*(?)

For the Exhibition of 1829 he prepared *Ulysses and Polyphemus* and *The Loretto Necklace*. His Roman works, sent by sea, did not arrive in time. In June there was an important exhibition of his water-colours for *England and Wales* at the Egyptian Hall. At this point a letter (printed by Finberg) was written to W. F. Wells, then in Surrey, from which it is clear that Turner had in a previous year or years helped with the haymaking at 3s 6d per day – and why not? – but not this year.

He had intended to go back to his rooms in Rome, but wrote that he would not see his friends there until next year. He went instead to Paris, Normandy and Guernsey – why Guernsey I do not know, for the 'English Channel' series had never got going. Some of the work he did in France was used in the 'French Rivers' series. Soon after his return in September his father died.

'After the funeral', writes Finberg, 'Turner went to stay for a few days with Mr. Trimmer, the vicar of Heston, for a change of scene. "He was fearfully out of spirits" we are told, and said he felt as though he had lost an only child. Mr. Trimmer's son told Thornbury that "Turner never appeared the same man after his father's death: his family was broken up."'

Heston was not really a change of scene, for both the Turners had occupied the villa at nearby Twickenham until the year before, when it had been sold, perhaps because of the elder Turner's ill health. Old William had been wont to travel to and from Harley Street, getting a lift from a carter for the price of a glass of gin; Turner would certainly miss his father's practical assistance in and out of the studio.

He still had his housekeeper, Hannah Danby, and he now made his first will, leaving her £50 a year, the same to two uncles and to his daughters, and only £10 a year to their mother. The greater part of his estate, at this time certainly several thousands, was to be devoted to a charity of his own invention, for the benefit of decayed painters cast in his own image – English, single, and landscapists. They were to live in little cottages arranged each side of a gallery (no doubt containing not a few Turners). He had bought land at Twickenham for the purpose: but it was not to be.

CCLII *57 Sark, G, J, H* (erm)

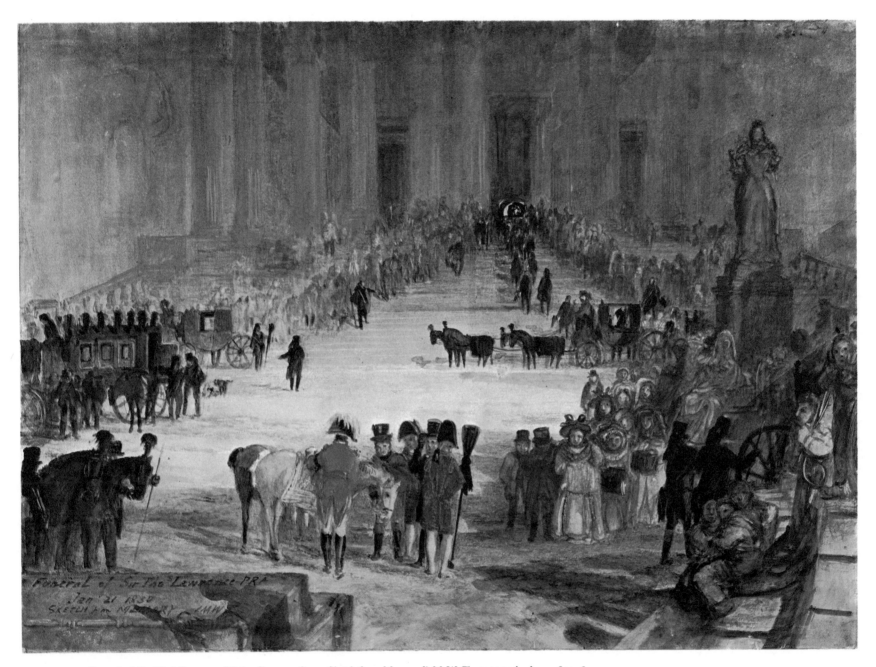

CCLXIII *344* *Funeral of Sir Tho* Lawrence PRA* *Jan 21 1830* *Sketch from Memory J M W T* 22 × 30 inches, 56 × 76 cm

1830

In the winter Wells's daughter Harriet died: 'gentle, patient amiability', wrote Turner; and Lawrence, aged only 60, also died. Turner was a pall bearer. He wrote to George Jones in Rome: 'Who will do the like for me, and when, God only knows how soon . . . May you be in better health and spirits.' Lawrence had been a good friend to him, and, as the painter of all the crowned heads of Europe and President of the Royal Academy, an influential one.

Turner's low spirits did not prevent him from sending a larger number of paintings to the Exhibition of 1830 than he had for many years; but the number was swelled by the pictures started in Rome two years before. The largest was the *Palestrina – a composition*. Turner appended a quotation from his unfinished, unpublished, and formless poem, *Fallacies of Hope*:

. . . misdeeming of his strength, the Carthaginian stood,
And marked with eagle-eye, Rome as his victim.

This picture was given to the national collection in 1958, and is now to be seen at the Tate Gallery, in very nice condition. Another oil of 1830, *Calais sands, low water*, is in the Bury Art Gallery, Lancashire. Unlike the grand *Palestrina* this small picture is free and expressionistic, the paint applied like watercolour.

In addition to his oils at the Academy Turner showed, unusually, a watercolour: *Funeral of Sir Thomas Lawrence, a sketch from memory*.

CCXXXVIII KENILWORTH 1830

$4\frac{7}{16} \times 7\frac{7}{16}$ 113×189 mm

After another funeral, this time King George I V's, Turner went off on a tour of the Midlands, starting at Woodstock and Blenheim Palace. The barricades were up again in Paris and he had given up the idea of Rome or France for the time being.

Finberg tells us that he had made the first 50 of his *England and Wales* drawings from sketches he already had – quite a feat even for such an inveterate collector of views. Now he needed new material.

The illustrations here speak for themselves; once again, it wasn't just a job. The drawings were, of course, for his use only: they are as he saw, and they contain what he needed, and no more.

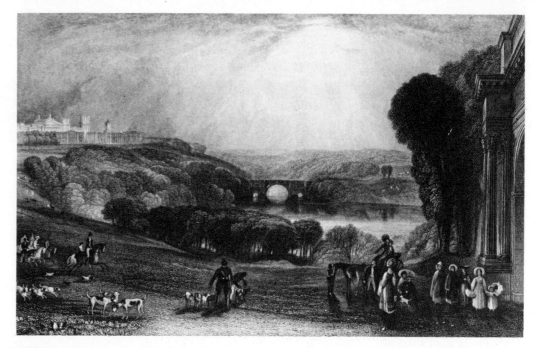

Bleinheim. Oxfordshire, from *Picturesque Views in England and Wales*, 1833, engraved by W. Radclyffe. $9\frac{1}{2} \times 5\frac{7}{8}$ inches, 242×151 mm

2a, 3 Blenheim Palace

Woodstock

29a, 30 Kenilworth Castle

30 Haddon Hall

4a

46 Chatsworth

86a Worcester

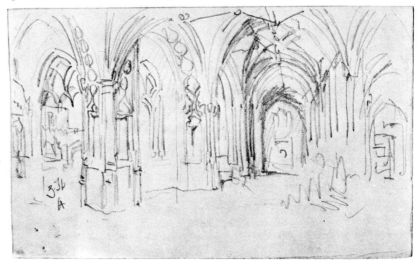

87a Worcester Cathedral

64

29, 28a

CCXXXIX *73a*

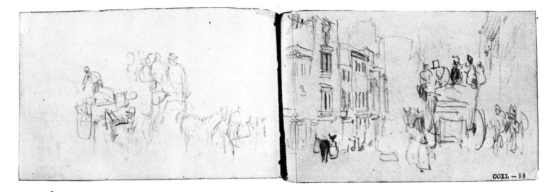

57a, 58

Of the three Midlands sketchbooks the smallest, CCXL, 'Birmingham and Coventry', is more of a general notebook with some travel sketches. At one end there are some accounts and a portrait: at the other, some views of Hammersmith, more female figures, even a nude.

Marine Dabblers was a catch-phrase, from the title of a *Liber* plate of several years before, which Turner scribbled under a figure on the seashore on one of the pages of the little book, CCXLI. This is a small autograph album with pages of different pastel tints, such as can be bought today at a stationer's – but not perhaps bound in red leather with gold blocking. Twenty-six pages contain casual 'thumbnails' of various seaside subjects, some landscapes, one life drawing. The rest of the pages are blank.

Sketchbooks CCXLII and CCXLIII are very slight and have been left out.

12a

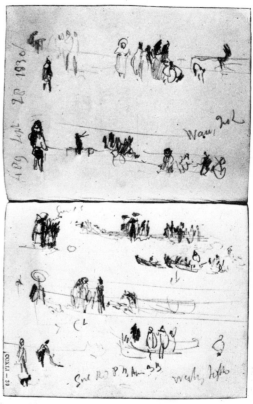

CCXLI *38a, 39*

Petworth, 1828–30

George, the 3rd Earl of Egremont, was 79 or 80 in December 1830, when Turner is supposed to have made his most protracted stay at Petworth. His host, a patron since 1802, was everything an English lord is expected to be, in fiction, and a Bohemian as well. He was cultured, but humane, shrewd, but benevolent, eccentric, but a good landowner and interested in the craze of the time, agricultural reform; a breeder of Derby winners; very, very rich, and rather shy. He was rumoured to harbour 43 illegitimate offspring under his capacious roof, and certainly had three, one of whom was his heir – though not, of course, to the title. He didn't drink, and he bought paintings.

The last that he had bought of Turner's was the high-coloured *Jessica*. About the same time he commissioned four canvas panels to go in his Carved Chamber, and gave the artist a room to work in, following the precedent set by fashionable Nash three years before.

Turner took the commission very seriously, to the extent of making full-size oil sketches for the long horizontal panels. He stuck to what had become for him a safe type of composition – the sun low in the centre, and a careful balance of shallow diagonals. But this is to generalize too broadly: Rothenstein and Butlin analyse the sketches and the finished panels, and show that the former are the more inspired. Part of the sketch for the panel entitled *The Lake, Petworth: Sunset, Fighting Bucks* is reproduced here. It shows the figure of Egremont greeted by a procession of his pet dogs. In the finished work the procession was replaced by a game of cricket and some supernumerary deer. But the panel is a wonderful picture, not least as a documentary.

A Ship aground, also connected with the Petworth panels, is a most poetic work which may serve here to remind us of Turner's continuing mastery of and enthusiasm for the sea and ships, which I have a little neglected in this book. The apparently careless brushwork of the water is, to me, an evocation of that certain slow rhythm of the waves which has only been matched by Debussy.

The Petworth watercolours

Except for the almost empty sketchbook, CCXLIII, which he labelled *Petworth* Turner appears to have given up the pencil while staying at the house. His blue paper was to hand and on this he sketched with the brush in body-colour. A very few of these 117 watercolours are possibly related to the works he was commissioned to paint, including some scenes at Brighton. The rest fall into four classes:

1 landscape and sunsets in the Park
2 interiors
3 interiors with figures
4 a handful of slight brush drawings of animals

Of these the interiors with figures are the most unexpected, while the interiors without figures include both detailed architectural subjects and much more mysterious corners of bedrooms.

The Petworth watercolours are famous, though very few have been reproduced before 1975. In trying to take a fair sample some magic, perhaps contained in some less explicit drawings, has escaped – or it may be that four drawings would suggest a great deal, while 40 is not enough.

Finberg gave each drawing a title, sometimes plain, sometimes fancy, and sometimes erroneous. Lady Leconfield added her corrections in 1933, and Andrew Wilton, in preparing the catalogue

Detail from
Petworth Park.
Tate Gallery

of the Turner Bicentenary Exhibition, has produced new descriptions. The numbers are fortuitous, for most of the drawings were found in two parcels marked by Ruskin, believe it or not, 'Inferior' and 'Worse'.

All are the usual size, for the blue-paper sketches, of $5\frac{1}{2} \times 7\frac{1}{2}$ inches, except for one twice that size.

Turner always had a purpose. What was the purpose of this series? The technique was the same as in the sketches for steel engravings such as the 'Rivers of France' – but only a handful of these scenes would ever have made engravings for Turner's public. There are no 'finished', i.e. saleable, watercolours of any of the subjects. They were not done for friends or fellow guests or for Egremont himself, for they remained in Turner's possession, like all his sketches. The natural conclusion is that he enjoyed and appreciated his time at Petworth and felt the need to express his feelings. But this is not quite like him, and anyway the feeling would not last for over a hundred drawings.

I think the explanation is that here he had found a great subject, many-sided. At the age of 22 he had filled a small book of tinted paper with miniature compositions, and labelled it, *Studies for Pictures*. At least two other books of gouache and tinted paper, LXIX (1802) and XC (1811), he had labelled the same way. I think the Petworth drawings, if they had formed the pages of a book, would have carried the label, in Turner's hand, 'Studies for Pictures, Petworth'. The precedent for such a series of pictures would be the watercolours done for Fawkes, of Farnley Hall and the elegant sporting life of its occupants.

The pictures never materialised, unless we count a few oil sketches – and they are remarkable. One of them is the feverish, ambiguous *Interior at Petworth*, in which the civilised gatherings of guests have given place to an invasion of wild animals. The date was probably 1837, and Egremont was dead. Turner had certainly an unfortunate way of outliving his best patrons.

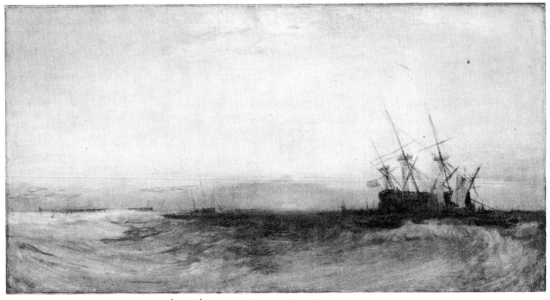

A Ship aground. Oil on canvas $27\frac{1}{2} \times 53\frac{1}{2}$ 70×136 cm Tate Gallery

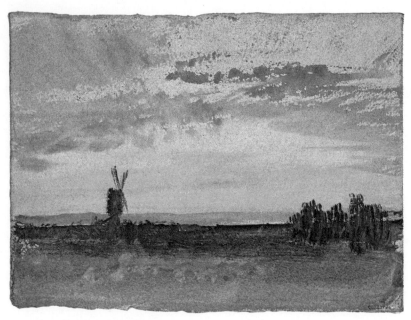

1 F Evening, Petworth Park
 w Petworth: a windmill at sunset

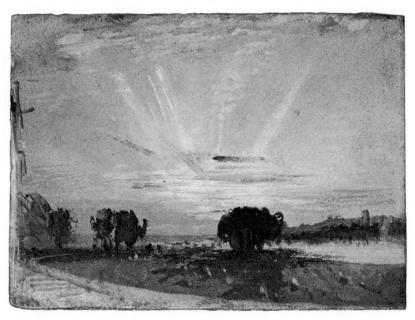

2 F Evening, Petworth Park
 L Tower of Tillington Church on the right
 w Petworth: sunset across the Park

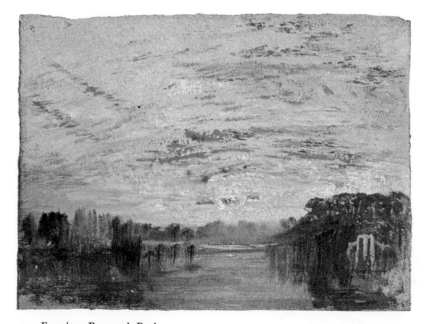

3 F Evening, Petworth Park

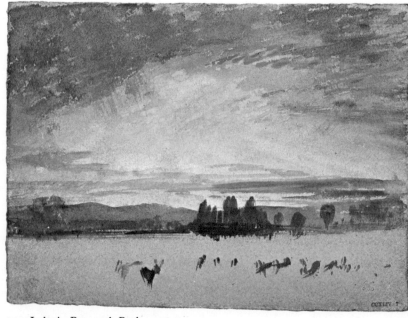

7 F Lake in Petworth Park, sunset

Key: F – Finberg, Inventory L – Lady Leconfield, 1933 w – Andrew Wilton, Catalogue of the Turner Bicentenary Exhibition at Burlington House

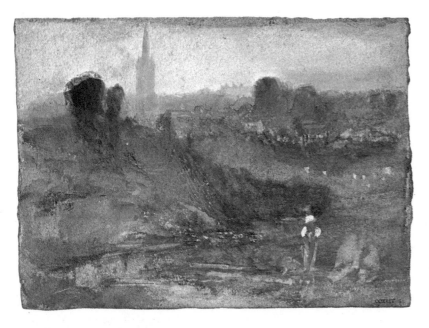

5 L Petworth Church and town

11 F At Petworth

8 F Petworth Church from the Lake

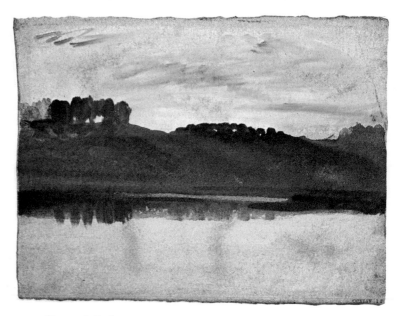

12 L Petworth Park

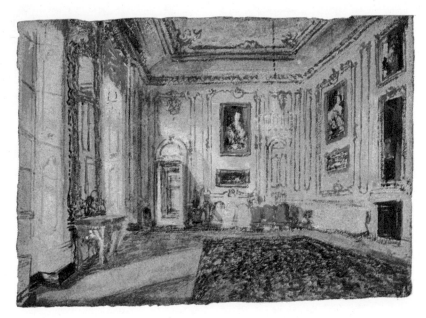

14 F White and gold room at Petworth House, with Vandyck portraits

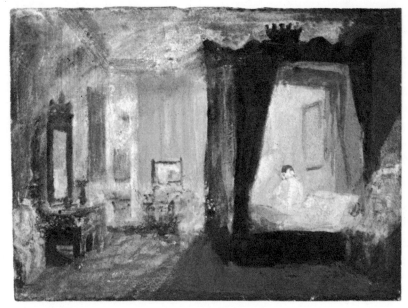

17 F Room at Petworth
 w Petworth: a bedroom with a large four-poster bed

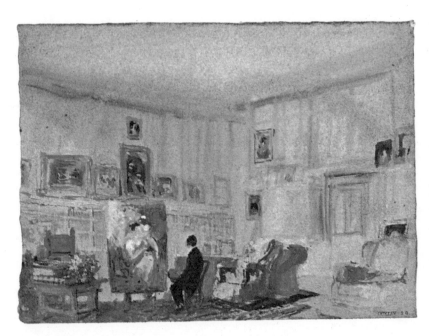

20 F/w Library, with a painter seated before an easel
 L A room in Petworth House

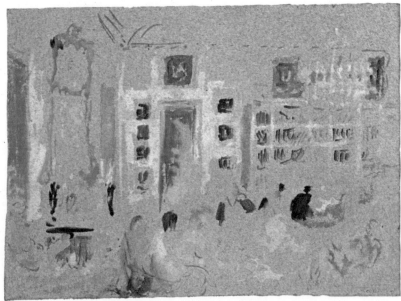

24 F Morning room with figures
 L A room in Petworth House

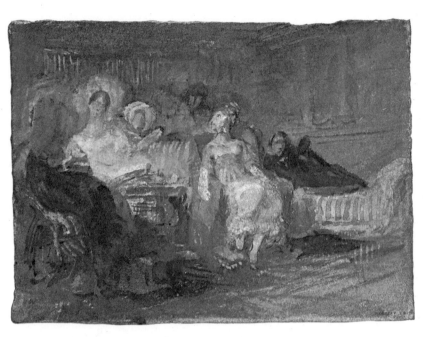

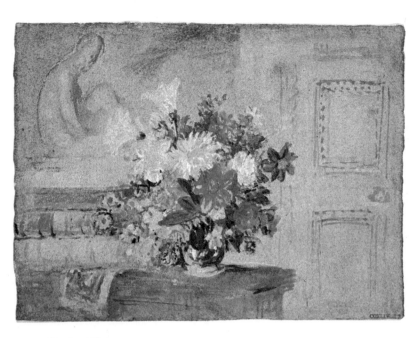

23 F Study of flowers
w A vase of lilies, dahlias and other flowers

26 F The lady in pink: an interior with figures
w Petworth: a group of figures seated in an interior

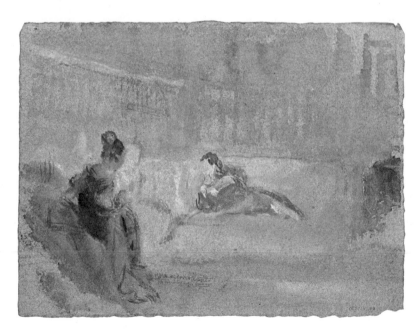

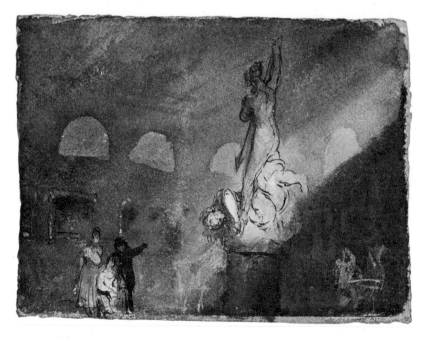

25 F Flaxman's group of the Archangel Michael and Satan
w Petworth: the Gallery, with Flaxman's 'St Michael'

33 F The red lady on a couch

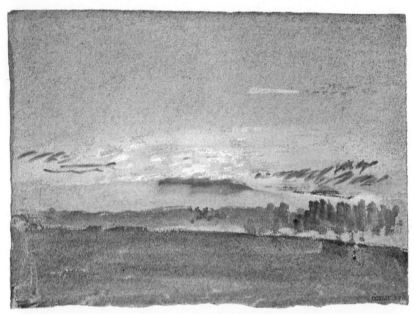

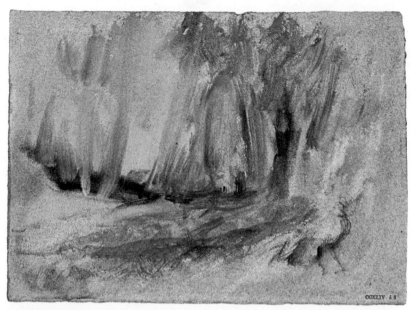

57 F The setting sun L Sunset in Petworth Park

55 F Group of trees

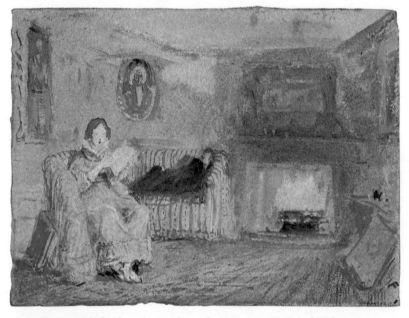

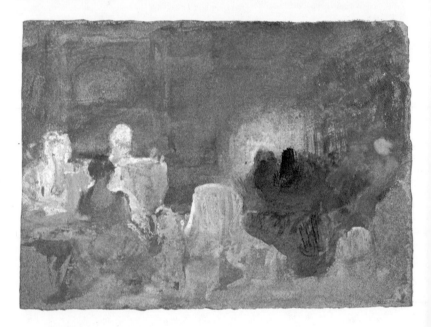

77 F Room with fire burning and two figures, one a man in black on a couch, the other a lady in blue, seated, reading

41 F Firelight and lamplight
 w Petworth: a candlelit interior with figures seated at a table

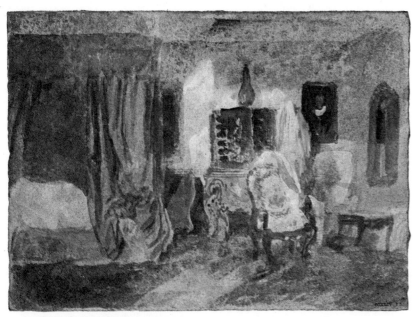

75 F Bed with green silk curtains

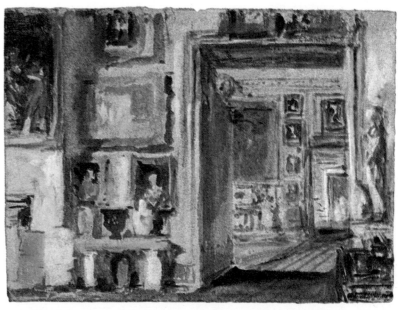

73 F The doorway L Looking down the vista of rooms

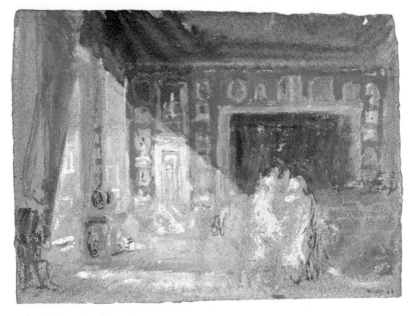

96 F Figures in the red room

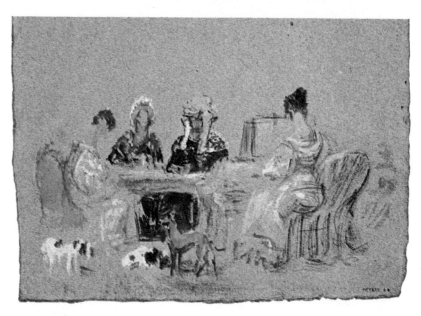

90 F A dames' party

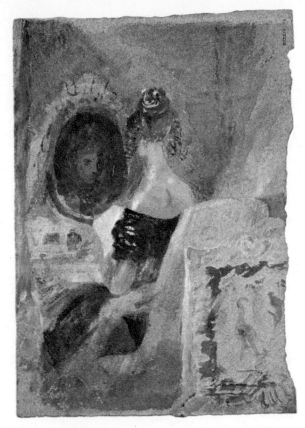

79 F Lady in a black dress at her toilet

82 F Men chatting round the fireplace (L) in the Marble Hall, Petworth

83 F Lady in black in a room with a green-curtained bed

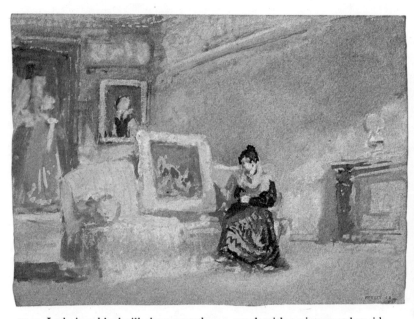

42 F Lady in a black silk dress seated on a couch with a picture at her side
w A woman in black sitting with a framed painting on a pink sofa

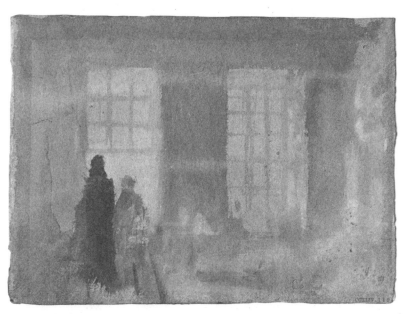

112 F At Petworth

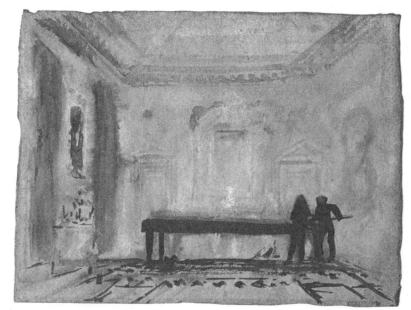

116 F The billiard table

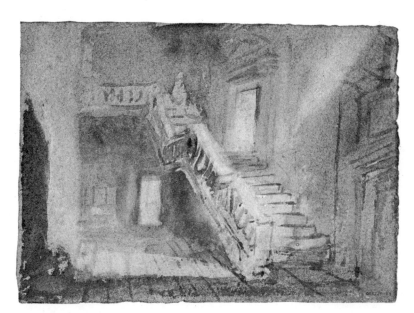

95 F The staircase
 L The staircase

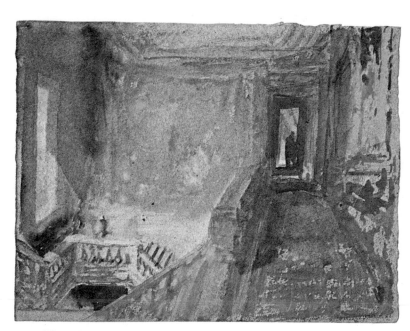

94 F The staircase
 L Staircase, looking south down chamber floor

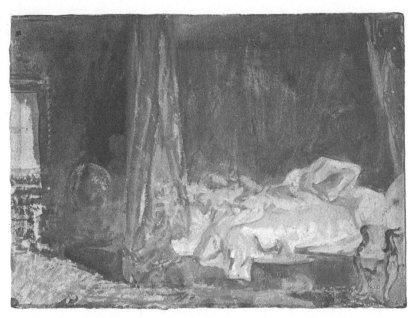

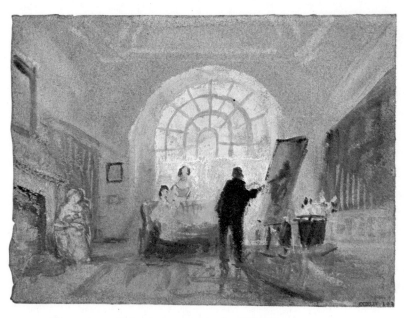

115 Unmade bed with red curtains (F A bedroom scene)

102 F The artist and his admirers (L) in the Old Library
w An artist painting in a room with a large fanlight

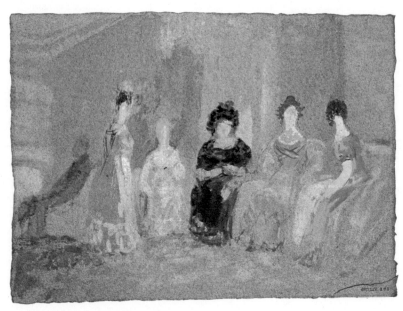

101 F A bevy of beautiful women
·w Petworth: a group of ladies conversing

103 F The artist and the amateur (L) in the Old Library
w Two artists painting

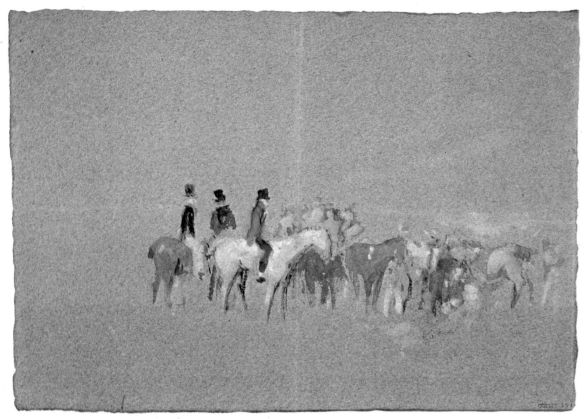

104 F The Meet

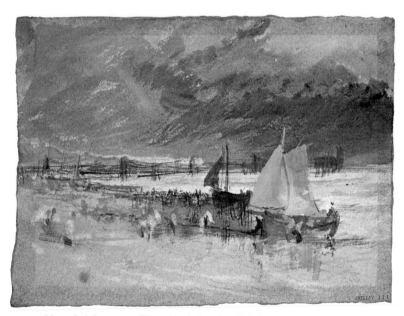

111 F Near Brighton L The old chain pier, Brighton

In addition to the Petworth watercolours, which may have been done over a period of two or three years, a large number of works have been attributed to the winter of 1830–1: but the first nine are dated 1827–8.

four panels for the Carved Chamber at Petworth (still in position)
five sketches for the above including
　A Ship aground (Tate Gallery)
A Woman Reclining on a Couch (5 ft × 8 ft, Tate Gallery)
Watteau study (Tate Gallery)
Lifeboat and Manby Apparatus or *Vessel in Distress* (Victoria & Albert Museum)
. . . on the French coast, 1805, cruiser aground, etc. (New York Public Library)
Admiral van Tromp's barge at the entrance of the Texel, 1645 (Soane's Museum)
three history paintings exhibited at the R.A., two with quotations from *Fallacies of Hope* (all in the Tate Gallery)
two watercolours of the Forum.

Just how the little 'Arundel and Shoreham' sketchbook fits in, I don't know. The profile of folio 55a somewhat resembles that of the large reclining nude of the painting mentioned above, but the body does not. The ink sketch, folio 27, shows the Turner we learn to love from the sketchbooks, coping somehow without his paints in the face of a blinding glory. This drawing contains a poem: *Grey/Livid Red/Yellow/Gold grn?/Cold/G.* And the drawing on folios 70a–71 is extraordinary: a castle, below it a promenade or sea front – and a ship breaking up in great waves?

The sketchbook CCXLVI, called 'Brighton and Arundel', is not shown here; it is nearly all blank.

27

71, 70a Arundel

33a

38a, 39 Arundel Castle

55a

French rivers and towns: hiatus

Twelve sketchbooks, CCXLVII to CCLVIII, as well as a mass of blue-paper drawings, are devoted to explorations in France. The sketchbooks are dated 1826–30 or 'about 1830' in the Inventory, and Finberg added an apologetic footnote: he had not time to travel in France in Turner's footsteps.

Even if the drawings were put in order, it would still not be certain in which years they were done; we have to allow for the possibility that Turner took half-filled sketchbooks to and fro. With his knowledge of every fishing port on the south coast, he would hardly find it necessary to travel by the regular packet boat, and he probably went to northern France more often than is on record. From the point of view of biography, the only use of which is to help in understanding his motives, the precise timing of the French sketches is unimportant. He covered a great deal of ground, and paper, and it must be admitted that a lot of the drawings are dull. One is inclined to think, perhaps irrationally, that these are the earlier ones.

It seems that the earliest drawings in France stressed a certain quaintness or gaucherie, very evident in groups of peasants in their distinctive costume, and in some of the more quirky vernacular architecture he recorded. At times he forced this effect, as if he found it hard to make anything of his subjects. Then, as he began to feel his way he gradually modified his picaresque style and chose more 'elevated' subjects, relying too on moonlight and evening skies to supply the poetic element and simplify his compositions.

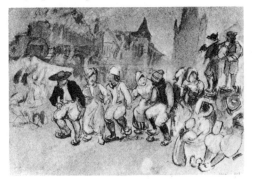

CCLIX 197

The content of the pencil sketchbooks is mainly factual, as we should expect. But many of the blue-paper sketches were also done on the spot. It appears that he carried both types of material with him and used whichever seemed appropriate to mood and subject. Eventually some, but not very many, of the pencil sketches were incorporated into colour sketches on the blue paper; some of these in their turn were worked up into the degree of detail required for the engraver.

CCXLVII 25

CCXLVII 50

CCXLVIII 44a

CCXLVIII 39 Place St Croix etc.

CCXLIX *35a* Pont au Change

CCLIX *33*

see page 95

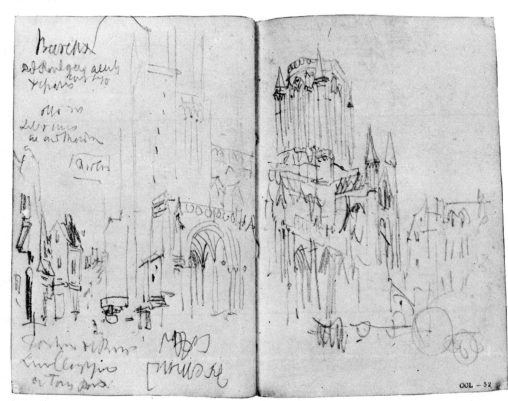

CCL *51a, 52* Coutances Cathedral

CCL *22*

The sketchbook CCXI, *Paris, Seine, Dieppe*, was first dated 1824 by Finberg; this was later altered to 1821, on the grounds that some pages showed the old spire of Rouen Cathedral, destroyed in 1822. Pages of CCLVIII, 'Dieppe, Rouen and Paris', also show the old tower. In CCLV the cathedral is shown without the spire. Rebuilding began in 1827. It can be assumed that the pages repro- duced here cover a period of at least ten years, as the great variety of styles would suggest. Even in a single book there can be a wide variety of styles, and this is reflected in the coloured drawings on blue paper. Several subjects from this book were engraved in *Wanderings by the Seine*, part two, 1835. Folio 55a, Pont Neuf (overleaf), is one of these.

CCL *26a* *Salle de Ventes Publiques Rue du Juifs*

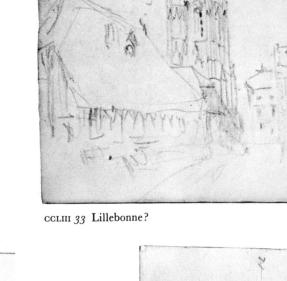

CCLIII *33* Lillebonne?

CCLV *17* Mont St Michel

CCLV *6* Rouen

CCXI *27a*

37 On the Seine

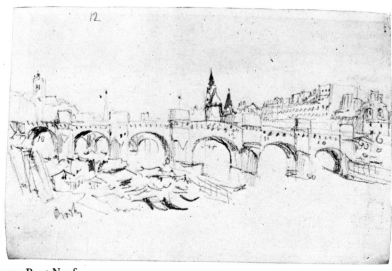

55a Pont Neuf

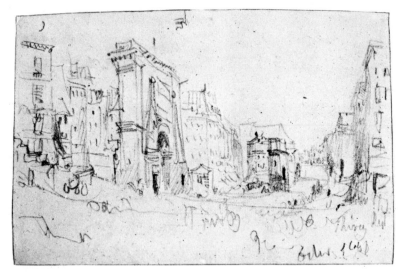

42a Porte St Denis

165

'French Rivers' sketchbooks, 1821–32

CCXI *Paris, Seine, Dieppe* 1824, redated 1821
CCXLVII *Morlaise to Nantes* 1826–30
CCXLVIII *Nantes, Angers, Saumur* 1826–30
CCXLIX *Loire, Tours, Orleans. Paris* 1826–30
CCL Coutances and Mont St Michel 1830
CCLI and CCLII, see page 46
CCLIII *Tankerville, Lillebonne* 1830
CCLVI Seine and Paris 1830
CCLV Rouen 1830
CCLVII Paris and Environs 1830
CCLVIII Dieppe, Rouen and Paris 1830 (1822)

The dates are those given as approximate in the *Inventory*. Titles in italics are Turner's.

CCLXIV ROKEBY AND APPLEBY 1830–1
$2\frac{7}{8} \times 3\frac{5}{8}$ 73 × 92 mm

CCLXV BERWICK 1831
$2\frac{1}{4} \times 3\frac{3}{4}$ 57 × 94 mm

CCLXVII ABBOTSFORD
$4\frac{1}{2} \times 7\frac{1}{4}$ 113 × 184 mm

[67

CCLXIV *52a*

CCLXIV *36*

CCLXV *34*

CCLXV *36*

Abbotsford and Staffa, *1831*

The new edition of Samuel Rogers' *Italy* with Turner's steel-engraved illustrations was published in 1830 and was very successful. Sir Walter Scott, then struggling in illness with his debt of £114,000, was persuaded by his new publisher, Cadell, that he needed Turner's illustrations – they would double the sales of the editions about to be published. Turner had already drawn some illustrations for Scott's *Provincial Antiquities of Scotland*, published 1819–26.

He was not eager to go to Scotland to draw the places specified by the publisher. He had, he wrote, 24 of the subjects already in his sketchbooks and was prepared to find other sources for the rest – and he could hardly spare the time. He seems not to have thought of refusing the commission, though Scott was no friend, and is on record as believing that Turner was interested in nothing but money. Scott would have preferred a local artist who would

do his best rather than the great man who might scamp the work, and Cadell's interest apparently went no further than the increased sales he might expect. But he was persuaded to go, and Scott invited him to stay at Abbotsford.

Many of the drawings on the way he seems to have done from a moving coach – like folio 36 of the 'Rokeby and Appleby' book.

The sketchbook CCLXVI has the grand title, 'Minstrelsy of the Scottish Border', but I found nothing of interest in it – more tipsy scribbles (but perhaps I am spoilt) – though the *Inventory* identifies several of the Scott illustrations. Turner's bread-and-butter sketches have now settled into an unrewarding shorthand, but he is none the less thorough, for he does six or seven studies of each subject, and it is clear that he sets down exactly what he wants. It's just that the drawings don't always 'read'.

Drawings in the 'Berwick' book are more intelligible, quiet but unremarkable. Then the sudden breadth of the view of Berwick, CCLXVII 48a–49, is refreshing. This also was the original of an engraving.

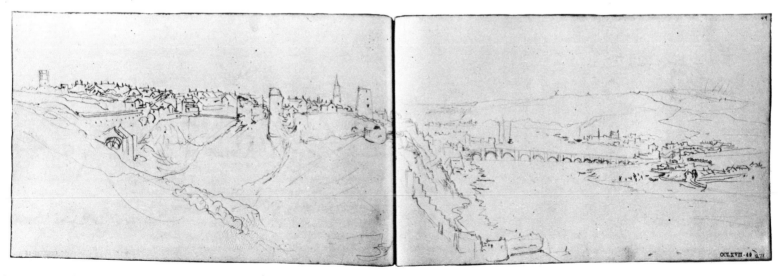

CCLXVII *48a, 49* Berwick-on-Tweed

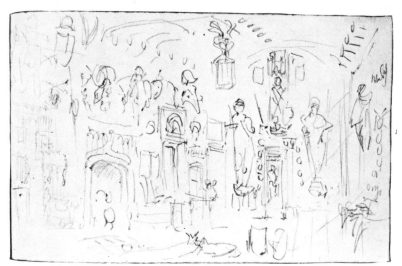

CCLXVII *68a* The armoury at Abbotsford

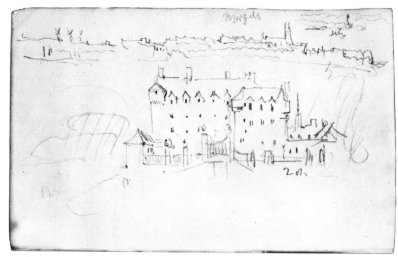

CCLXVIII *17a*

CCLXIX *75* Edinburgh

CCLXIX *78* The Burns Monument, Calton Hill, Edinburgh

At Abbotsford he gave no special attention to the house, but there are some interiors, notably the weird armoury. The ailing Scott, with others of his party, accompanied him to Smailholm Tower, a scene of the novelist's childhood, and to Ashestiel, Bemerside and the Vale of Melrose. Relations between author and illustrator warmed on closer acquaintance, and Turner put the figures of himself, Scott and Cadell, top hats and all, into some of the engraved drawings. When he moved on to Edinburgh Scott sent his compliments via Cadell, trusting that Turner's journey northwards would be 'as successful as it has been, more so it can not be'. We cannot imagine that Scott would be impressed with Turner's sketchbooks, even if he had been granted much of a sight of them: perhaps some of the watercolours were already started, or perhaps Scott was simply reassured by Turner's manner and conversation, now that he had got to know him.

Folio 17a of the 'Edinburgh' sketchbook is unidentified, unfortunately. In Edinburgh itself he is inspired, as always; a sort of urgency speeds his

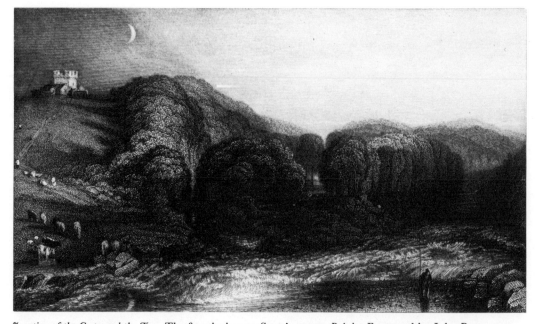

Junction of the Greta and the Tees. The frontispiece to Scott's poem, *Rokeby.* Engraved by John Pye

fist as he climbs in search of a vista for one of Sir Walter's prose works (CCLXIX 78).*

Some 'pother' caused by Turner as he left the lowlands was resolved, to Scott's satisfaction at least, as being due to Turner's fears that if he, Scott, went abroad for his health during the ensuing year the work for publication would be interrupted. In fact the journey resulted in a fatal stroke for poor Scott, but the publications went ahead all right.

The going was harder as Turner travelled to the western Highlands, and he reverted to his most perfunctory style. He sailed to Skye and back to Mull, and then took the steamship to Staffa, where because of rough weather he had only an hour to scramble over the rocks to Fingal's Cave. The drawing gives no hint of the precise observation which distinguishes the engraving. But there is a hint of pictorial resolution in the rocks of folio 20.

A rare first-hand account survives in a letter to the American, Lenox, who nobly bought the picture of *Staffa* unseen, and at first didn't like it at all. Turner writes: 'Such a rainy and bad-looking night coming on, a vote was proposed to the passengers: "Iona at all hazards, or back to Tobermoray [Mull]." Majority against proceeding. To allay the displeased, the Captain promised to steam thrice round the island in the last trip. The sun getting towards the horizon, burst through the rain-cloud, angry, and for wind; and so it proved, for we were driven for shelter into Loch Ulver, and did not get back to Tobermoray before midnight.' There is no sketch of a smoky steam-boat or of the sun bursting through a rain-cloud.

He must have run out of sketchbooks; CCLXXII is made of roughly folded sheets cut with a blunt knife, and two others, CCLXXIV and CCLXXV, called 'Sound of Mull 1 & 2', are nothing but penny notebooks – with nothing much drawn in them.

CCLXXII *24*

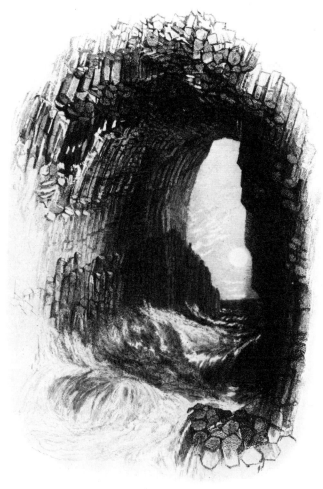

Fingal's Cave, Staffa, from *Lord of the Isles*.
Engraved by E. Goodall

CCLXXIII *20* Staffa

CCLXXXIII *28a* Fingal's Cave

* For notes and illustrations of Turner's visit to Scott, see the article by Gerald Finley in *The Connoisseur*, August 1973.

CCLXXVI is made of sheets of pale blue laid paper stapled together with bent pins. The ruined castle was somewhere near Loch Ness – the book takes us to Inverness. Here he bought an excellent sketchbook – CCLXXVII – from D. Morrison & Co., and in seven pages had completed his assignment. Then he went on to Elgin and left us two poetic pages of the Cathedral, one of which is reproduced here. He probably returned to London by sea. He had been away two months, 'his health not improved by the excursion', according to a letter dated 23 September 1831.

He almost certainly went to Petworth for a period in the winter.

CCLXXIX 7

CCLXXVI *19*

CCLXXVII *122* Elgin

1832

In March 1832 some of his illustrations to Scott were exhibited in Pall Mall. 'Unequalled for beauty, and finished with more care than usually distinguishes the pencil of the artist,' said the *Athenaeum*.

Staffa and five other oil paintings were in the Academy show. Three were historical sea pieces, and found buyers. A small panel, *Nebuchadnezzar at the mouth of the fiery furnace*, much abused by the critics, kept him in the avant garde. The largest picture was *Childe Harold's Pilgrimage* (Turner had been illustrating the works of Byron), a successor to *Palestrina* (1830) and *Caligula's palace and bridge* (1831). He gives us a mushroom-shaped, instead of a toadstool-shaped, tree, and some seductive Italian scenery.

His movements in the summer are unknown. Two sketchbooks which Finberg claims he 'may have used' in 1832 deserve half a page of our book.

MOUTH OF THE THAMES 1832? $4\frac{3}{8} \times 7\frac{1}{2}$ 111 × 189 mm | CCLXXIXa LIFE CLASS (1) 1832? $3\frac{3}{8} \times 4\frac{3}{8}$ 85 × 111 mm [71

GRAVESEND AND MARGATE 1832? $8\frac{1}{8} \times 3\frac{3}{8}$ 207 × 86 mm

CCLXXIX *39* Ramsgate

CCLXXVIII *3*

CCLXXIXa *31*

death in 1851. A silly story about their first meeting does not bear mentioning, even to deny it, save to say that Lindsay's research establishes some ordinary facts from which he makes reasonable conjectures (*J. M. W. Turner*, p. 175).

Two more sketchbooks are provisionally dated 1832: CCLXXIXa and b. The first is mainly devoted to life drawing. The second, which contains nothing but a series of life poses in red chalk, was in Ruskin's parcel 'Kept as evidence of the failure of mind only'. I am sure it isn't a Turner sketchbook:

At Margate he is supposed to have been in the habit, since 1827, of staying at a house overlooking the harbour owned by John and Sophia Booth, who took in boarders. Mrs Booth was widowed in 1833 or 1834 and later lived with Turner until his

CCLXXIXa *7 The Bivalve Courtship*

he rarely used red chalk and was never quite as dull as this. As a Visitor to the Life Academy (from December 1833) he might have brought home the work of a student and forgotten to return it.

Inventory no. CCLXXX is 'Studies for Vignettes', some of which are shown on pp. 39–40.

CCLXXIXa *51a*

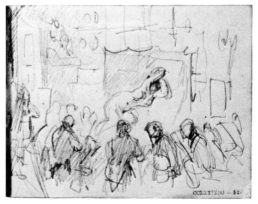

CCLXXIXa *52*

1833

1833 saw the publication of *Turner's Annual Tour – the Loire*, followed at the end of the year by *The Seine* (part one: part two came out in 1835). *Annual Tours* of the Meuse and the Moselle were intended, but never engraved. Turner continued to explore these rivers and the Rhine and Danube for the series *River Scenery of Europe*, which Charles Heath intended to publish.

Part 16 of *Picturesque Views in England and Wales*, (line-on-copper engravings) came out in June and a large exhibition of watercolours, mostly for this series, drew the crowds to Messrs Boon, Boys & Graves, in Pall Mall. There were 78 pictures; twelve of them were for Scott's *Poetical Works*.

A dozen or more of the *England and Wales* drawings are now in municipal galleries up and down the country – apart from the national collections in London – though many will be faded through exposure. At the time of their first showing 25 drawings were bought by Thomas Griffith, M.A., who here enters the story of Turner's life. Griffith was an amateur who used his money to collect the works of contemporary artists, usually selling them again after a time. First the artists profited, then (in most cases) he did, and in the meantime was the possessor of a fine collection. He became increasingly involved in many of Turner's transactions in later years.

In this year, 1833, Turner's first two oil paintings of Venice were exhibited at the Royal Academy. Thirteen years is a long time to wait before turning sketches into paintings, but so far as is known this is what he had done. It isn't like him: his paintings so often reflect his experiences of the previous year. I always suspected that the colour sketches of Venice, usually dated 1819, were later (see *The Sketches of Turner, R.A., 1802–20* pp. 182–6) and some authorities have believed that he went to Venice in 1832. The current theory favours 1834, *after* the success of *Bridge of Sighs, Ducal Palace and Custom House, Venice : Canaletti painting* (in the Tate Gallery). It is quite a small painting, and it fetched 200 guineas. Turner said to George Jones: 'Well, if they will have such scraps instead of important pictures they must pay for them.'

He also showed *Rotterdam Ferry Boat, Van Goyen, looking for a subject,* and *Van Tromp returning after the battle off the Dogger Bank.* Only the last is in a public collection (Tate Gallery).

The sixth painting was the beautiful *Mouth of the Seine, Quillebœuf,* obviously as directly inspired as the *Staffa* of the year before. As it happened it formed a very good advertisement for the first of the 'French Rivers' publications, in June.

Princess Victoria, with her governess and several English ladies, visited the Academy Exhibition. 'It was a very good exhibition,' she wrote in her diary. 'There were several very fine pictures by Sir Martin Shee. Seven by Westall. . . . All very fine.' She saw three pictures by Hayter, three by Wilkie, and 'several very fine ones by Howard, Davies, Eastlake, Landseer, Calcott, Pickersgill, Hilton, etc etc.' She was only 13, but her tastes were already formed.

Turner probably visited Paris and the Seine in the summer, according to Finberg. Lindsay quotes Delacroix, who wrote in his *Journal* in 1855 of having met Turner some time before 1835: 'He produced a mediocre impression on me: he had the look of an English farmer, black clothes, gross enough, big shoes and a hard, cold demeanor.'

18a, 19

1834

Colnaghi's exhibited some of Turner's illustrations to Byron, and Griffith bought several. At the Academy his new instalment in the wide-screen epic illustrating his *Fallacies of Hope* was *The Golden Bough.* Unusually, perhaps because it is especially sickening, it was sold. It was presented to the National Gallery in Turner's lifetime. Also exhibited were *Venice,* now in the National Gallery, Washington, *Wreckers, Coast of Northumberland, with a steamboat assisting a ship off shore,* now in a private collection in Pittsburg, and *St Michael's Mount, Cornwall,* now in the Victoria and Albert Museum.

19a

The date of the small sketchbook 'Fishing at the Weir' is very vague. Most of the 40-odd sketches are slight – there are some smudge-drawings in

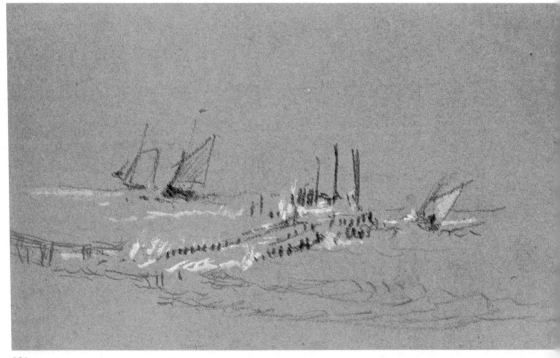

33a

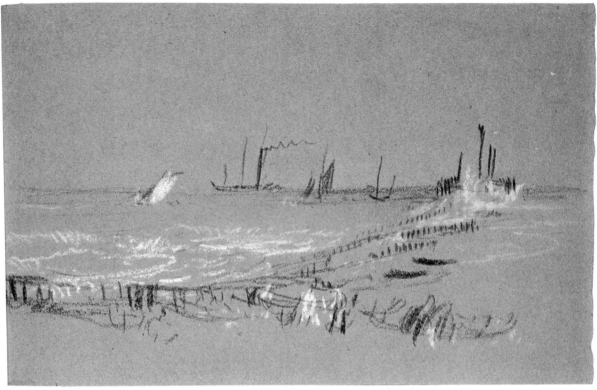

35a

which Turner seems to have been inventing figure groups, after the manner of Cozens' blots for landscape composition. A group of drawings of rather elegant fishermen is unusually tonal and quiet in atmosphere.

In contrast, a larger book of brown pastel paper of excellent quality is used for a brilliant series of black, white and red chalk drawings of a jetty on a windy day (folios 33a, 35a) and in the calm of evening (folio 38a).

The two groups, the fishermen and the jetty, are good examples of Turner drawing for pleasure, with thoughtless skill and versatility. The name 'Fire at Sea' comes from some indifferent, and now faded, watercolours of a ship on fire.

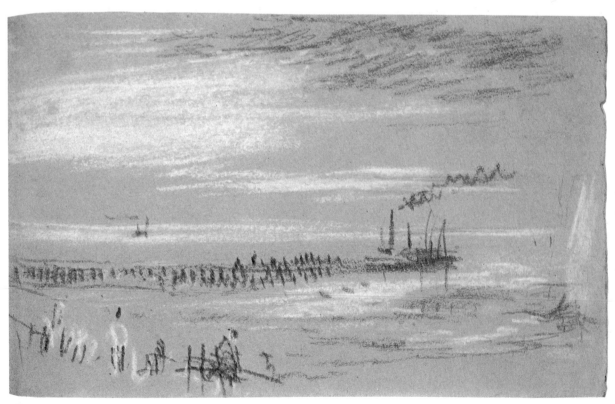

38a

According to Finberg he had some new work to do in Oxford, for Ryman, but nothing was ever published. In the sketchbook CCLXXXVI there is a forlorn attempt at a diatribe against the noise of Old Tom, which Turner dated *July 2nd 1834*. The same book continues with coast scenes and drawings of Bruges. We are told that he followed the course of the Meuse, Moselle and Rhine, much as he had done in 1826.

The Spa, Dinant and Namur book, CCLXXXVII, was bought in Brussels, though the paper is English-made. Note the close correspondence between folio 2a and the same scene at Louvain in CCXXII D (p. 87), which Finberg dated 1826. Which came first?

The style of folio 30, the boats of Metz, with its own peculiar gaiety, also, I think, refers back to an earlier time. The book, CCLXXXVIII, has many pages of sketches of Luxembourg.

CCLXXXV *4* High Street, Oxford

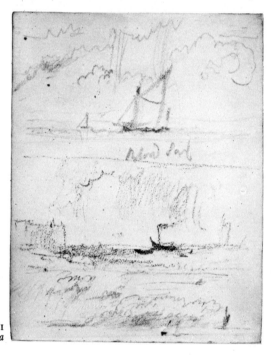

CCLXXXVI
35a

CCLXXXVII *35a* Spa?

CCLXXXVII *2a* Louvain

see page 87

CCLXXXIX *20* Iffley Church, near Oxford

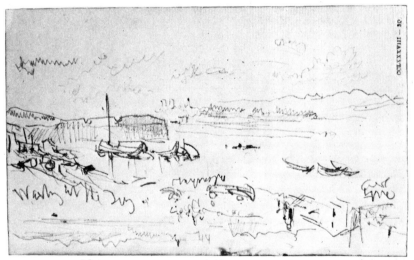

CCLXXXVIII *30* Metz

CCXC *3a*

CCXCI *32a* Moselweis

Again, in CCLXXXIX, the style of folio 20, Iffley Church, conflicts with that of the much more notal and delicate views in Oxford opposite – but both are almost certainly dated 1834.

Sketchbook CCXC is full of Turner's labels of place names on the Moselle and Rhine, and is correspondingly inarticulate in drawing. Obviously it served its purpose. On the cover he lists the five sketchbooks used on the tour and their contents, providing Finberg with authentic titles and, by linking the books together in one year, as much evidence as we can hope for to date the drawings. We still have to allow for the possibility that the books were half full when he took them to Germany; and this, I think, is what happened. *Cockem to Cob. Home* is Turner's title for sketchbook CCXCI: more labels in his vernacular, and, on folio 52, *Bread and cheese. Bottle of Ale. Dinner. 2 Small Bottles of Stout. Glass of Gin and Water.* The drawing of *Moselweis*, folio 32a, is above the average for this hurried book.

CCXCA is entitled 'Rhine between Cologne and Mayence, also Moselle and Aix-la-Chapelle'. It doesn't fit in with Turner's list in CCXC, and it is very scrappy, so I have left it out.

On his return Turner went to Petworth, according to the reminiscences of C. R. Leslie's son, who was then 8 years old – but as reliable as many a witness of Turner, for he remembers a long and boring fishing incident (Finberg, p. 349).

CCLXXXV Oxford $5\frac{3}{4} \times 9\frac{1}{8}$ inches 145 × 234 mm
CCLXXXVI Oxford and Bruges $3\frac{1}{2} \times 4\frac{1}{2}$ inches 89 × 114 mm
CCLXXXVII Spa, Dinant and Namur $6 \times 3\frac{3}{4}$ inches 152 × 94 mm
CCLXXXVIII *Givet, Mis,* (Mezières) *Ver*(dun), *Metz, Lux, Trèves* $6\frac{5}{8} \times 3\frac{7}{8}$ inches 168 × 98 mm
CCLXXXIX *First Mossel and Oxford* $5\frac{1}{2} \times 9\frac{1}{4}$ inches 140 × 235 mm
CCXC Trèves to Cochem and Coblenz to Mayence $6\frac{3}{8} \times 4$ inches 162 × 100 mm
CCXCI *Cockem to Cob. Home* $6\frac{1}{8} \times 4$ inches 157 × 100 mm

The beautiful little book called 'Colour studies 1'
and a less coherent sequel, 'Colour studies 2',
CCXCI*b* and c, are dated 1834. They belong to a
private world of Turner's where coloured
smudges could be turned into poetry, like pictures
in the fire. Folio 38 would appear to locate the scene
of these imaginings at Petworth, where beds and
curtains were part of his subject matter.

The little book is claustrophobic, some of the
pages very heavily worked with layers of dark
watercolour. A great painting of Turner's may
seem to open and expand before us: this miniature
closes us in, mysteriously suggesting in half-
revealed images some truth which he could not
paint. The interior climax of the sequence is at
folio 42. Here is no orgasm of primary colours,
but instead a complex of shadows enclosing two
figures, crouching together, who seem to stare . . .
but we cannot quite see.

5

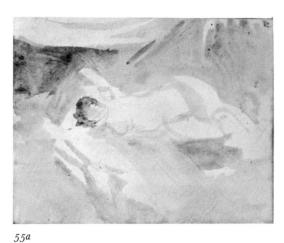

55a

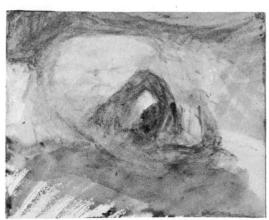

53a

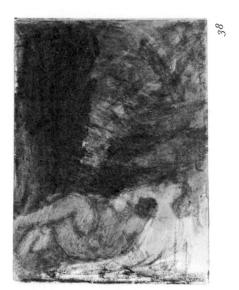

38

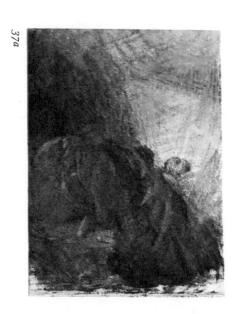

37a

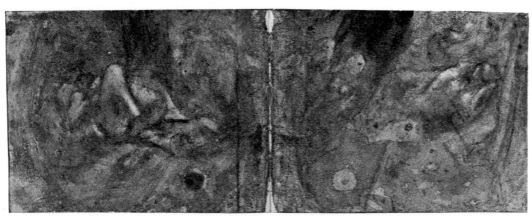

35a, 36

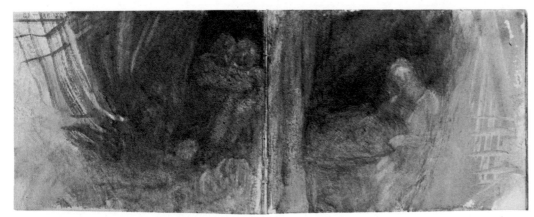

42 *41a*

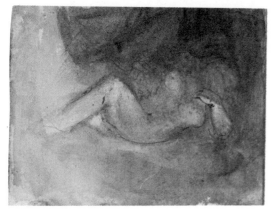

44a

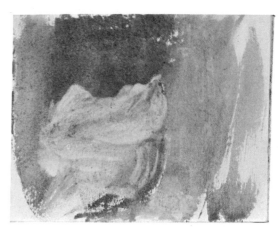

CCXCI*c 35a*

In 'Colour studies 2' we are presented with a
series of blots or smudges of pink and grey which
here and there coalesce into sculptural figures
(folio 35a). Other pages, such as those reproduced
in Lindsay (plates 16 and 17) show a couple
embracing, but they are neither well-conceived
nor well drawn.

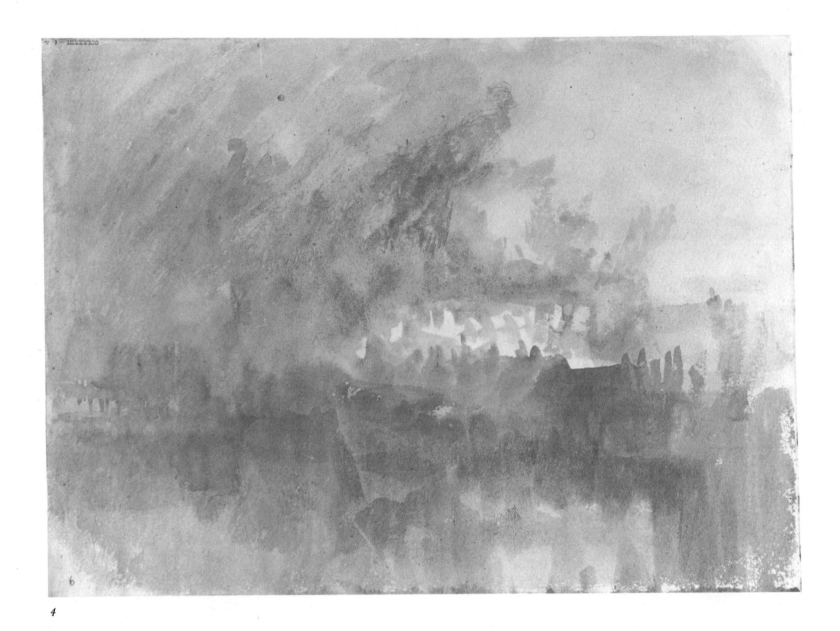

4

Turner was in London for the event of the year when, on the evening of 16 October, the Houses of Parliament burned down. He made several pencil sketches at the scene in a small paper-bound book. A larger sketchbook contained the nine immortal colour sketches which were on view at the Tate Gallery.* He produced an oil painting of the disaster for an exhibition at the British Institution in February 1835, where it was much admired, and another for the Academy Summer Exhibition. One of these pictures is now in Philadelphia, the other in Cleveland, Ohio.

* From 1970 to 1974.

The fire, which was caused by the overheating of a furnace, must have seemed symbolic at the time, two years after the passing of the Reform Bill. It was not widely regarded as a tragedy, especially as the wind had shifted just in time to save the historic Westminster Hall. Turner's paintings are great expressive evocations of the drama, in brilliantly handled pigment. The Philadelphia picture, particularly (reproduced [in reverse] in Gage), has something of the same powerful imbalance of the *George IV at a Banquet* of 1822. Because of the subject, the primitive handling, as it then seemed, was accepted.

But the colour sketches, whether they were made

on the spot, as Reynolds believes (in the dark?) or after the event, from the pencil shorthand in sketchbook CCLXXXIV – which seems to me more likely – are not concerned with documentary detail. They are variations on a primary theme, in which the perspective, the flaming structure and its reflection, the smoke and the darkness, are interchanged: and the scene itself could be anywhere, at any time in history. In two of the sketches the building assumes a rudimentary classical shape: in another it might be a great forge. 'From this time on,' writes Reynolds, 'he was more and more liberated in his attitude to colour of the highest pitch.'

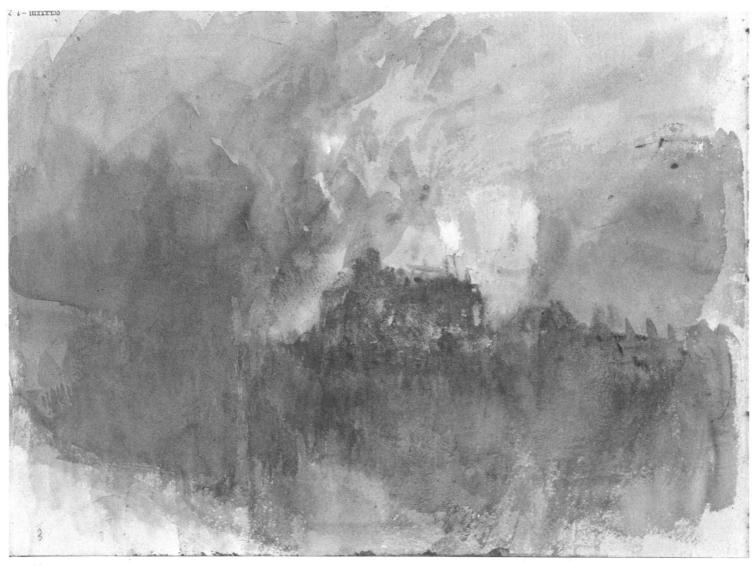

CCLXXXIII 7

CCLXXXIV 6

Sketches on blue or grey paper

The only tinted paper drawings which have positive dates are the East Cowes Castle series and those of section CCLIX which are linked to published engravings. The Petworth watercolours must have been made between 1827 and 1837, which isn't very precise, but I have placed them in this book about 1830, in their catalogued position.

Finberg's arrangement of the Meuse, Moselle and Rhine drawings into two main groups, 1826(?) and 1834(?), does not stand up, as I explained on p. 34. The selection reproduced in the following pages, however, adheres loosely to the catalogued order.

The work remains as a sea of blue and grey papers, all the same size, with no dates, few reliable titles and a complex, inconsistent system of numbering. It is not possible for a student at the Department of Prints and Drawings to see more than one or two sections at a time. Thus any attempt to chart the sea and put the drawings in the order in which they were made, if possible at all, must either be an inside job or await a researcher who can afford photographs of the whole – at least 959 drawings – and can take long holidays on the Continent.

All the drawings are about $5\frac{1}{2} \times 7\frac{1}{2}$ inches (140×190 mm). Finberg catalogued them in twelve sections:

1 Watercolours connected with the Meuse–Moselle tour, about 1826
 CCXX (A–L on white paper) M–Z
 CCXXI A–Z
 CCXXII A–Z
 CCXXIII A–E

2 CCXXIV 1–240. Black and white on blue, Meuse–Moselle (see p. 34)

3 CCXXVIIA. East Cowes Castle, ink and white chalk. 1827 (see p. 37)

4 CCXLIV 1–116. Petworth watercolours (see pp. 51–61)

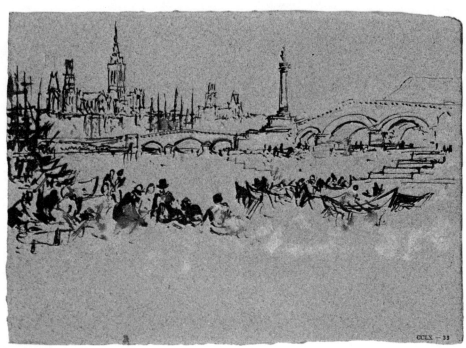

CCLX *33*

5 Watercolours mostly connected with the 'French rivers' series, about 1830
 CCLIX 1–101 various
 102–136 engraved 1834–5
 137–271 various

6 Pencil or pencil and ink on blue, some with white chalk, 'French rivers'
 CCLX 1–136
 CCLXI 1–128
 CCLXII 1–21 (large)

7 Watercolours connected with the Meuse–Moselle–Rhine tour, and others, about 1834
 CCXCII 1–80, mostly on grey paper

In addition some hundreds of grey and blue paper pencil drawings are catalogued under 'Miscellaneous' 1830–1841: sections CCCXLI and CCCXLIII, with CCCXLII on brown paper.

Meuse–Moselle, 1826?

The pencil sketchbooks of Turner's first tour of
the Meuse and the Moselle are dated 1826
(see pp. 34–5). It was about this time that he
began to work with body-colour on tinted paper.
It may seem an obvious and simple technique,
but there is plenty of evidence that he took many
years to evolve it, or adapt it to his needs.
Watercolours on tinted, or more often previously
colour-washed, paper are found in his sketchbooks
as early as 1796. In the Rhine watercolours of
1817 and the Rome ones of 1819 he used
watercolour in varying degrees of opacity. Now
he adopted the continental gouache technique.
He applied semi-transparent washes here and
there, but built up the design in true opaque
colours.

He may have acquired some new pigments.
Body-colour or gouache is watercolour with clay
added. Simply adding white to the colours does
produce body-colour, but the effect is pale and
chalky.

Using body-colour on a tinted ground is not
easy – or rather it is too easy: without great
dexterity and presence of mind, clarity of
conception, judgment – in short, without the
skill of a master – it can quickly result in
meretricious and inaccurate effects. The effort to
correct and modify such effects, without skill,
can lead to accretions of chalky sludge.

When working with transparent colours,
Turner's method, as we know, was free. 'He has
no settled process but drives the colours about
until he has expressed the idea in his mind,'
wrote the careful Farington in 1799. He relied
heavily on blotting and scraping. His early
watercolour sketches are frequently spontaneous
in effect, because he was working quickly and
instinctively in the medium which had become
habitual. Not so his 'finished', more composed
watercolours for the gallery and the engraver:
these avoid a laboured effect (usually) only
because of his superb technique – the art which
conceals nothing.

Turner's slowness in adopting pure gouache is
understandable. He had started from the opposite
manner, and he would need a very light touch.
That he achieved this no one will deny. The
advantages of gouache were considerable: he
could avoid wasting time in building up tones,
and the background colour had a unifying, often
an atmospheric, effect. Blue, the colour of
distance, was a very practical choice in preparing
work for engraved illustrations, because it
corresponded to (and was interpreted by the
engraver to mean) the warp of horizontal lines
which support the engraved design. Turner
could establish the broad masses and the mood

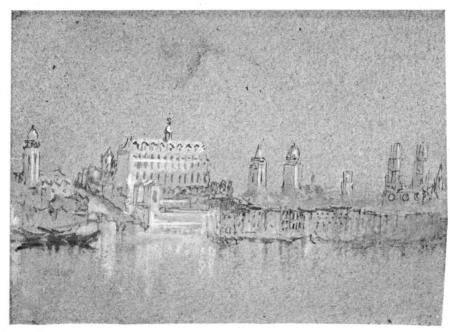

CCXX-R

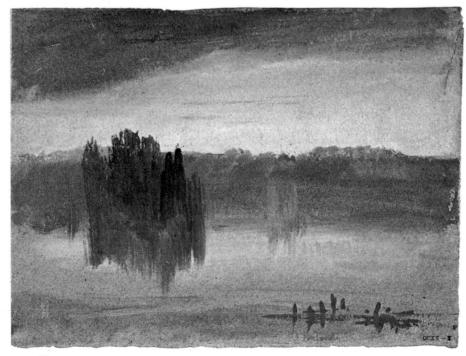

CCXX-X

of the landscape to his satisfaction, then, if he needed to, could work into the composition with light and dark to the degree of detail required for the engraving. He evolved a similar method with oil paintings, as explained on p. 14.

He used a soft quill pen for adding details in black (now brown) ink, but, I think, gave this up in favour of a fine brush. There are several technical reasons for avoiding penwork over gouache. Where he used the pen I have noted the fact under the drawing.

Further comment would be superfluous. You will note and admire as I do his versatility and resoucefulness with the medium. His object is to illustrate a book or books, but he succeeds in inventing a Germanic fairyland.

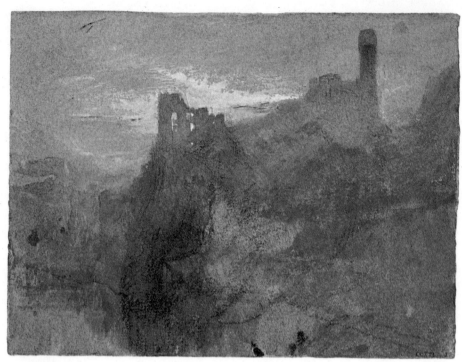

ccxxi-I Belstein?
'Such things *are*, though you mayn't believe it' – Ruskin

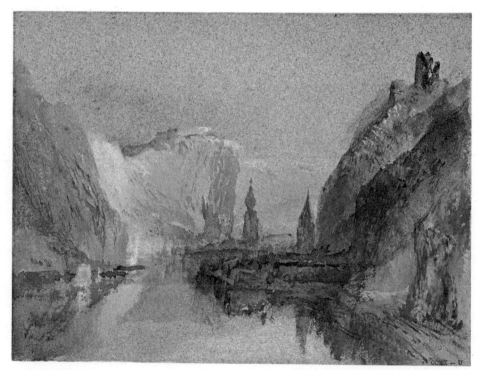

ccxx-U Dinant

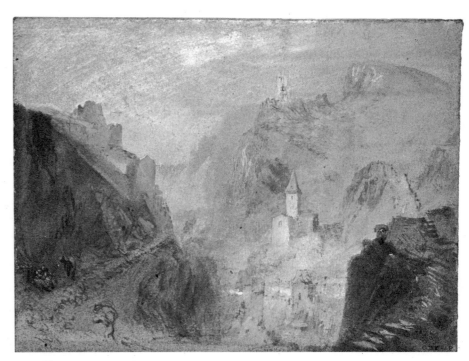

ccxx-P

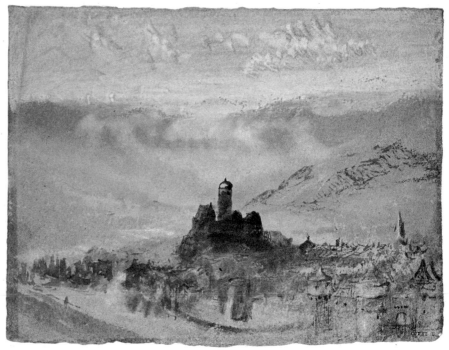

ccxxi-U

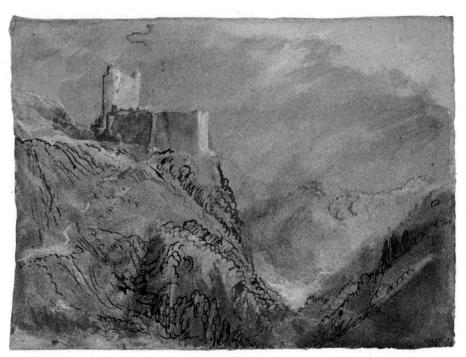

CCXXII-J (with pen and ink)

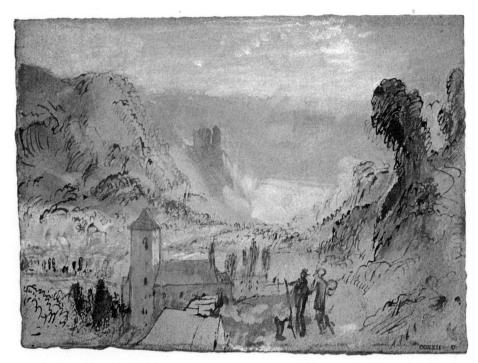

CCXXII-U (with pen and ink)

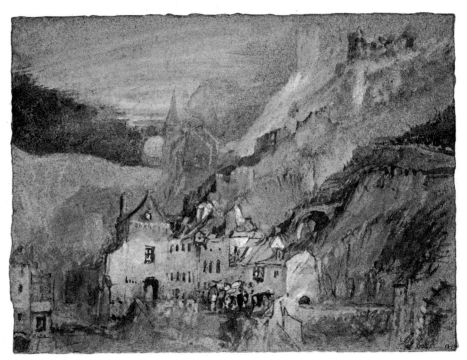

ccxxi-G Bacharach

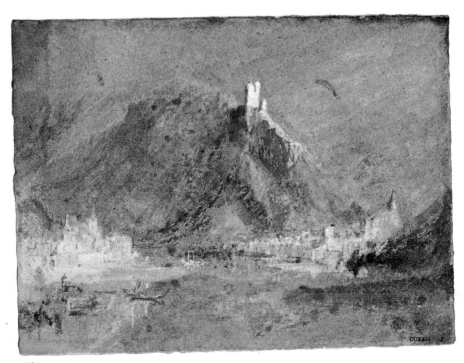

ccxxii-P

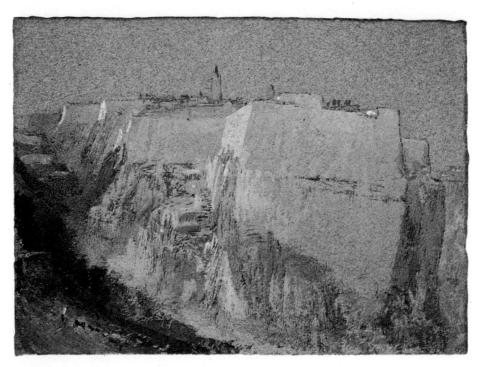

CCXXI-O Luxemburg
'Probably the grandest drawing of this date' – Ruskin

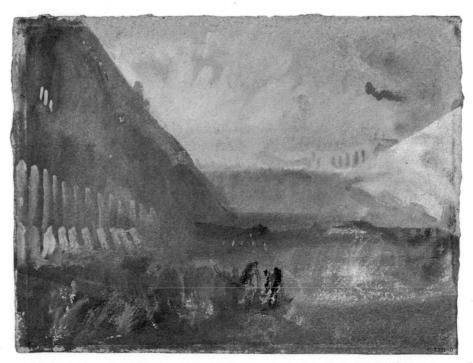

CCXXII-O

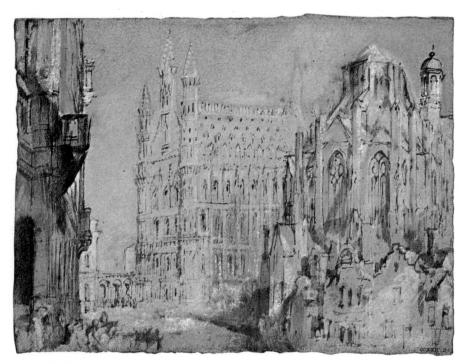

CCXXII-D Louvain

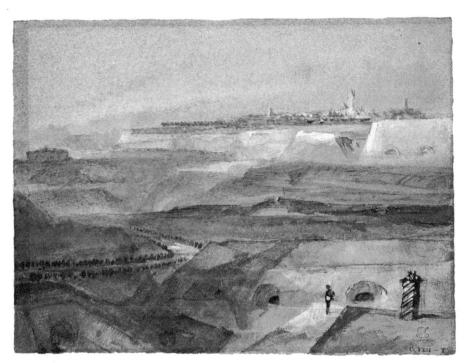

CCXXII-Y

'French Rivers' drawings

Turner's work on the Loire and the Seine and in Paris appears to have begun in the early 1820s with sketches concentrating on the life of the people and the distinctive character of local building (but not ignoring the grandeur of Gothic churches – that is a constant theme). His sketches on blue paper were mostly in monochrome – pencil, ink and white chalk.

Later, around 1830, working for the definite publication of the *Annual Tours*, he alters his approach. The peasants with their funny costumes and houses almost disappear and Turner takes a wide, lofty and poetic view of French river scenery. This is the mood of the pictures engraved for Leitch Ritchie's wordy 'Wanderings' (the books were only Turner's 'Annual Tours' by courtesy of an extra, engraved title page).

Two of the 'worked up' drawings are reproduced on p. 93, facing the resultant engravings. The artist's use of powerful colour for the originals of black-and-white engravings is interesting. He is now far away from the ochre-brown-blue scheme of his designs for vignettes. I am sure that his intention was at least partly to stimulate the engraver to the use of his richest textures. But also, of course, he was working out pictorial ideas for later use, as in the *Quilleboeuf* painting, exhibited in 1833, which is virtually the same composition as the illustration in *Turner's Annual Tour – the Seine*.

The rest of the drawings are in the primary form – perfectly satisfying. But even the finished engravings were criticised in their time, and long after, as – inaccurate.

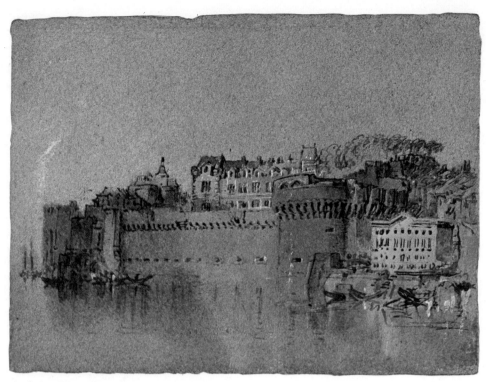

Amboise (Fitzwilliam Museum, Cambridge)

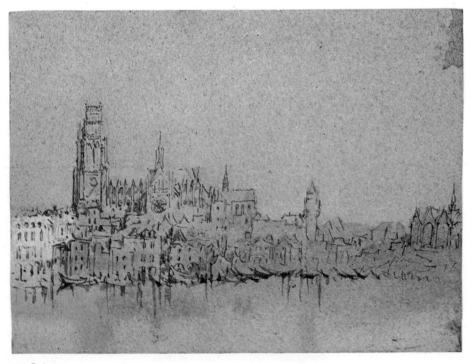

71 Orleans

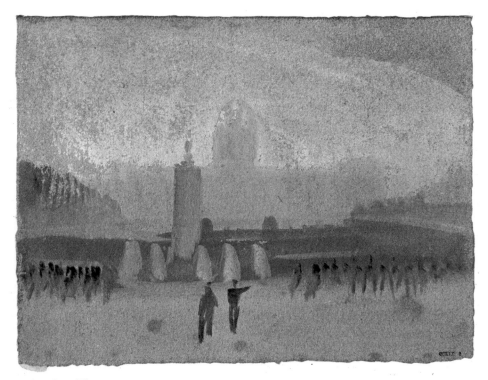

7 Aux Invalides

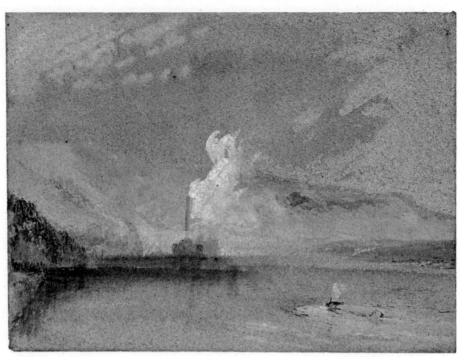

81 Shoal on the Seine

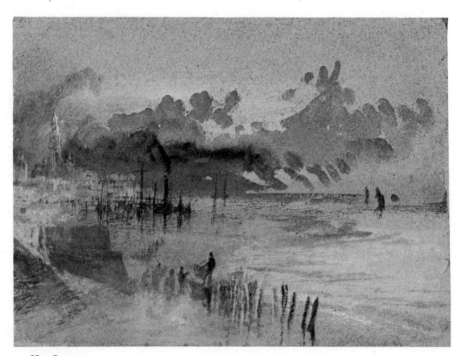

75 Honfleur

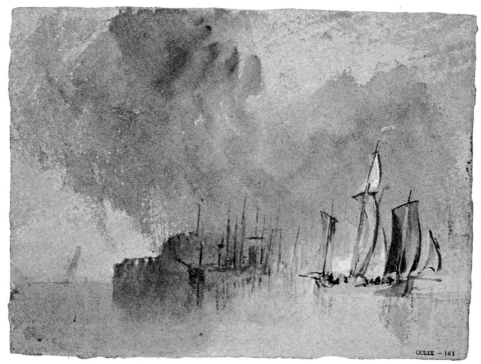

161 Le Havre?

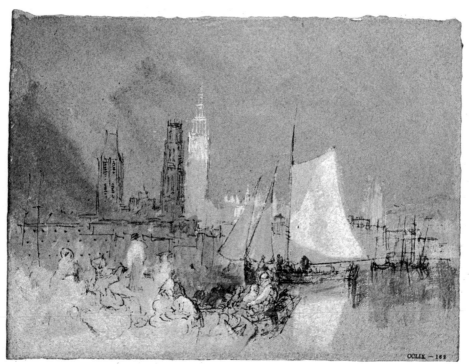

162 Rouen

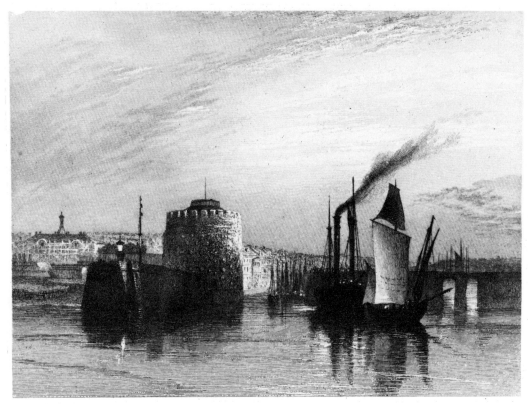

engraved 1834

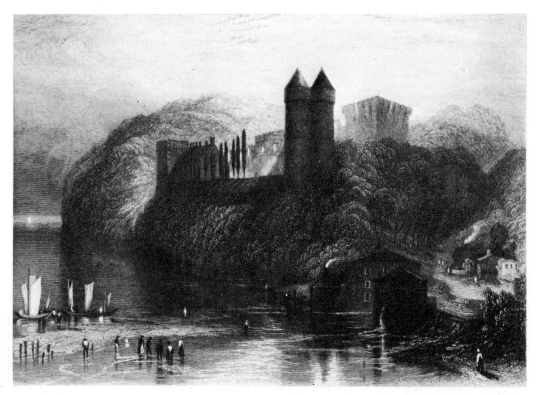

engraved 1834 actual size

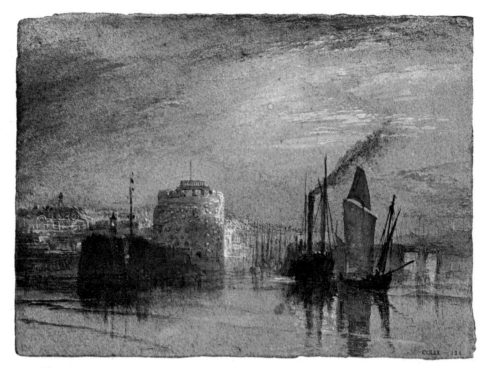

134 Havre

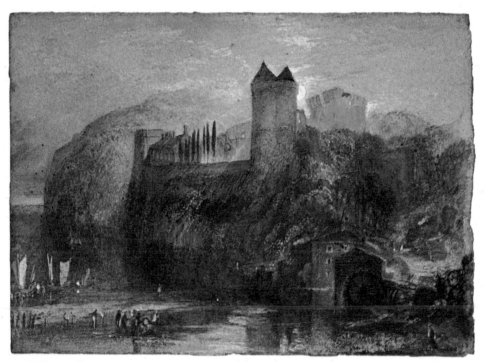

128 Tancarville
working drawings, about two-thirds actual size, for the engravings opposite

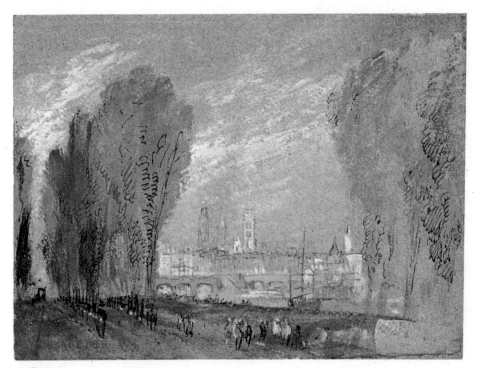

90 Rouen

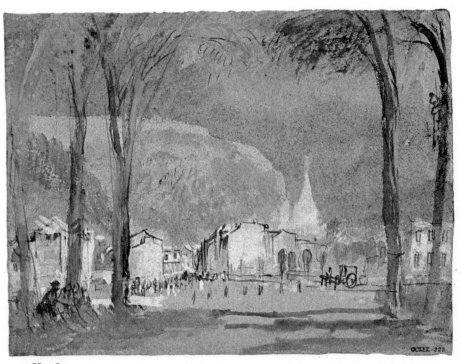

223 Honfleur

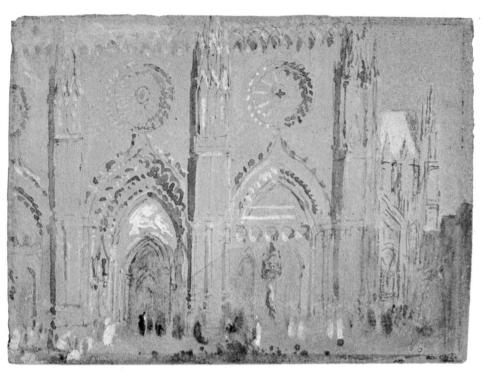

260 Rouen Cathedral

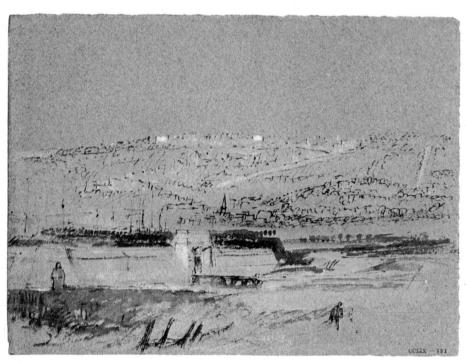

181

Meuse–Moselle–Rhine, 1834?

It is not certain that these drawings belong to the later tour, only that they are, as a group, nearer to purely expressive landscape and further from topographical illustration than the others. Here he was working out some of the brilliant colour schemes which are typical of his later paintings.

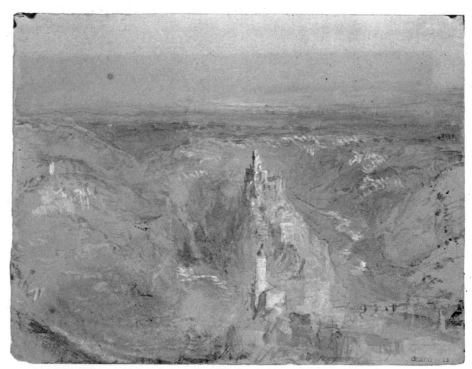

13 'Schloss Eltz?'

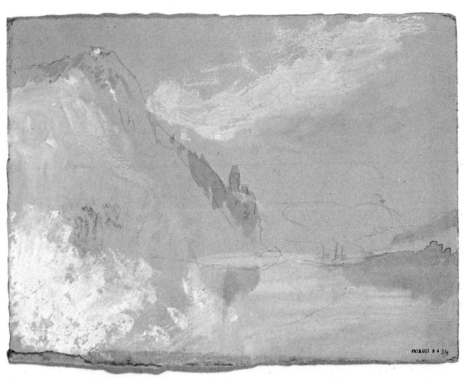

24 'Castle beside a river'

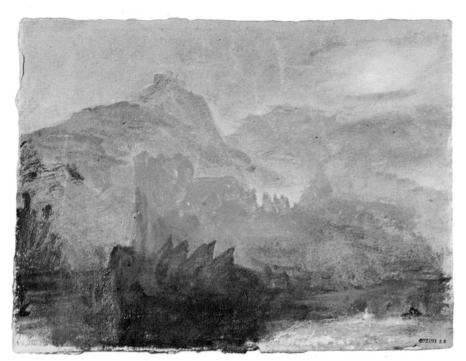

30 'Red ruins & blue rocks'

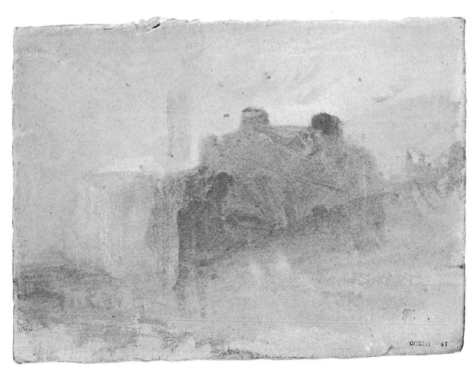

67 'Crimson fortress'

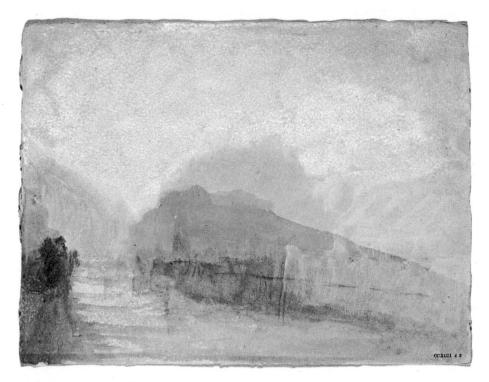

43 'Italian lake scene?'

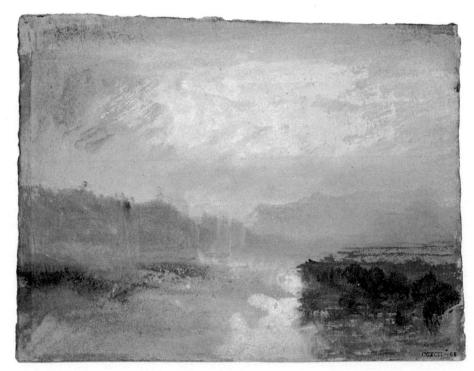

68 'River scene'

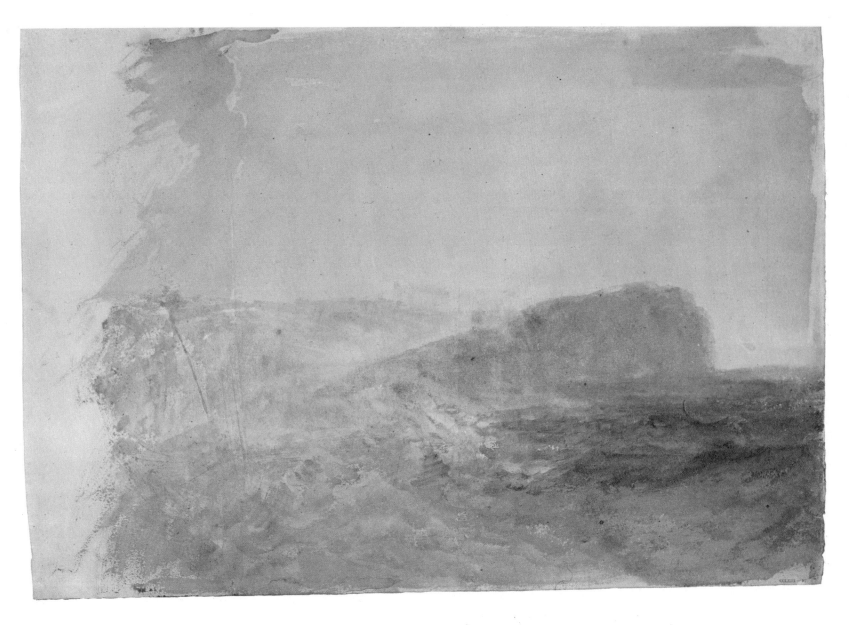

The 'Colour Beginnings', CCLXIII

27 'Rocky headland' 16½ × 19½ inches 419 × 492 mm

The placing of the shadowed cliff over the dark
sea corresponds to the composition of *Scarborough*
(*Ports of England*, 1826) but the highly finished
drawing for the engraving (Turner Bequest
CCVIII – I) is only 9 inches wide, against the 19
of this example. Still, I think this is a study for,
or after, the *Ports* drawing. Another sketch is on
p. 24 of this book.

Under the heading of 'Colour Beginnings', Finberg placed 390
unfinished watercolours on odd pieces of paper. He dated them
roughly between 1820 and 1830 on evidence of style, mood and
subject; with a few exceptions there is no reason to dispute this. A
smaller group he dated 1802–20 (CXCVI and CXCVII).

He found the drawings in various parcels marked, presumably by
Ruskin, 'Colour effects. Valueless; Colour effects. Finer; Colour
dashes on white. Valueless; Colour on white. Beginnings. Of interest;
Colour on white. Larger and later &c.'

The name 'beginning' has a source in Turner's words pencilled on
an abandoned watercolour: *Beginning for Dear Fawkes of Farnley*
(*The Sketches of Turner, R.A.*, p. 16). Finberg amplified the term as

'colour structures', and this has been taken up by Jack Lindsay; but it no better describes the various watercolours, few of which are merely structured. Most of them are clearly ends in themselves – though of potential use in more complex works: they are ideas, thoughts, observations, experiments – and sometimes they are 'beginnings', given up for one reason or another.

All artists produce rough ideas on scraps of paper that happen to be handy, and the results are more often than not attractive. The creative impulse combined with the unconsidered use of materials, free of any constraint, provides the ideal conditions; work is as instinctive as play. Turner was perhaps the first artist to value such pieces, or, it might be better to say, avoid destroying them, for he kept everything else as well. Today, of course, an artist will apply different criteria and be careful to destroy any work, rough or elaborate, that does not fit in with his conception of his own larger purposes. There is no evidence that Turner (who, said Wilensky, had no taste) was ever troubled by such doubts. He even collected his own earlier works, buying them back at sales for more than he had been paid in the first place.

The comparison with a modern artist is apt, however. These colour sketches are quite dateless. They often look as if they had been done in this century instead of the last – sometimes as if they were done yesterday. This timelessness is partly due to the lack of 'clues' – almost all the subjects are natural effects, and architectural elements are usually left vague, figures nearly absent. The style too is free from contemporary mannerisms, yet embraces many manners, from the naturalistic to the heroic, verging here and there on the decorative, plunging elsewhere into great intensity of expression.

These colour sketches are of Turner's favourite themes in isolation, his daydreams, divorced from practical purpose (usually) at the point of their creation, but not, of course, inapplicable to various branches of his picture making. Of the first 300, Finberg could give names to less than 30: of the last 90 several are false starts on identifiable subjects, eight are still life studies and one is the *Sketch from memory* Turner exhibited at the Academy: *Funeral of Sir Thomas Lawrence PRA* (p. 47).

This last is the largest of the sketches, on a full Imperial sheet. The smallest is the 'Study of sea and sky', no. 314, eight and a half

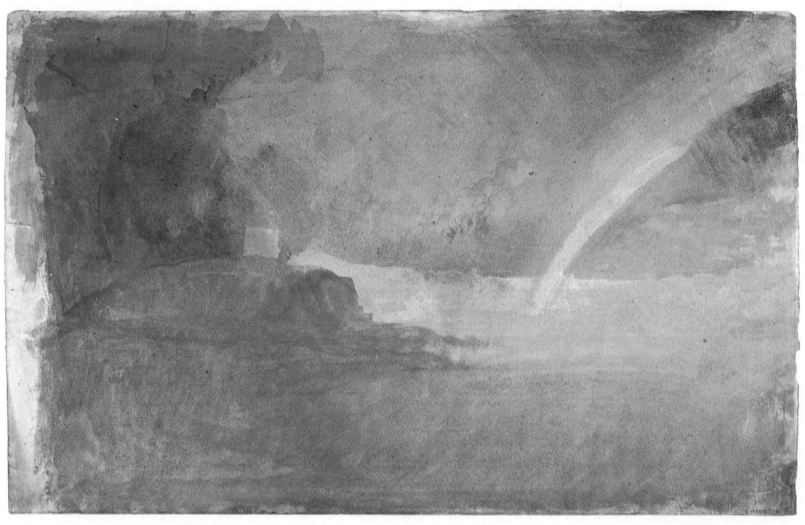

150 'Tower on hill, with rainbow' 12 × 19 305 × 480 mm

inches wide, and this faces one of the larger examples in this selection, no. 41 (pp. 138–9). I have reduced the smaller drawings only slightly, and made the largest ones as wide as possible on the page, keeping the rest in proportion as nearly as possible.

The titles are Finberg's when inside quotation marks, mine when not. Titles for sketches are trite unless supplied by the artist. But we must use the existing titles where they are not misleading. The main thing is to remember that they are not Turner's. The dates of watermarks are indicated by the initials WM.

The numbers of the drawings are quite irrelevant. For ease of reference I have grouped my selection according to what I feel is the main subject in each case:

Shadows, when the shape of a shadow seems to have been
 Turner's main interest pages 102–5
Planes of colour 106–10
Places, when the sense of place seems to override other
 content 111–19
Mountains 120–2
Ships 123–4
The shore 125–30
The elements 131–9
Sunrise and sunset
Moonlight } 140–55
Reflections 156–7
Clouds 158–9
Compositions 159–60

Several favourite pieces were not available at the time of production, but these no doubt will appear in various catalogues of Bicentenary exhibitions.

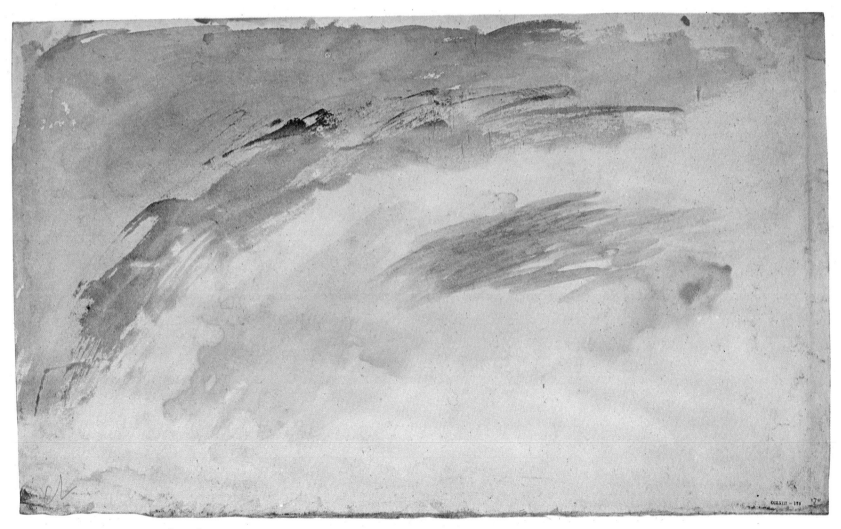

170 'Crimson clouds' $11\frac{3}{4} \times 19\frac{1}{2}$ 298 × 490 mm

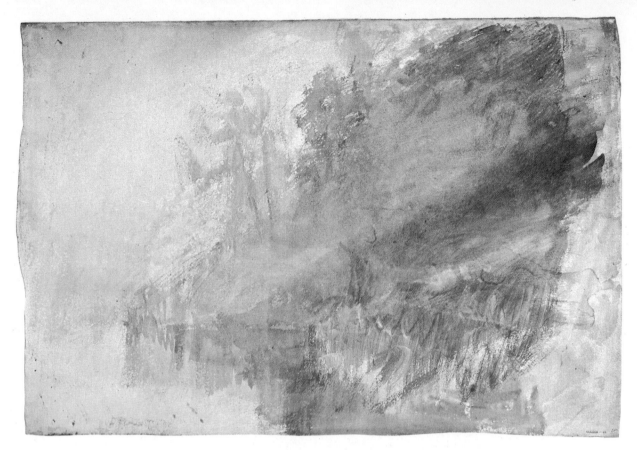

35 'Wooded river banks' $13\frac{3}{4} \times 18$ 349×457 mm. Finberg says: 'cf no 14', which is below.

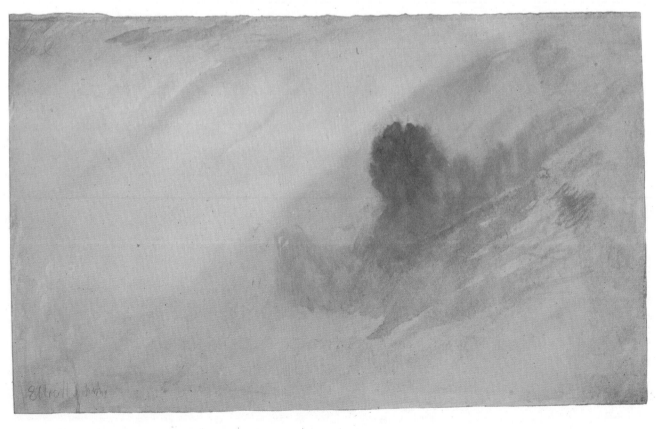

14 'Landscape with trees; stormy effect' $11\frac{3}{4} \times 19\frac{1}{2}$ 298×492 mm *Elliott's paper*

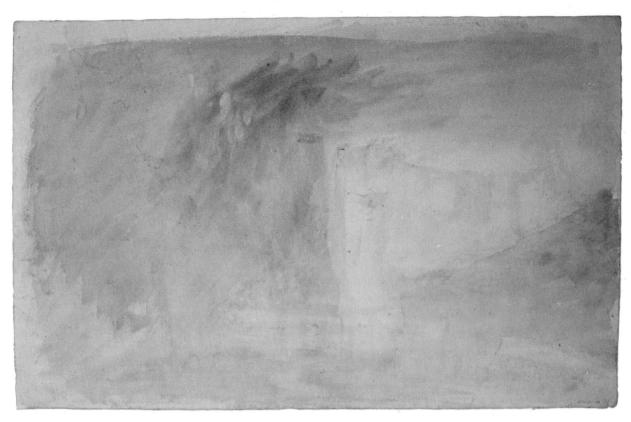

89 'Sunlight on ruins' 12 × 19 305 × 482 mm

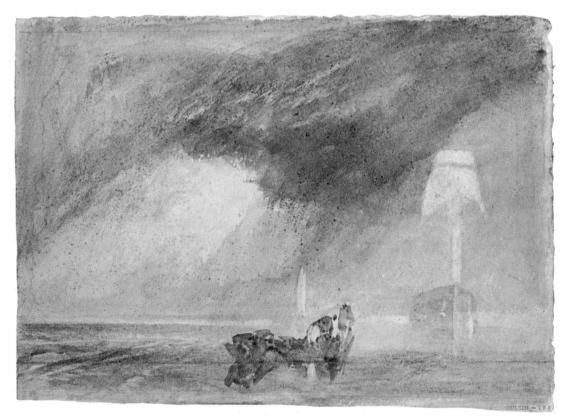

198 'Sail in golden light' 6¾ × 9½ 172 × 246 mm

The coppery colouring as well as its size relate this drawing to the mezzotint series, *Rivers and Ports of England*. In these drawings Turner used fairly conventional colour but used it constructively to aid the engraver. The dramatic, rather inexplicable lighting is clearly the main theme – it might almost be a stage set for *The Flying Dutchman*.

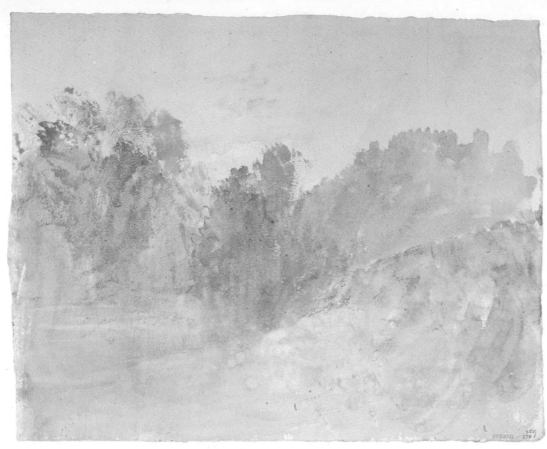

Turner frequently explored in sketches the theme of a leaf-shadowed patch of water, presumably on a river. As a fisherman he would appreciate such places. See 'Silent pool', a sketch for a *Liber Studiorum* subject (*The Sketches of Turner, R.A.*, p. 118). *Ivy Bridge Mill, Devonshire*, 1812, was a pleasantly informal oil painting using the same thought. The addition of a castle was perhaps an attempt to give currency to the rather shapeless, but valid, idea.

229 'Wooded landscape with castle on the right' $7\frac{5}{8} \times 9\frac{3}{4}$ 194 × 248 mm

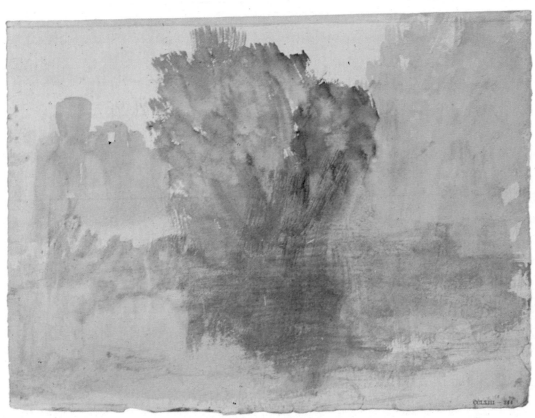

284 'Trees by water' $6\frac{3}{4} \times 9\frac{1}{2}$ 171 × 242 mm

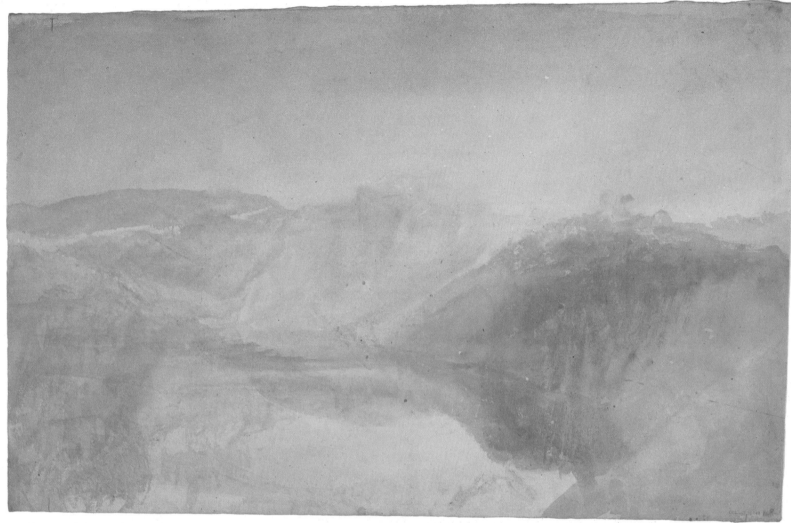

148 'River with high banks' $11\frac{1}{2} \times 18$ 292×457 mm

Finberg's titles are very misleading, though one can see his difficulties. The drawing above is remarkably similar to a late watercolour of Lake Lucerne with a steamboat. The faint pencil outlines on the skyline do perhaps indicate a smaller scale than Switzerland's, but the colouring is of the 1830s.

The drawing on the right, were it not for the watermark, would suggest the Rhine of 1817, rather than the lake of Finberg's title.

237 'Lake with mountains' $5\frac{3}{4} \times 9\frac{3}{8}$ 146×238 mm WM 1819

223 'River with steep and wooded banks' $7\frac{1}{4} \times 10\frac{3}{4}$ 184×273 mm

This is very like *Berry Pomeroy Castle*, which was
painted in monochrome for the *Liber Studiorum*.
The colour is not inconsistent with that period
(1813), but it would fit better into the 1820s.

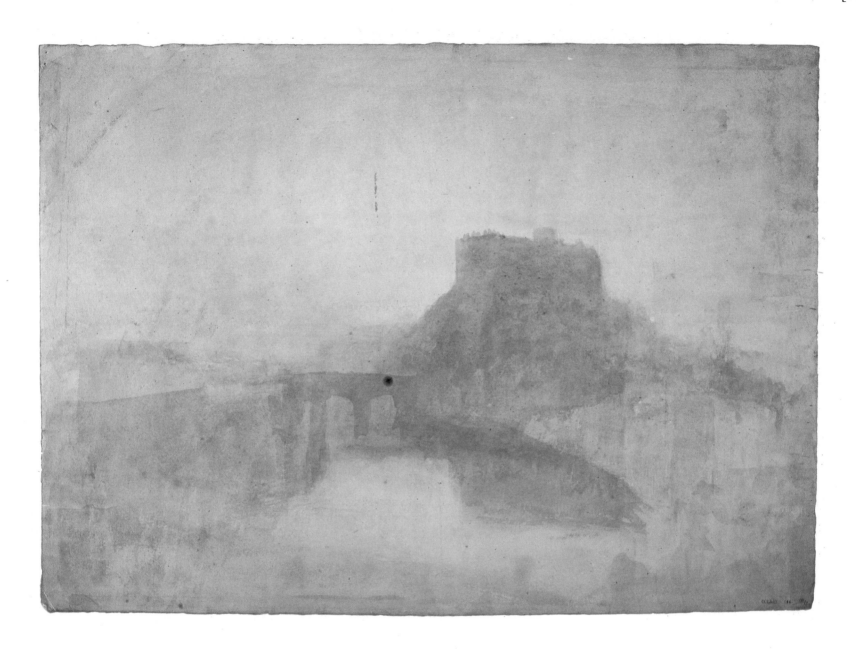

184 'Grey castle' $13\frac{3}{4} \times 18\frac{1}{2}$ 350×470 mm

Exactly like part of the *Durham Cathedral* composition for *England and Wales*. The engraving is reproduced here. In this 'Grey castle' drawing – it is purple, not grey – the light source has been moved behind the Castle. The castle-and-bridge arrangement became almost a cliché in the Meuse and Moselle drawings, of which I assume this Durham Castle experiment was an early precursor.

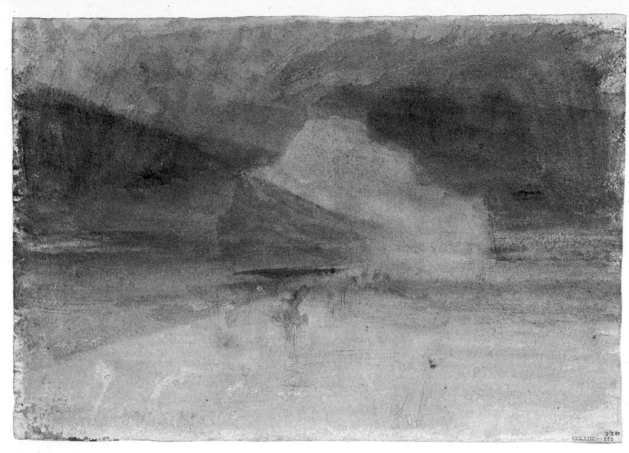

220

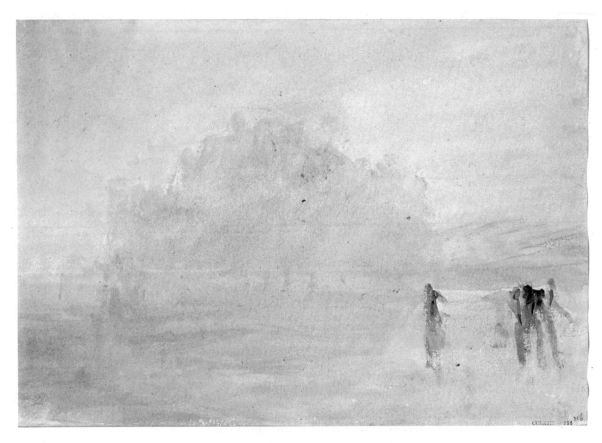

256

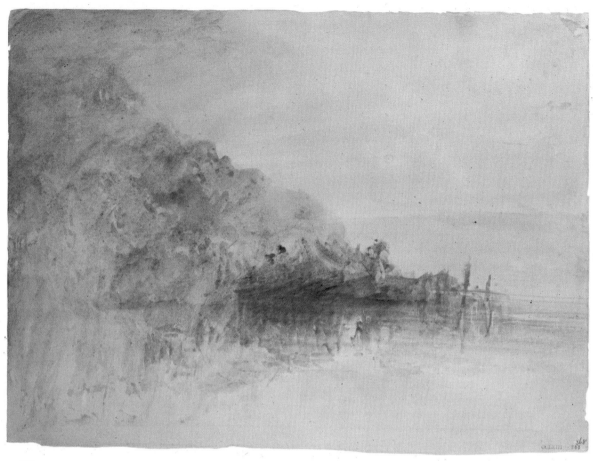

268

220 'Castle on rock from the sands' $7\frac{1}{4} \times 10\frac{1}{2}$ 184×267 mm

256 'On the sands' $7 \times 10\frac{1}{8}$ 178×256 mm

Turner was familiar with both St Michael's Mount (1811, 1838) and Mt St Michel (about 1827).

268 'Lake Lucerne?' $7\frac{3}{4} \times 10\frac{1}{2}$ 197×268 mm

A watercolour of *Lake of Lucerne, from the landing place at Fluelon looking towards Bauen and Toll's Chapel, Switzerland* was exhibited in 1815, and bought by Walter Fawkes. Finberg would be familiar with that drawing. The colour of this sketch, however, is not of 1815. Turner next visited Lucerne in 1841.

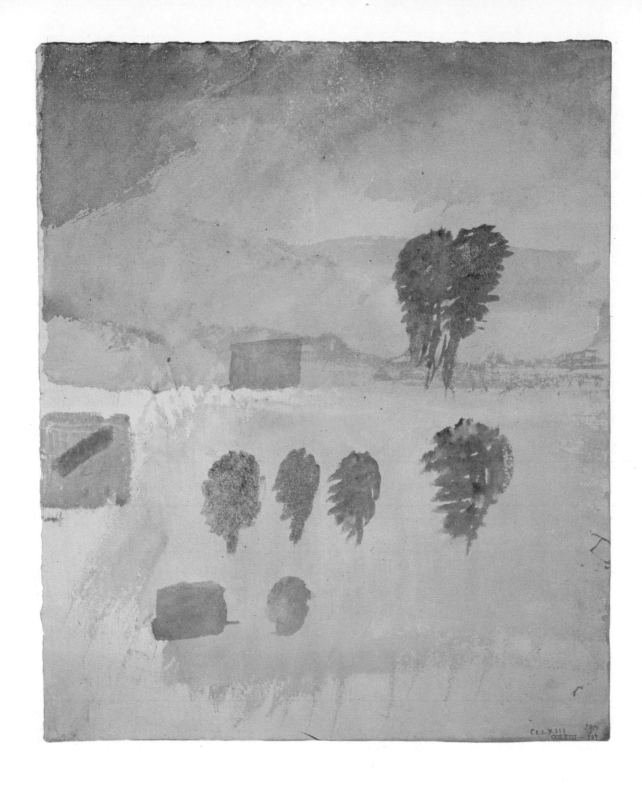

297 'Experiment with trees' 10 × 8½ 254 × 216 mm

Finberg's title would translate well into German, as the inscription under a Paul Klee. Another title of Finberg's is quoted by Christian Geelhaar in his *Paul Klee and the Bauhaus* where the author shows that Klee comes close to Turner in such watercolours as *The Pink Sky*. I think the connection is tenuous, and if Turner had not been given these spurious titles no one would have thought of it.

This is not an experiment with trees at all. As in the *Durham* sketch (frontispiece) Turner has simply used the lower half of the paper as a testing area. If we cover this up we have a somewhat trite little landscape in very clear, sweet colours. The way the washes are economically overlaid is interesting. This drawing might have been a demonstration for a pupil; but Turner is not known to have done any individual teaching in the time of his maturity.

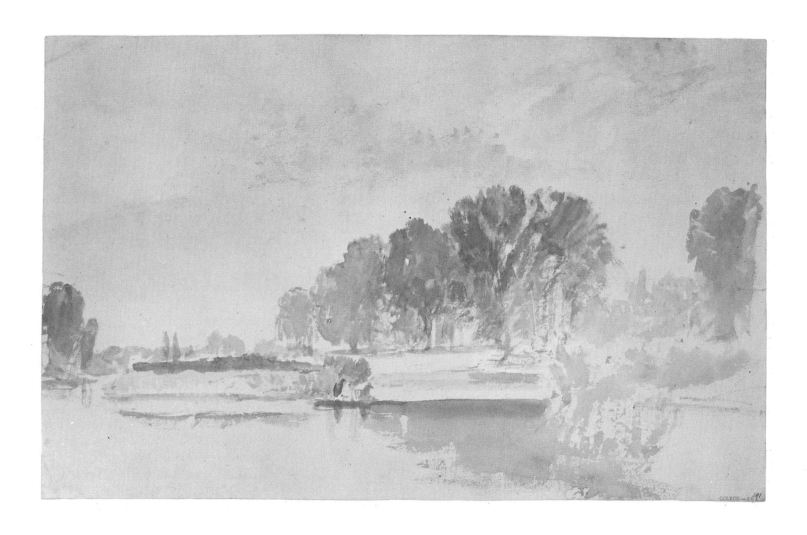

201 'River scene' $9 \times 14\frac{5}{16}$ 228×365 mm

Almost certainly from the Thames 1806–7
period: in fact the width of the paper agrees
with that of the colour sketchbook XCV *Thames,
Reading to Walton* (*The Sketches of Turner, R.A.*,
p. 75). But the paper has been folded and
Finberg identifies it as 'notepaper'. The colours
are right for a 'beginning' of this period, and so
are the fairly expansive view, the affectionate
rendering of elms, reeds and fishermen, the
distances closed by tall poplars or grey buildings.

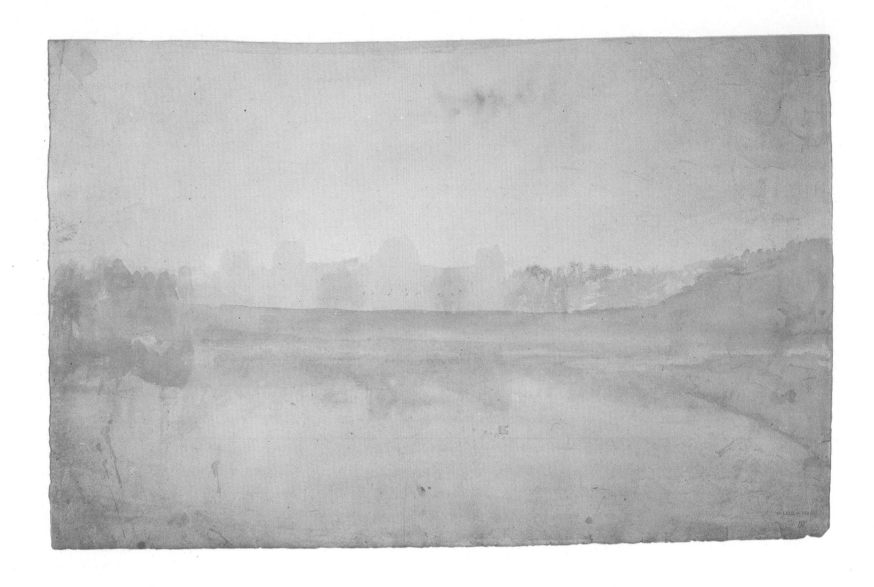

188 'Hampton Court?' $10\frac{1}{2} \times 17$ 267×430 mm

A 'beginning' – rather a promising one, I should
have thought, but perhaps Turner decided it was
too symmetrical?

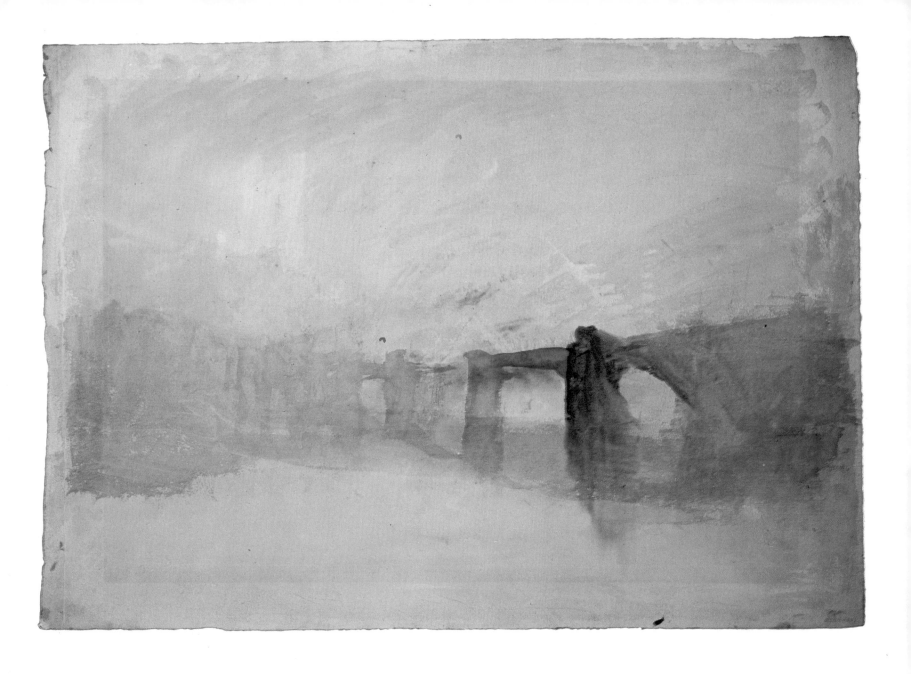

351 'A bridge, sunset' $13\frac{3}{4} \times 20$ 350×510 mm

The colossal power of the treatment of the bridge
is reflected in the 'Rocky Bay' oil sketch (right),
dated 1828–30, in the Tate Gallery. A ghostly,
very tall church tower may be discerned, also a
sickle moon and the geometry of some alto-
cumulus cloud. Perhaps a sense of place is less
important here than the fine, sculptural idea –
though so far expressed in unpleasant colour.

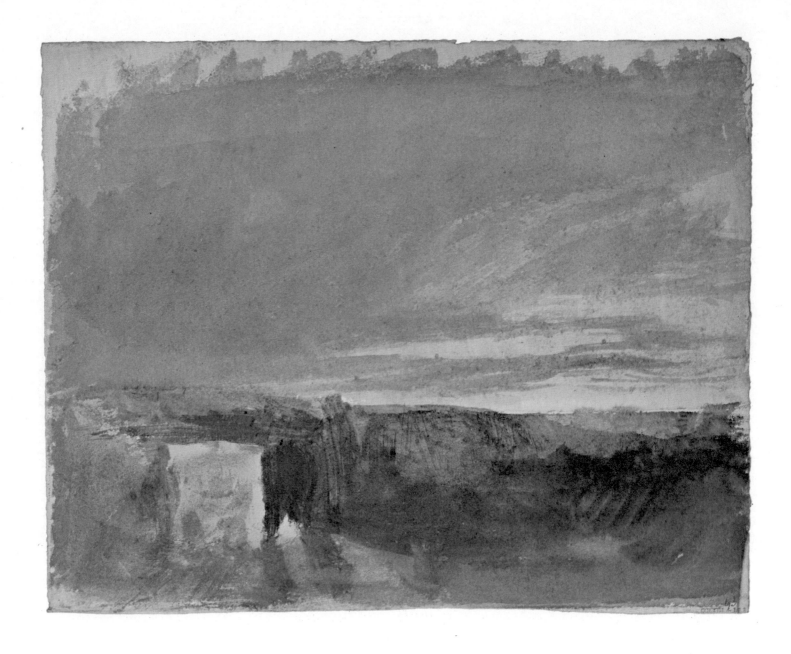

193 'Sunset' 9½×12 242×305 mm

A cold sunset in a lonely place. If that is a gleam
of sea at the right and those are dunes at the
left, the place must be on the northern coast of
France.

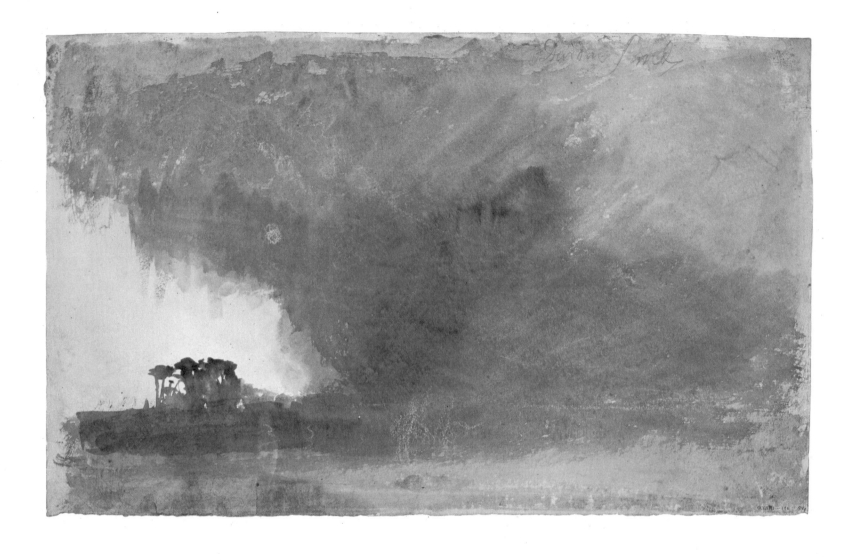

104 *Duddon Sands* $10\frac{3}{4} \times 17\frac{3}{4}$ 273×450 mm

Turner's title, in pencil at the top right.

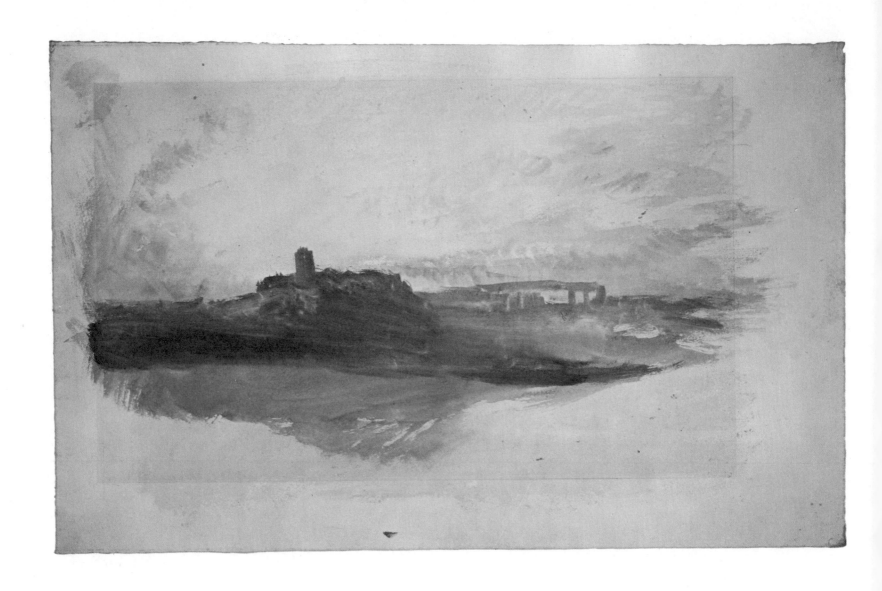

325 'Tower on a hill, sunset' $11\frac{3}{4} \times 19$ 298×480 mm WM 1825

Not much of a hill and not much of a sunset.
This drawing is like, but much larger than, some
of the sketches for vignettes. The marks of
mounting and exposure resulted from a loan
exhibition in the late 19th century.

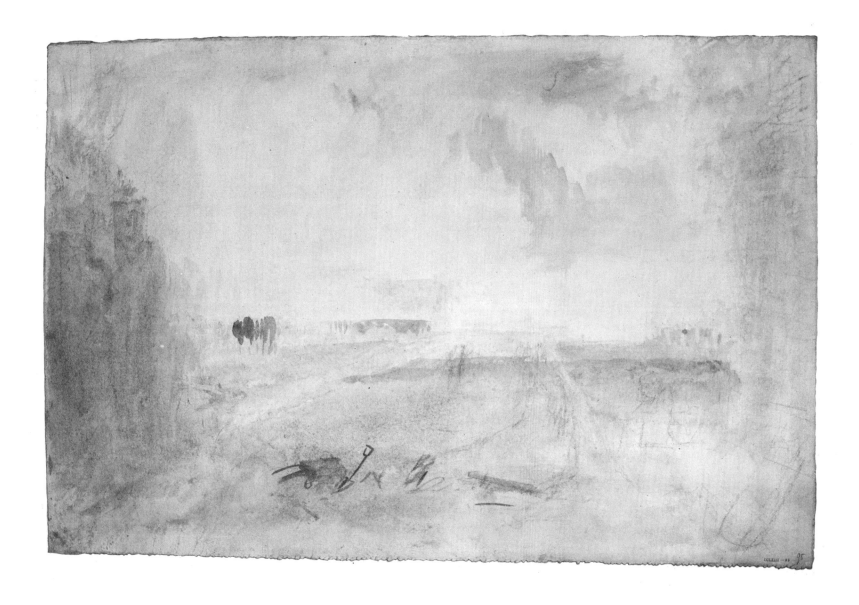

95 'Road leading to cathedral(?) in middle distance' 13 × 19¾ 330 × 475 mm

The 'cathedral' is so near invisible that it can be
discounted. An empty, yet strangely interesting
'beginning'.

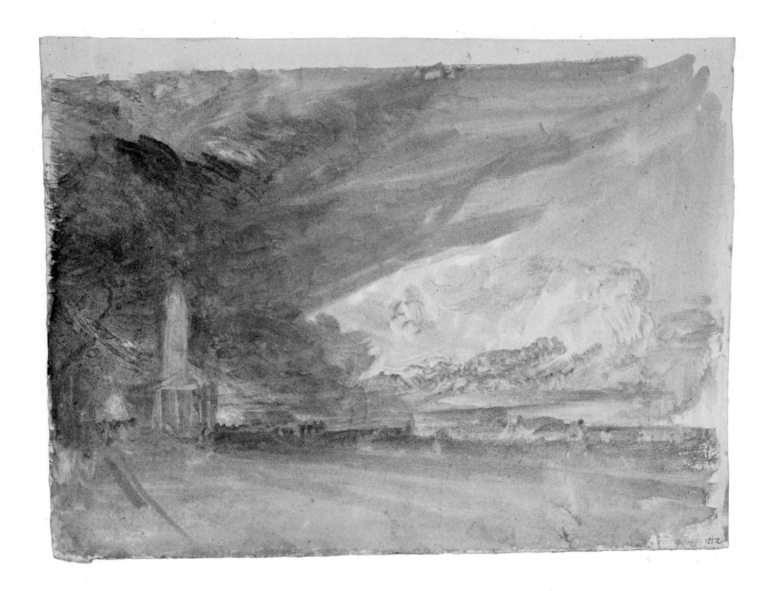

252 'Obelisk' $8\frac{1}{2} \times 11\frac{1}{2}$ 215×290 mm

The tower is obviously attached to a classical
portico and, though disproportionately large,
cannot properly be called an obelisk. The general
layout agrees with looking north to St John's
Wood Church, the open space of Regent's Park
on the right – not that it matters, of course.

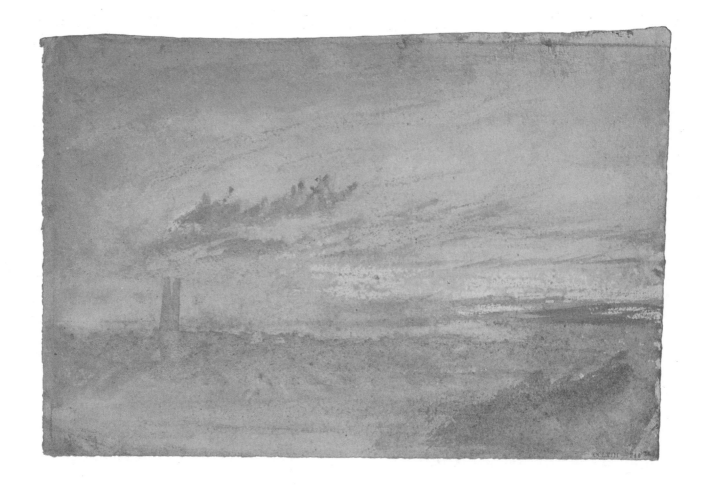

246 'The distant tower: evening' $6\frac{1}{4} \times 9\frac{1}{2}$ 160×240 mm

Turner engraved the same subject in mezzotint in a series of apparently private experiments, which came to be called the 'Little Liber'. This subject has been identified as 'Boston Stump' and as 'Gloucester Cathedral'. It strikes me as a midland town with a parish church. The colours, of evening or early morning, are consistent with a smoky atmosphere.

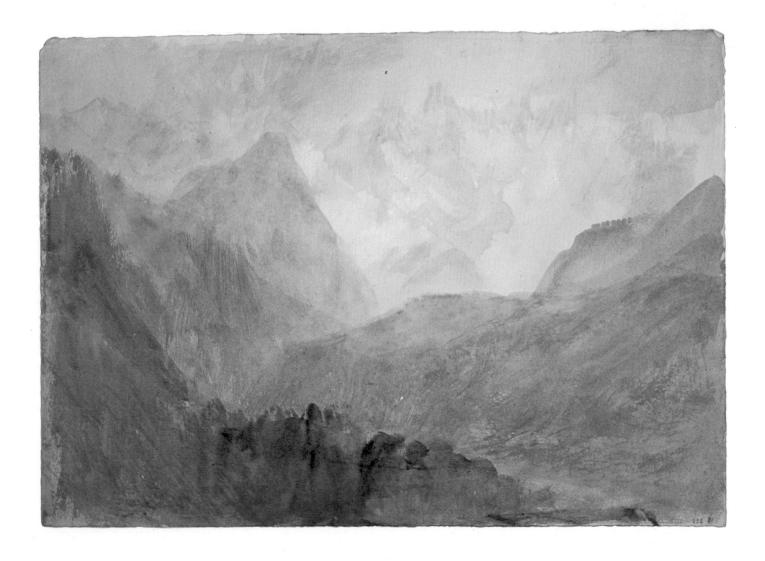

258 'Among the mountains' $7\frac{5}{8} \times 10\frac{7}{8}$ 195 × 275 mm

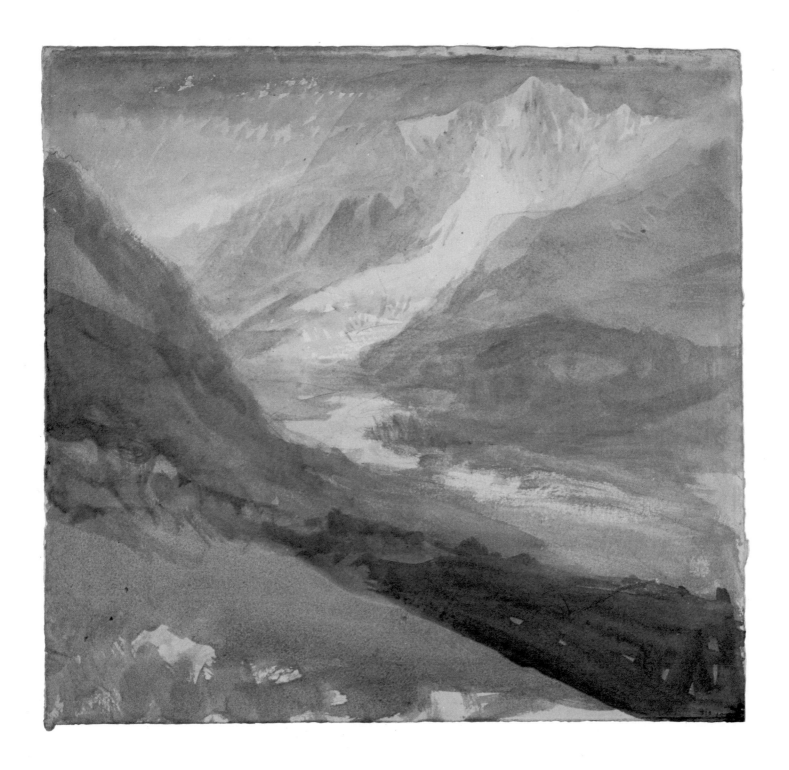

316 'Morteralsch Glacier, Engadine' 10 × 11 255 × 280 mm WM 1827

Finberg's title is a winner this time. The broad
washes give the drawing the character of a
twentieth-century travel poster – Turner in a
very happy mood.

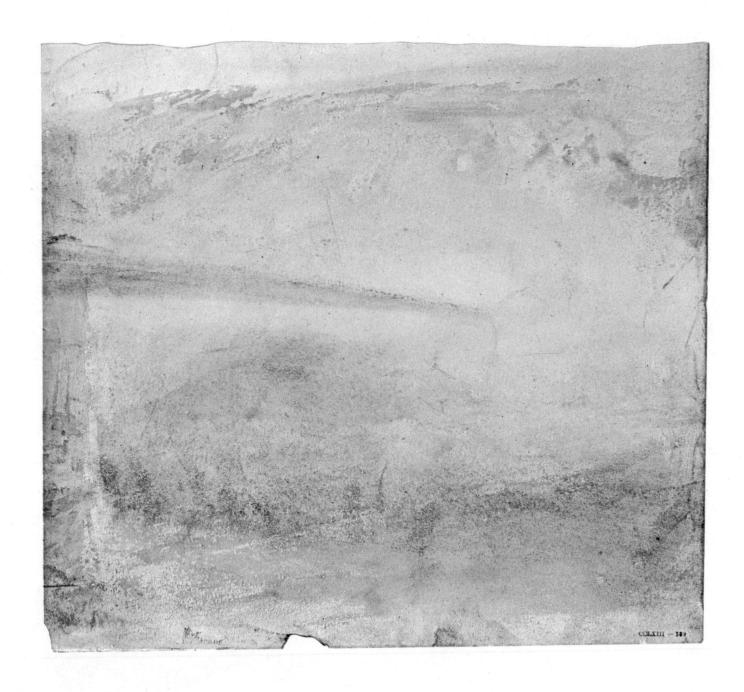

389 'Study of sky' 9 × 10 230 × 255 mm

I think this is a mountain subject: he is recording
an unusual straight line of stratus cloud, such as
can be seen in still, rising air.

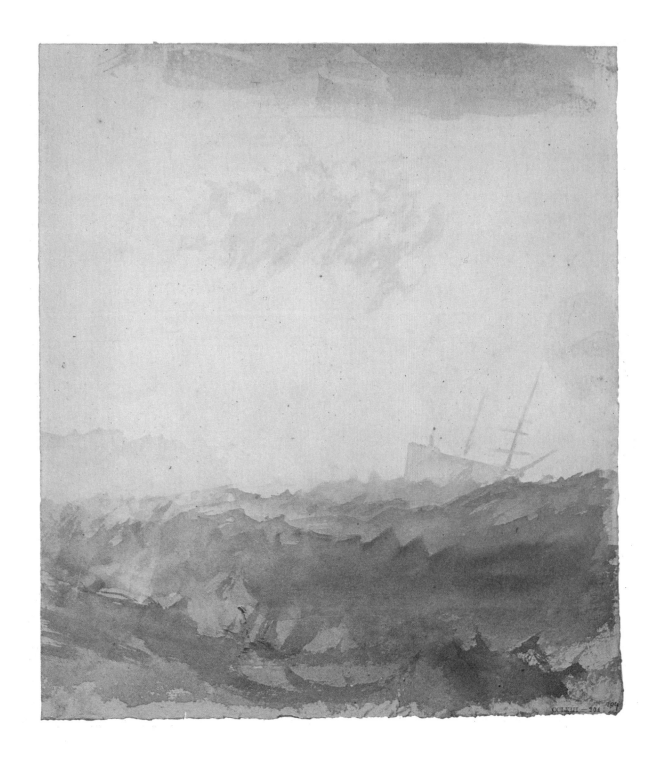

204 'Ship at sea' $9\frac{5}{8} \times 8\frac{1}{2}$ 245 × 215 mm

Untypical proportions and a most untypical
decorative treatment. Among the 'Colour
Beginnings' there are very few ships, considering
they were such a favourite subject. Although the
treatment is mannered, it must be admitted that
the sea and sky are very convincing.

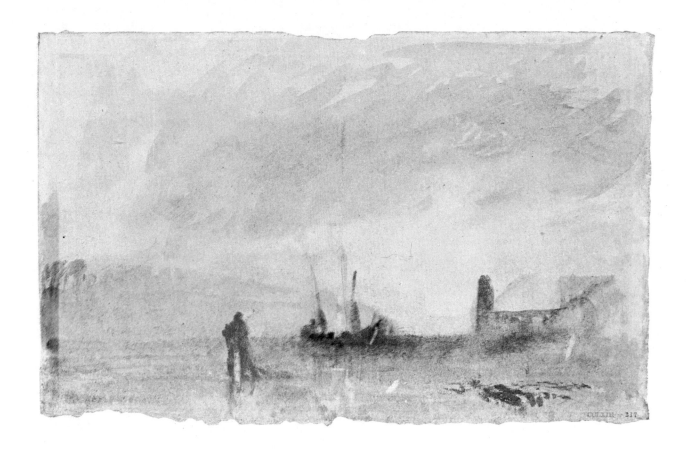

317 'River scene' $5\frac{1}{2} \times 8\frac{3}{4}$ 140 × 222 mm

Again the title suggests something quite different. The composition has classical connotations and is conceived in the primary (Turner's 'primitive') colours, much faded as the edges show. The 'river' may be a bay with an island, or it could be an estuary.

282, 281 Two seascapes $6\frac{1}{2} \times 9\frac{1}{2}$ 165 × 240 mm, approx.

These two drawings are from the same sheet, folded and torn in two. Part of the top of 282 appears at the top of 281, the latter being the more formalised of the two. In this second drawing paste has been added to the watercolour to make it viscous, so that part of the brush does not deposit the full depth of the colour.

There are many examples of this use of thickening paste or gum in Turner's watercolours, back to 1809 or before. The thickening makes the colour behave more like oil paint, just as, conversely, Turner's use of thin media allowed him to use oils somewhat in the manner of watercolour.

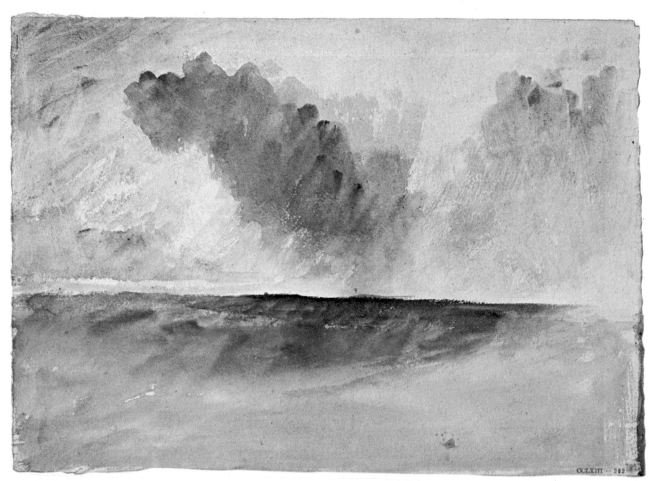

282

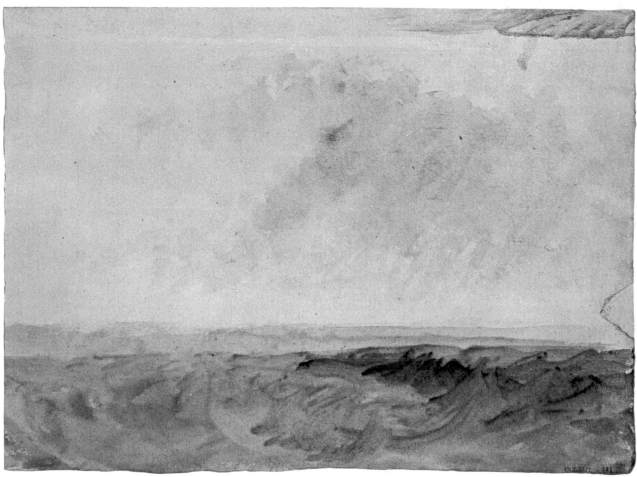

281

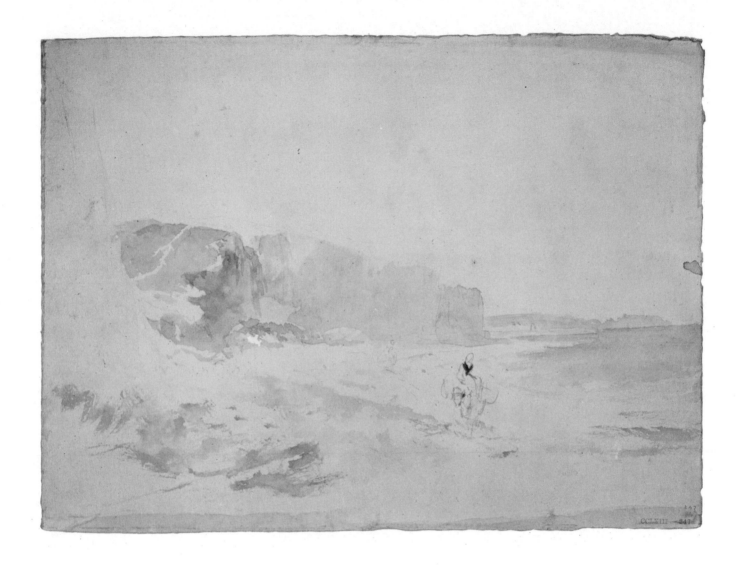

247 'Ride across the sands' $7 \times 8\frac{3}{4}$ 178×222 mm

There is a Turner watercolour somewhere with a similar composition: the cliffs at Scarborough with some women in the foreground – not the pretty figure on horseback here. The handling of the receding cliff line is impressive – perhaps because it is so lightly touched, yet definite.

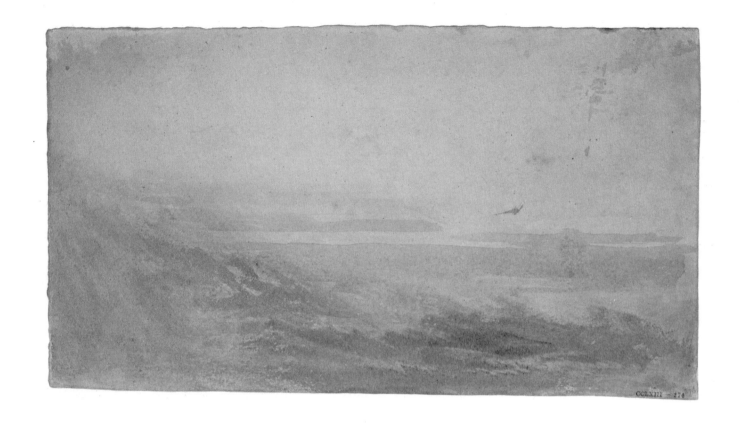

276 'Twilight' $5\frac{1}{8} \times 9\frac{3}{8}$ 130 × 238 mm

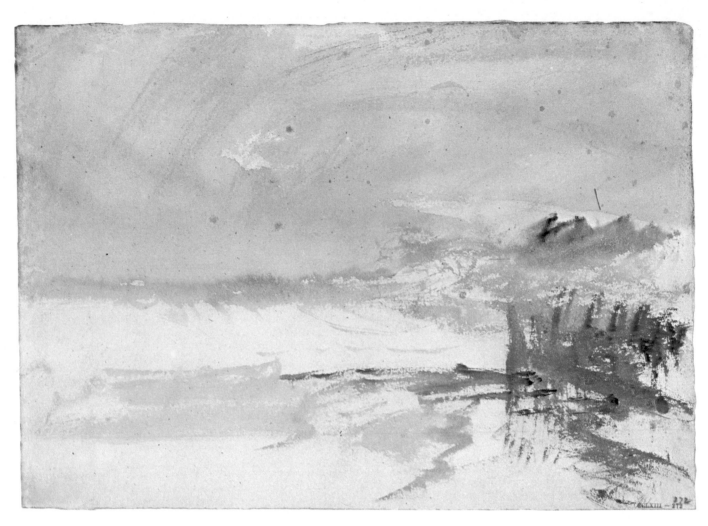

272

272 10¾ inches wide, 273 mm ⎫
275 10½ inches wide, 268 mm ⎬ The shore
273 10½ inches wide, 268 mm ⎭

Nos. 274, 230 and 233 are of the same vein. I
refuse to accept Finberg's titles: 'A stretch of sea'
for instance, is nonsense. These brilliant action
paintings have in common a sub-theme of blots.
It may be that the action began with a few flicks
of a loaded brush, or it may have been an
accident. The game is to join the blots into an
intelligible pattern – it was well played.

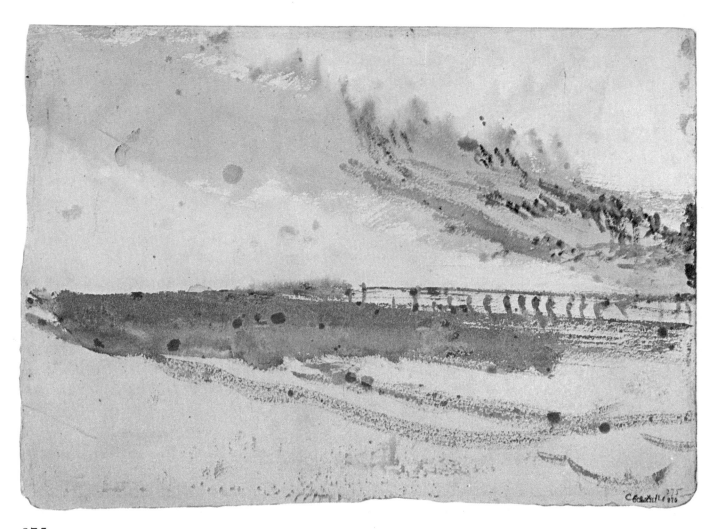

275

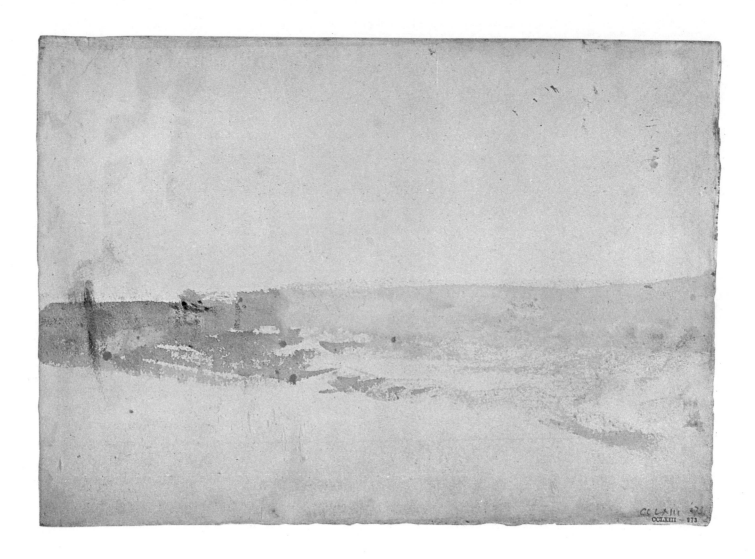

273

The third of the sequence is particularly elegant,
and as nearly abstract as makes no difference.

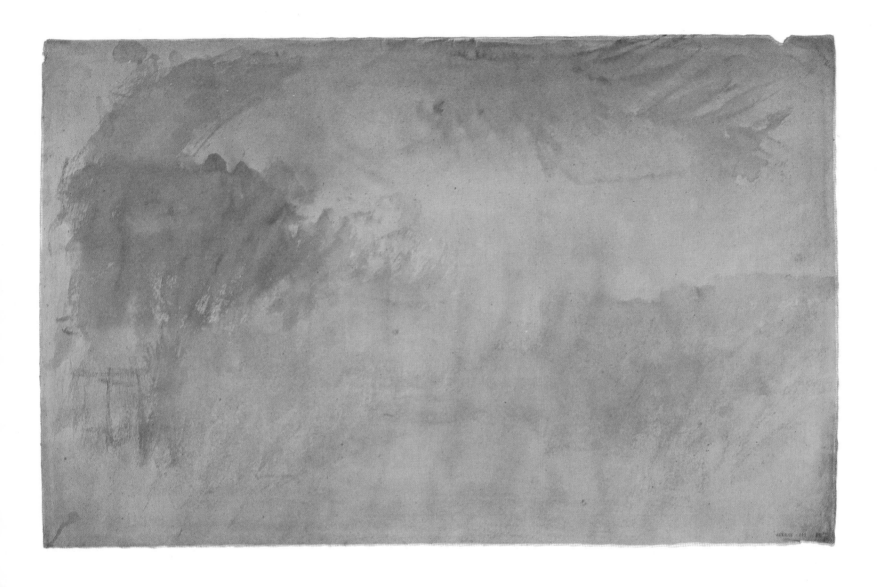

157 'River scene' 12 × 9 305 × 230 mm

Perhaps it *is* a river scene?

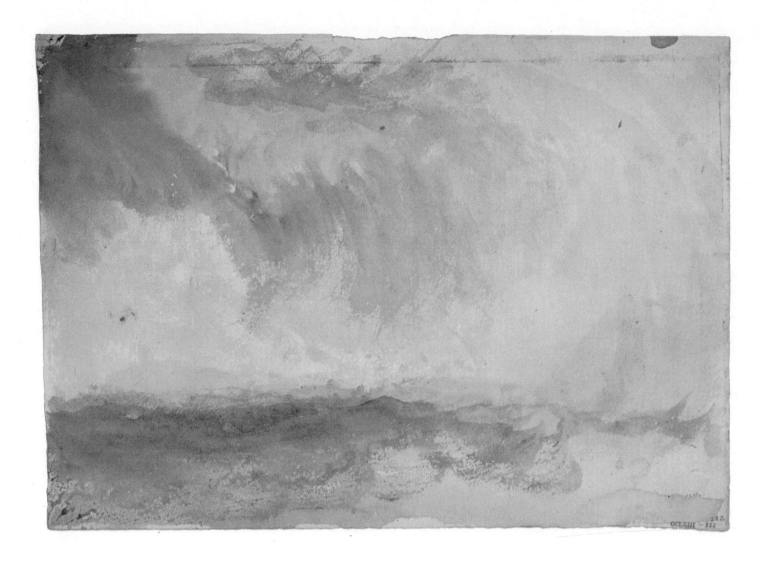

222 Sunlit headland with stormy sky $7\frac{3}{4} \times 10\frac{3}{4}$ 197×273 mm

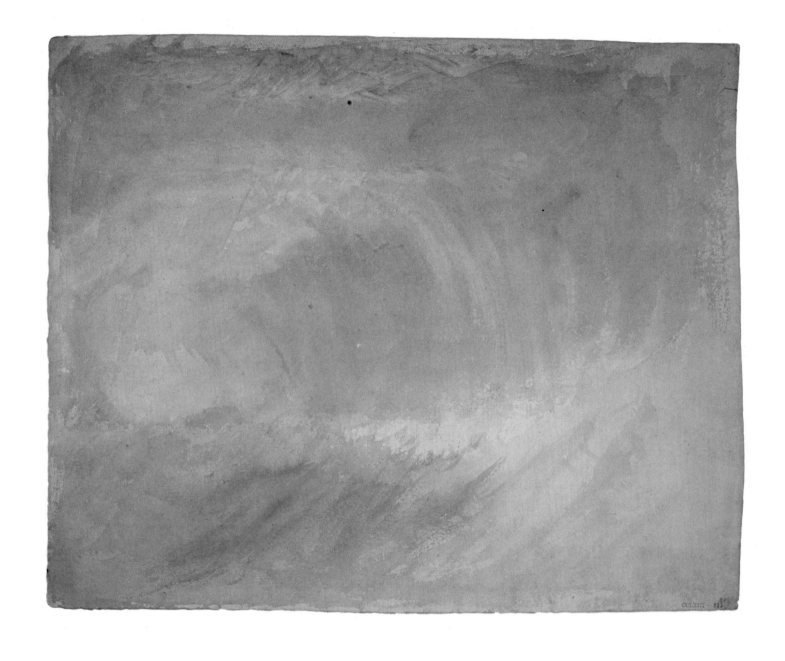

215 'Storm at sea' $9\frac{1}{2} \times 11\frac{3}{4}$ 242 × 298 mm WM 1819

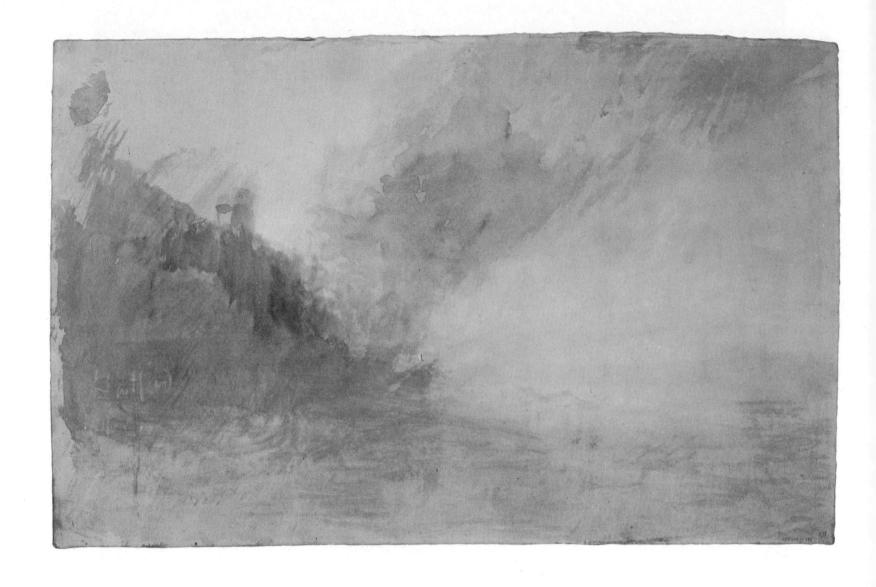

171 A study, the word *Hatfield* (?) written in white 12 × 18½ 305 × 470 mm

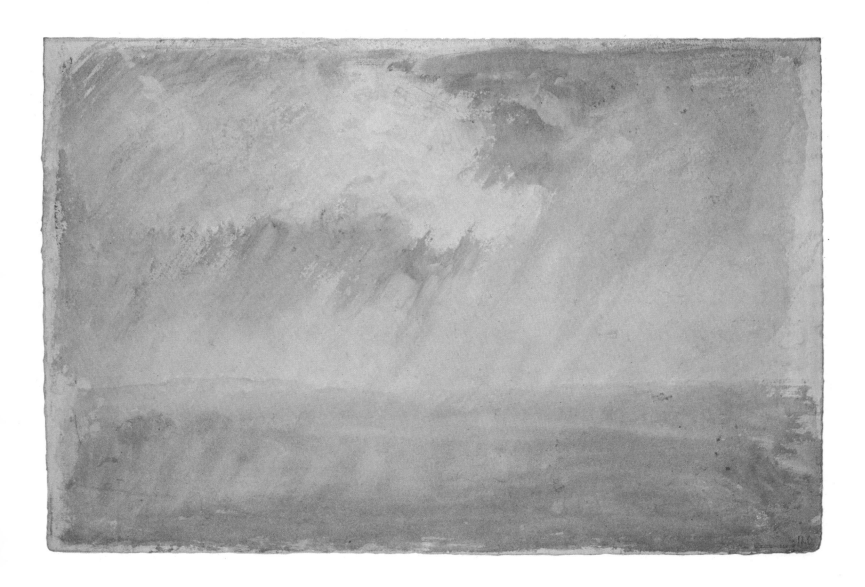

140 Rain 11×17 280×430 mm WM 1815

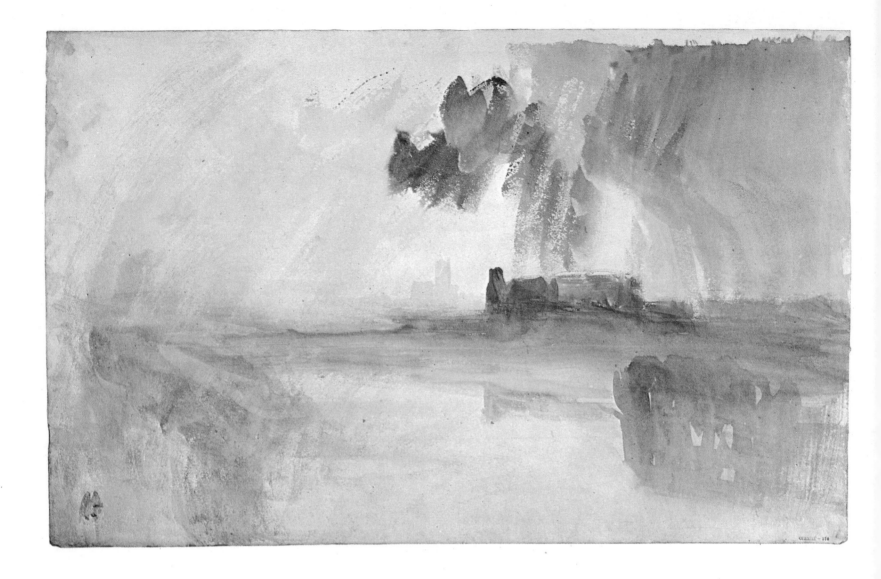

176 Distant buildings and a dark cloud, water in the foreground 12 × 19 305 × 447 mm

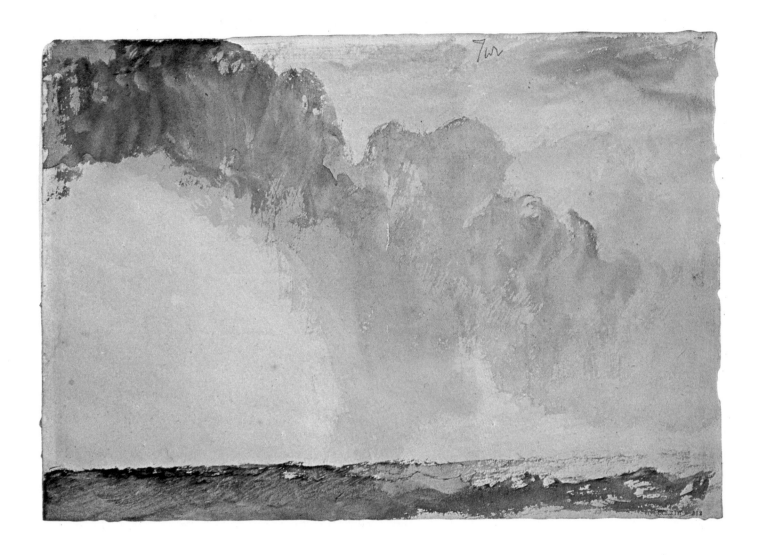

312 Arch of clouds over the sea $7\frac{1}{2} \times 10\frac{1}{2}$ 190×267 mm

Sadly darkened by exposure, mostly on the left
only. We have attempted to reduce the yellowing
in reproduction as it destroys the balance of the
drawing and defeats the brilliance of the open
area of sky – a truly Turnerian vision.

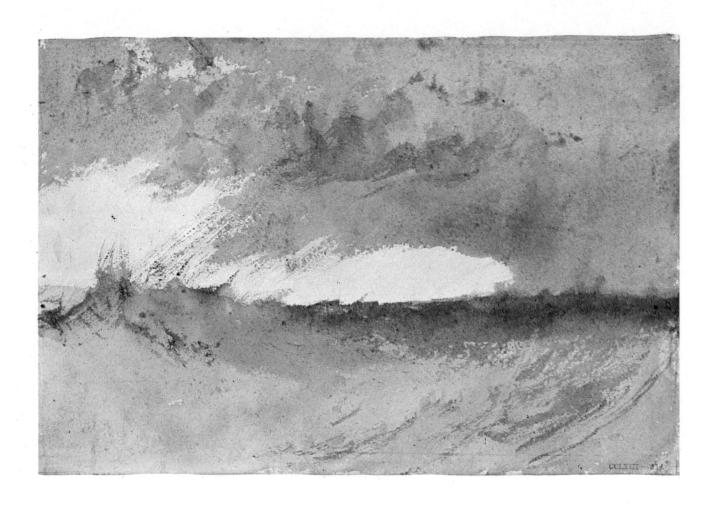

314 'Study of sea' $5\frac{5}{8} \times 8\frac{1}{2}$ 143×215 mm

If I had to choose just one of the 'Colour
Beginnings' it would be this one.

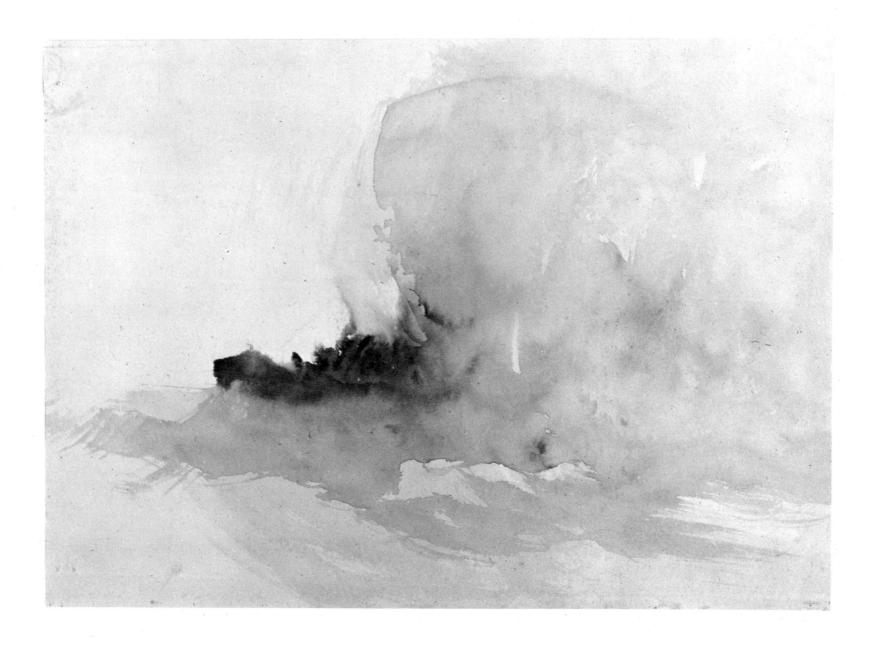

41 Sea study in black 12½ × 19 317 × 480 mm WM 1826

Finberg gave it the title, 'Storm', but this is either too specific or too vague. The drawing, if you can call such calligraphy drawing, has been on view at the Tate for some years, so many readers will have their own ideas about what is depicted.

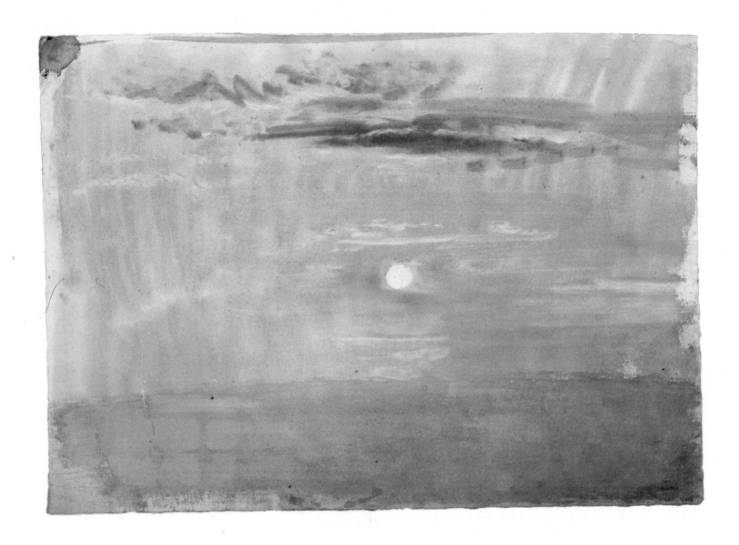

210 'Sunrise', or sunset $9\frac{1}{2}\times13\frac{1}{2}$ 242×343 mm

A controlled brilliance achieved without primary
colours.

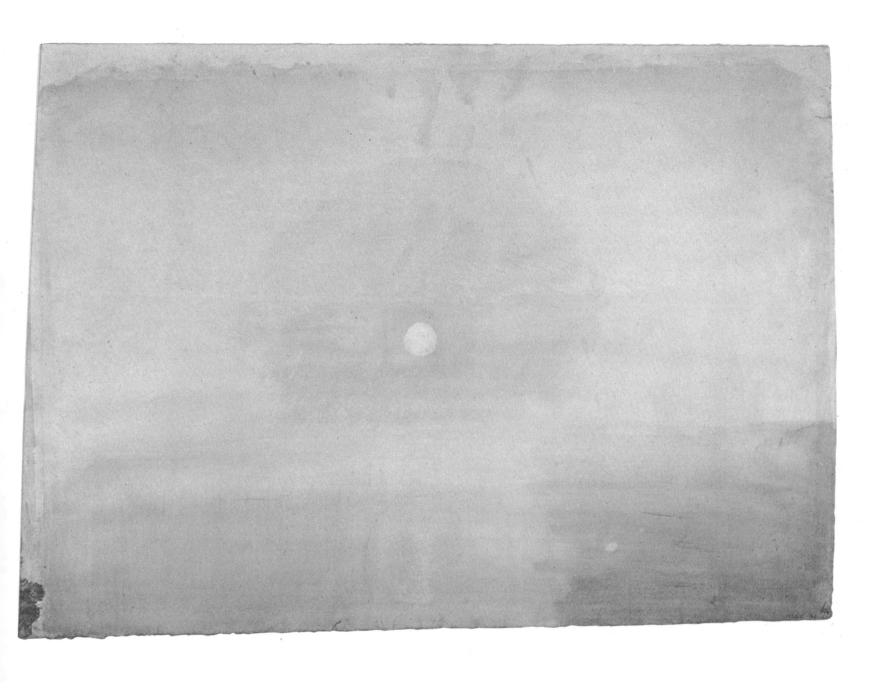

64 'Sunrise' 13 × 18½ 330 × 470 mm WM 1823

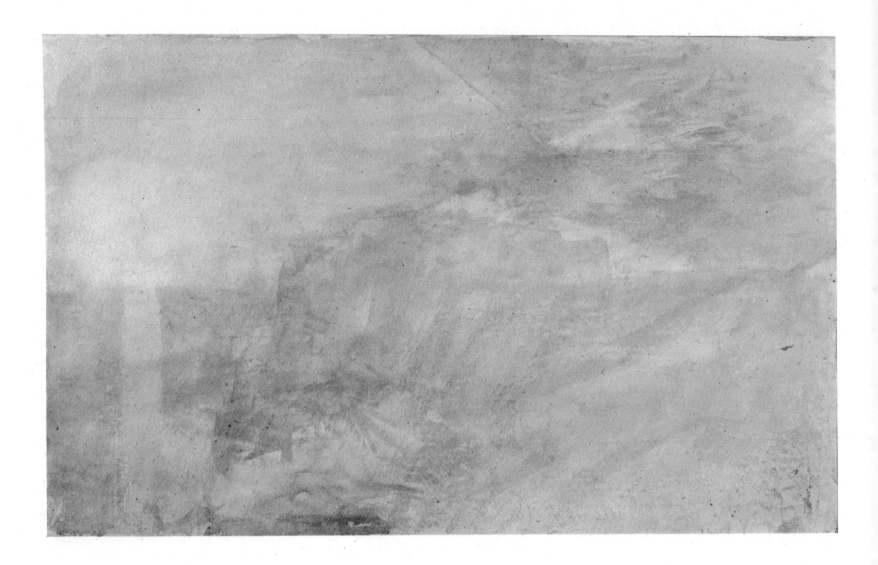

90 Headland with setting sun $11\frac{1}{2}\times19$ 292×480 mm

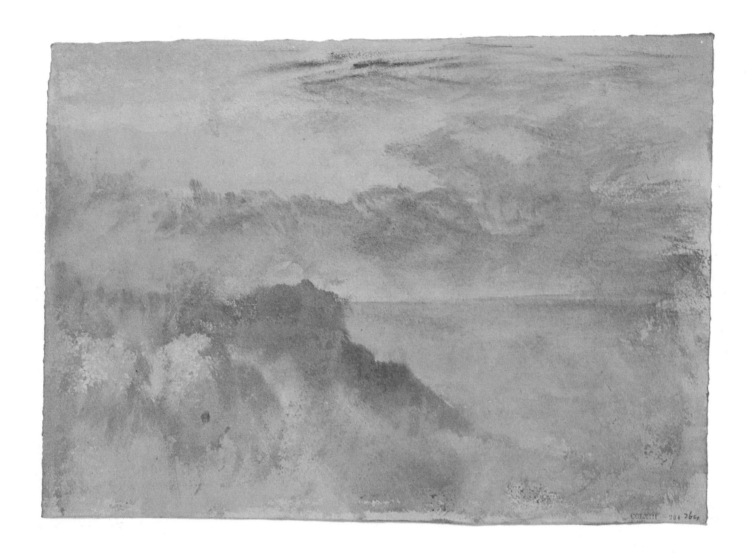

264 'Sunset from the cliffs' $6\frac{3}{4} \times 9\frac{1}{2}$ 172×242 mm

The thin, prismatic colouring of these two
watercolours places them somewhere near 1840.

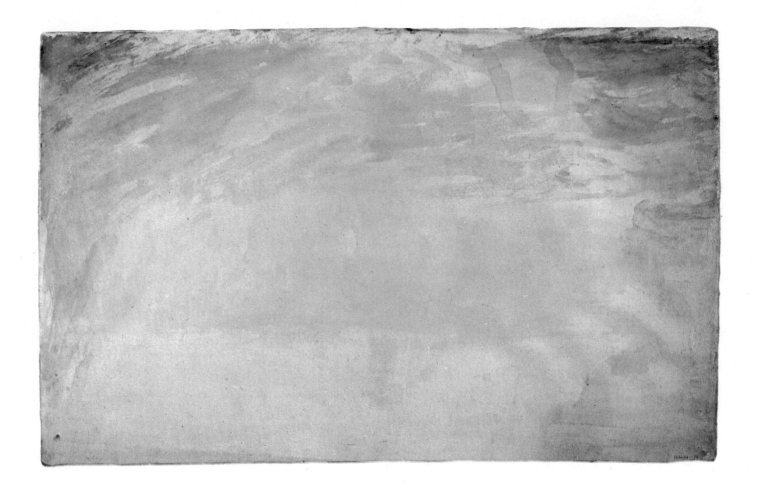

78 'Sunrise?' 11¾×19 298×480 mm

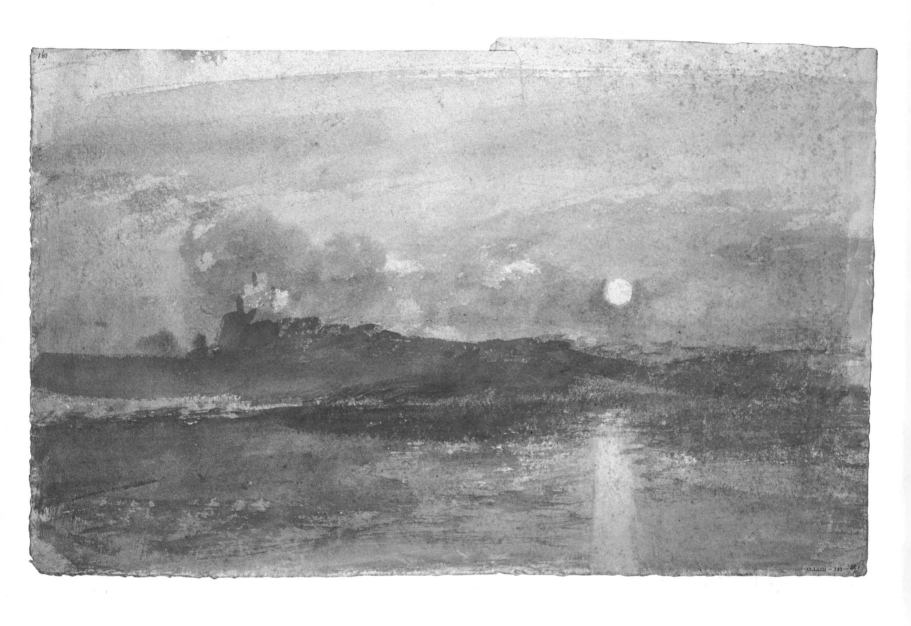

191 Promontory and setting sun 10½ × 17 262 × 432 mm WM 1825

A very wide angle of view (such as Turner often used, apparently instinctively) which contains in effect two contrasting pictures. In the left half is the headland with a tower, attended by an ominous cloud; in the right half the sun presides over a mountain landscape of its own.

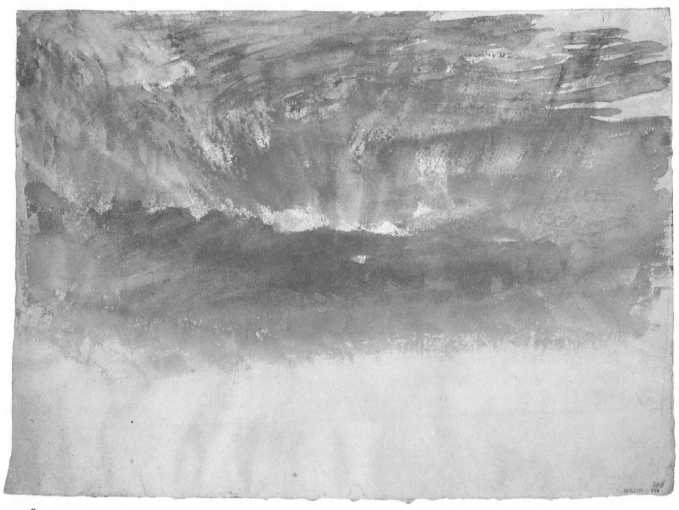

208

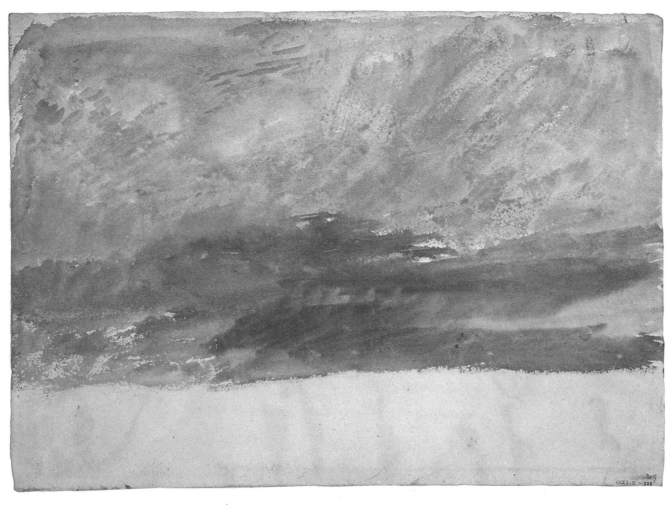

209

208, 209 Two stages of a sunset $9\frac{1}{2} \times 13\frac{1}{2}$ 242×343 mm WM 1823

Here the angle of vision is narrow and
concentrated on what seems to be the struggle
of the colours of fire and blood against the
encroaching purple of night, or death. There are
many indications in his notebooks that Turner
thought of his colours in just such terms.

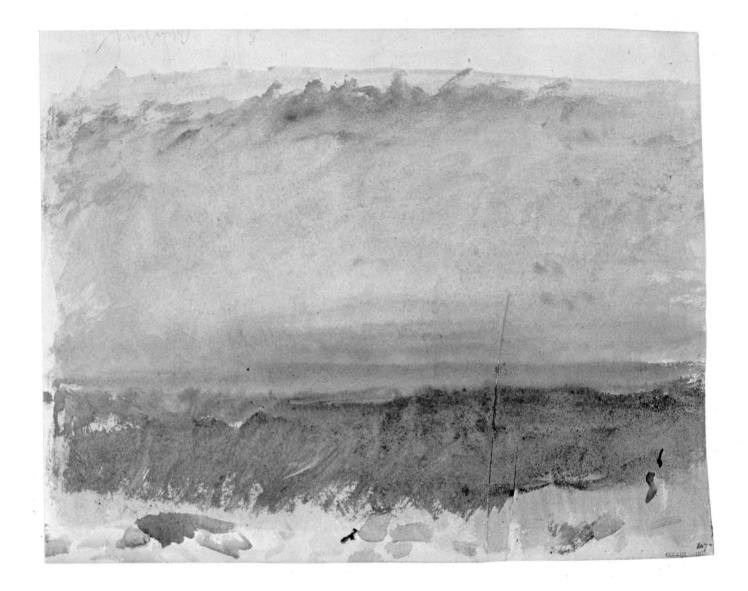

207 A red sky, with mist below the horizon 10 × 13¾ 255 × 350 mm

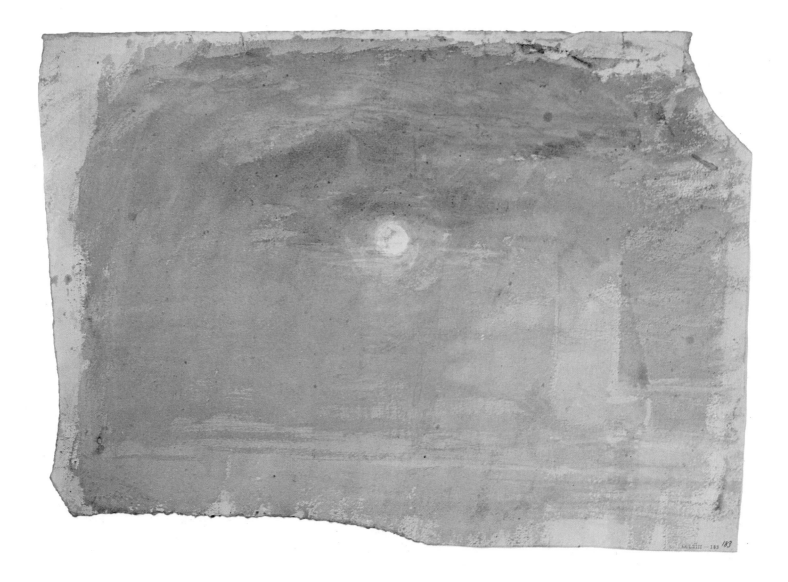

183 Moon and fishing boats $9\frac{3}{4} \times 13\frac{1}{2}$ 248×343 mm

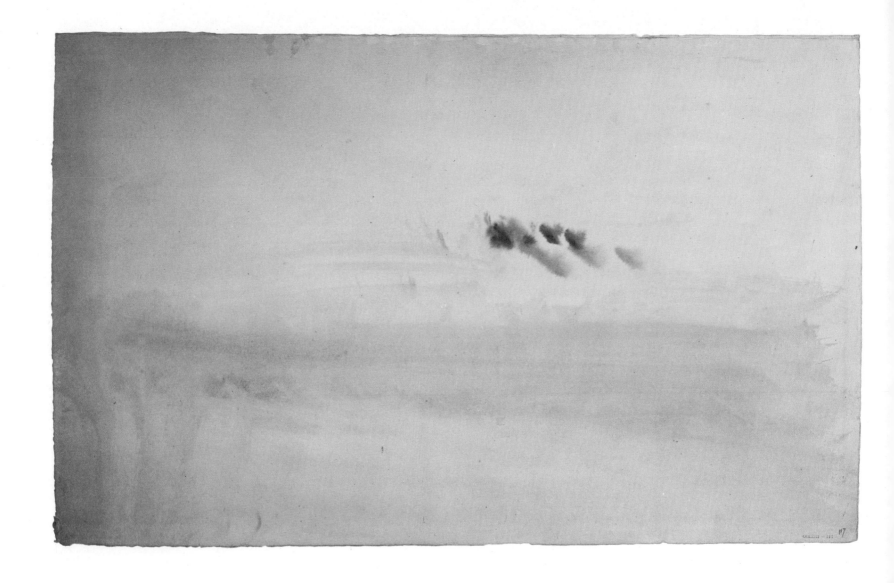

117 'Crimson clouds' $11\frac{3}{4} \times 19$ 298×480 mm WM 1816

Clouds like these, represented by blobbing
colour into a wet ground (sky) appear as early
as 1817, in a drawing of *Mainz and Kastell*
(reproduced in Butlin, plate 5).

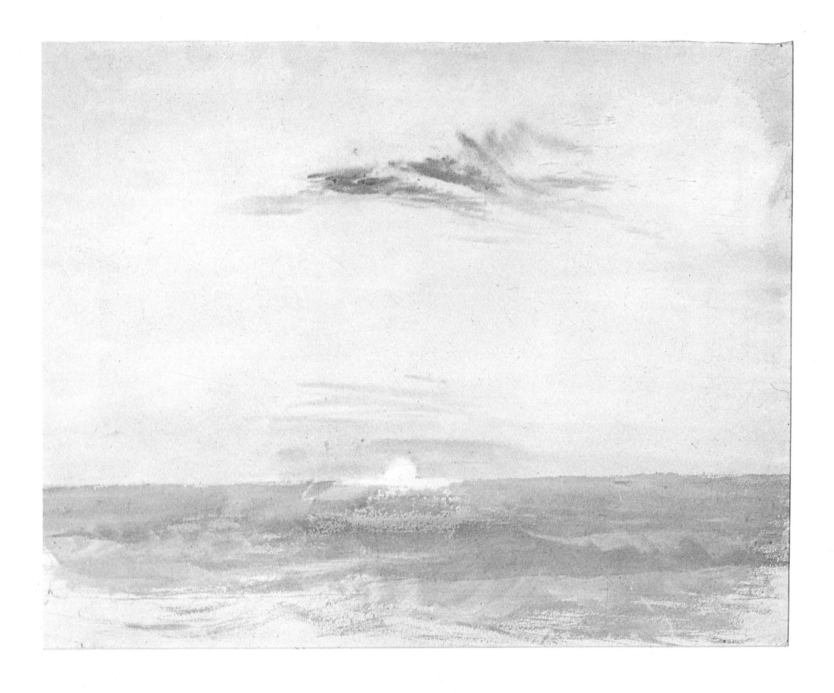

68 'Sunrise at sea' $11\frac{1}{2} \times 15\frac{1}{2}$ 292 × 394 mm WM 1819

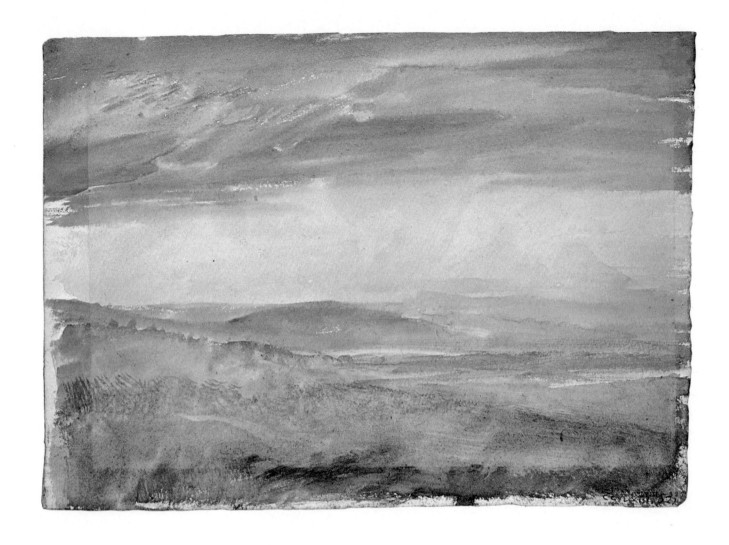

327 Sunset or sunrise in hilly country $6\frac{3}{4} \times 9\frac{1}{2}$ 172 × 242 mm

The true brilliance of the colours can be seen at
the unfaded edges – including a surprising green.
In spite of the fading, and the rather dreary
foreground, the picture stands as a fine and
complete statement.

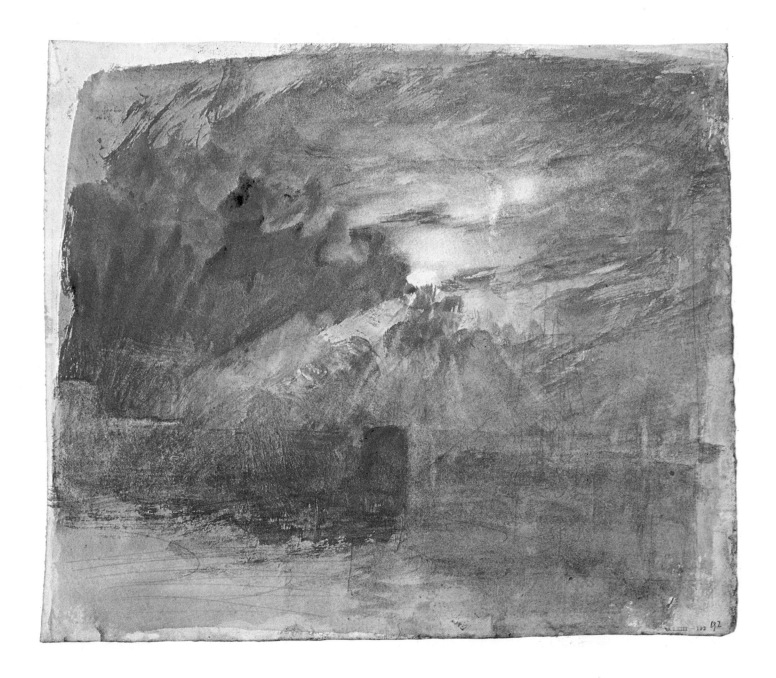

192 'Moon behind clouds' $10\frac{3}{8} \times 12$ 264×305 mm

Finberg adds, 'with shipping', but I am not so
sure: it might be a Swiss lake town. This hectic,
occluded moon is a recurring theme in Turner's
work, from his earliest oil painting onwards.

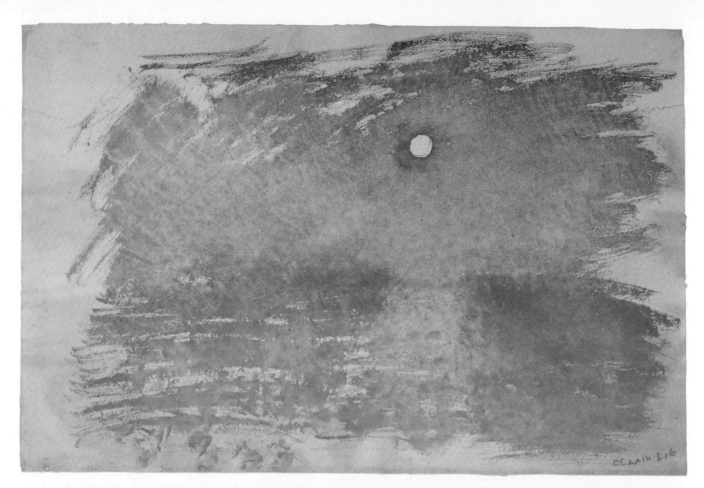

216

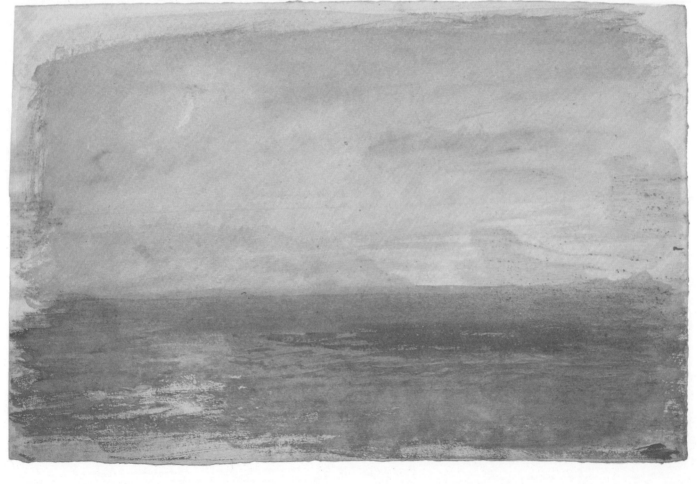

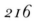

216
reverse

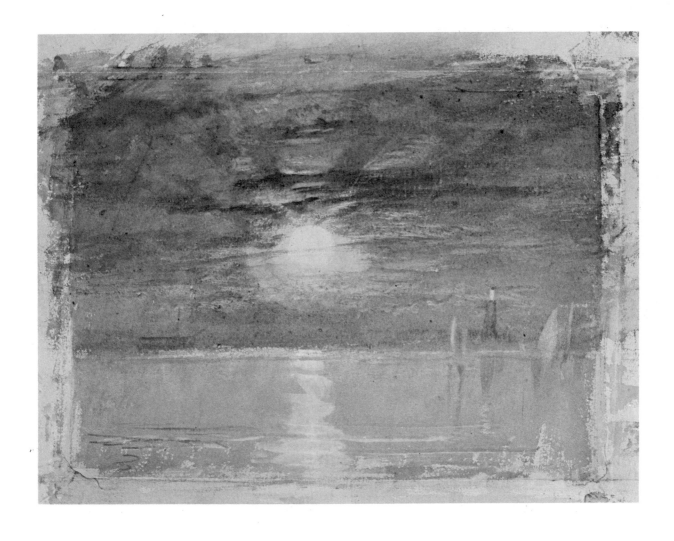

216 and reverse Two nocturnal seascapes $9\frac{7}{8} \times 14\frac{3}{4}$ 250×375 mm

Unfortunately stained with, I think, glue. The
moonlight side is an example of blotting out
carried to virtuoso extremes.

308 Moonlight on a calm sea $7\frac{1}{4} \times 9\frac{3}{4}$ 185×248 mm (area shown)

We have partly masked the edges to avoid some
distracting blots.

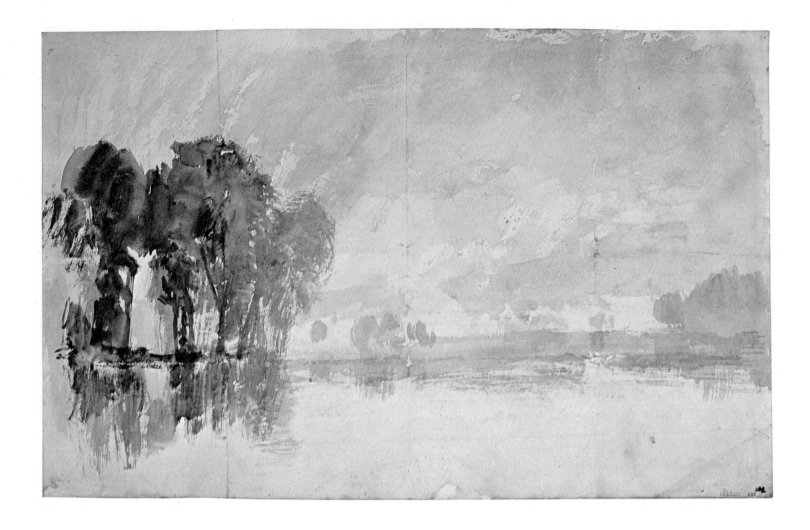

202 'River scene with trees' 9 × 14¼ 230 × 360 mm

On the theme of reflections in water, here are two damp English landscapes – of fairly early date.

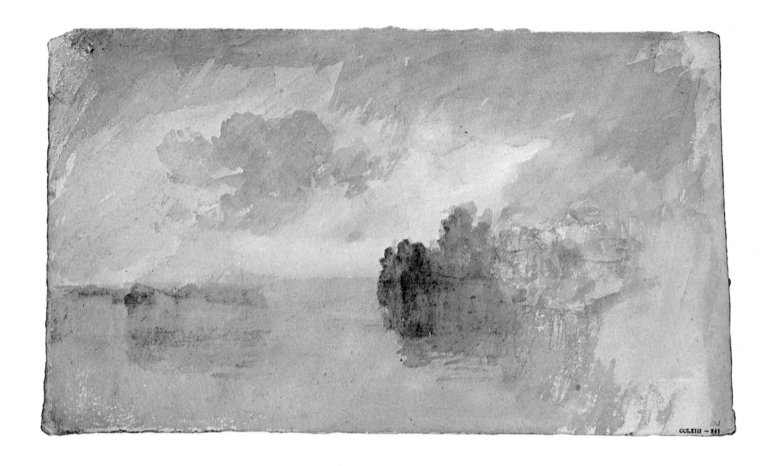

241 'Trees by water' $6\frac{7}{8} \times 12$ 175 × 305 mm

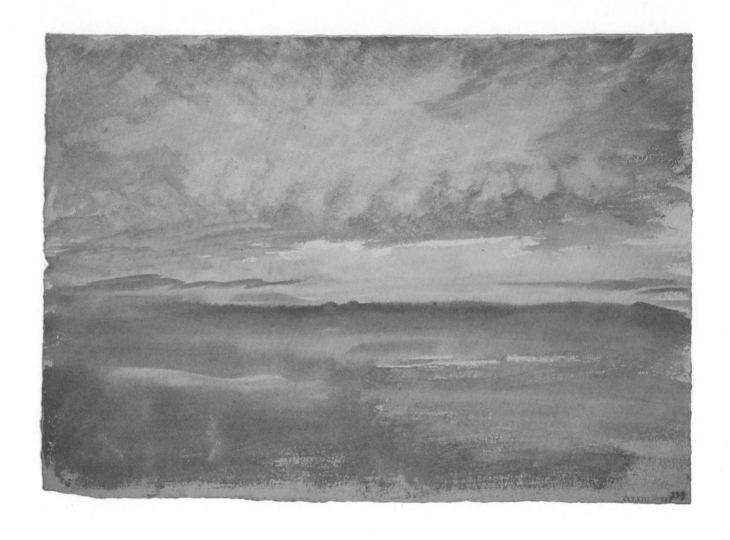

239 'Stormy sunset' $6\frac{5}{8} \times 9\frac{1}{2}$ 168×242 mm

A strangely shaped cloud, which must have been
painted from nature.

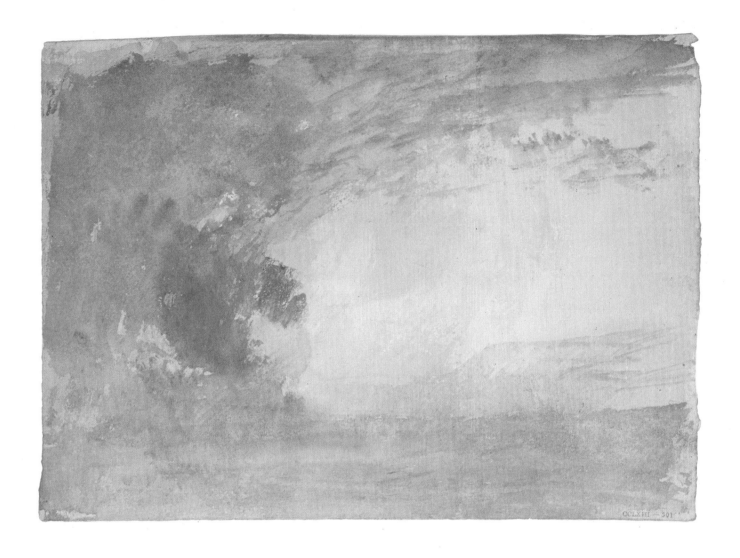

301 Cloud composition $6\frac{3}{4} \times 9\frac{3}{8}$ 172×238 mm

Titled 'Landscape: Evening' by Finberg,
unsatisfactorily I think. It is a piece of very
plastic brushwork and has some of the heroic
style of the oil sketch for *Ulysses* on p. 11.

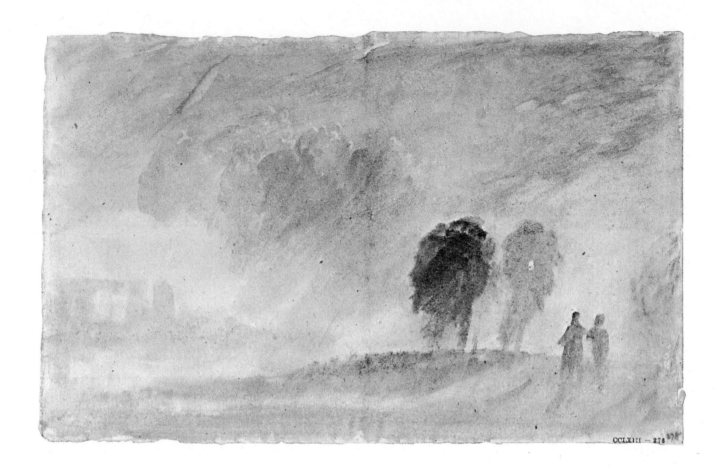

287 'Two travellers' $5\frac{3}{8} \times 8\frac{3}{4}$ 136×222 mm

Checklist

		CCLXIII *125* frontispiece		CCLXIII *201* page 111		CCLXIII *241* page 157		CCLXIII *284* page 104		
		140 page 135		*202*	156	*246*	119	*297*	110	
		148	105	*204*	123	*247*	126	*301*	159	
CCLXIII	*14* page 102	*150*	100	*207*	148	*252*	118	*308*	155	
	27	99	*157*	131	*208*	146	*256*	108	*312*	137
	35	102	*170*	101	*209*	147	*258*	120	*314*	138
	41	139	*171*	134	*210*	140	*264*	143	*316*	121
	64	141	*176*	136	*215*	133	*268*	109	*317*	124
	68	151	*183*	149	*216*	154	*272*	128	*325*	116
	78	144	*184*	107	*220*	108	*273*	130	*327*	152
	89	103	*188*	112	*222*	132	*275*	129	*344*	47
	90	142	*191*	145	*223*	106	*276*	127	*350*	9
	95	117	*192*	153	*229*	104	*278*	160	*351*	113
	104	115	*193*	114	*237*	105	*281*	125	*389*	122
	117	150	*198*	103	*239*	158	*282*	125		